THE ORIGINS
OF WESTERN ART

EGYPT, MESOPOTAMIA, THE AEGEAN

WALTHER WOLF

WEIDENFELD AND NICOLSON
5 Winsley Street London W 1

3154

First published in Great Britain by Weidenfeld and Nicolson
5 Winsley Street, London W 1 © 1972

English language translation © Weidenfeld and Nicolson 1972

SBN 0297 00387 9

CONTENTS

FOREWORD

This book deals with two ancient non-Western civilizations and with a third that can in only a limited sense be called European. To treat them together requires a few words of explanation.

Throughout antiquity there were innumerable contacts between Egypt and Europe. Egypt made a deep impression on Herodotus and Plato. Beginning with the Hellenistic period, Alexandria played a significant role in the exchange of ideas. With the decoding of Egyptian hieroglyphics and the start of a systematic science of Egyptology, the West began its efforts to understand the essence of ancient Egypt. The same is true of Mesopotamia, which also left many traces in the West. Therefore an attempt will be made to point continually to artistic experiments, to peculiarities of form, and to certain motifs that spread from Egypt and Mesopotamia to the West. The situation is somewhat different with the Aegean. It is by no means a foregone conclusion that Creto-Minoan art is the earliest manifestation of the European genius. Nevertheless, there can be no doubt that the fundamental artistic characteristics of that area influenced classical antiquity—or rather were revived in it—so that for a fuller understanding of ancient art we must take a look as well at the early Mediterranean world.

Egypt, Mesopotamia, and the Aegean, each independent of the other, established three artistic traditions with their own unique and highly expressive styles. Quite apart from the question of their relation to each other and their influence in the West, a comparative study of their art shows us the sort of conditions under which civilizations are born; the development of a style; in what sequence the genres of architecture, sculpture, and painting take the lead; the way in which religion, society, and art are related to each other; and much more. As well as inviting speculation of this kind, they bring sharply into focus the West's vastly different solutions to artistic problems. Only by being aware that other solutions are possible—and have in fact been developed—can we be more fully conscious of the value of our own art.

EGYPT

INTRODUCTION

Like every other culture, the culture of ancient Egypt grew up and was largely determined by a limited geographic area. The Nile, with its floods in July and retreating in October, was a generous harbinger of fertility and governed the course of the seasons. The farmer could entrust his seeds to the freshly deposited fertile mud, while swards of grass and vegetation served as pasture for his cattle. In swamps at the edge of the desert papyrus plants flourished and a richly varied animal world existed, led by crocodiles and hippopotamuses. Plant life was more diverse in ancient times than it is today, but it could yield no proper timber; cedar had to be imported from Lebanon and acacia from Nubia. The presence of valuable stone was therefore treasured all the more, from the rich rose granite of Aswan to sandstone and finely grained limestone, which were easy for Egyptian sculptors to hew and work. Translucent alabaster, black and green basalt, metamorphic slate, and colorful breccia were also available, as were amethyst, cornelian, rock crystal, jasper, and other semiprecious stones. Gold came mainly from Nubia, copper from Sinai, and lapis lazuli from western Asia.

In contrast to the narrow corridor of Upper Egypt, which is enclosed by harsh mountain walls, the Nile Delta is an alluvial swampland. If the south impresses by its contrast of colors, the juxtaposition of lush growth and barren waste, the luxurious green strip of fertile soil on each side of the stream cut off as if by a knife from the reddish golden desert, then in the north the eye can roam unhindered into the distance, where the contours of natural forms are preserved and where colors blend into a single tone. Such contrasts in the structure of the Egyptian landscape have encouraged contrasting talents. In the south, a plastic three-dimensional, cubistic imagination was stimulated, while in the north there was an inclination toward the flattened images of painting.

Archeological and linguistic research suggests that basically there were two population groups—one a substratum of Ethiopian origin spreading over northeastern and northwestern Africa, whom we must imagine as cattle-rearing nomads; and the other an Oriental variant of the Mediterranean type, which infiltrated in continuously renewed waves from western Asia and started an early Stone Age farming community in the Delta.

Since the south remained nomadic for a considerable time and the north agricultural, and since both groups were adapted to radically different ways of life and thought, the contrast in the landscape was accompanied by an ethnological and sociological contrast. Admittedly this contrast was largely suppressed in the course of thousands of years through the sharing of a common history; however, it often reappeared, especially in times of crisis.

Artistically this tension stimulated constant changes. The process of development, with its sequence of prehistoric cultures spanning two millenniums, becomes important precisely at that moment during the first century of the 3d millennium B.C. when in a rather dramatic way Egyptian civilization was born. Instantly a pattern appeared involving all aspects of life. From separate states a united kingdom arose embracing the whole of Egypt,

with one ruler at its head. Horus, the falconlike god of heaven and earth, took on human form; this god-king guaranteed divine order on earth. The magical thinking of olden times was transformed into mythology, while demons in the guise of fetishes and animals were humanized and arranged into a company of personal gods. The "great leap into history" led to the invention of writing, the calendar, and the keeping of annals, while art took on a character that made even the most humble work unmistakably Egyptian. In a word, the Egyptian style was created.

The unification of the kingdom during the Early Dynastic Period (1st and 2d Dynasties*) is ascribed to Menes, but other kings—"Scorpion," Narmer, and Aha—have equally valid claims. Unification came with the advent of nomadic supremacy over the agricultural population living mainly in the north. The Horus kings who stemmed from Upper Egypt seem to have lived in Memphis, which, according to Herodotus, was founded by Menes and is said to have been fortified by a wall.

The humanization of the gods was effected during the prehistoric period, as the result of an enlightened Egyptian consciousness, which now wanted to see divinity in human form. The most common figure was the god with a human body, sporting the head of an animal—a relic of his earlier form. Since the gods had now become feeling human beings, they could react in a friendly or hostile way toward each other. A foundation was laid thereby for the evolution of myths, which appeared in colorful abundance in an attempt to interpret the evolution and essence of the world.

The Old Kingdom (3d to 8th Dynasties) began with the 3d Dynasty, the Age of Pyramids, during which Egypt achieved its purest expression and made its greatest contribution to world history. Recently, with the excavation of the holy enclosure around the Step Pyramid at Saqqara, new light has been shed on the times of King Zoser. With the 4th Dynasty, an absolute peak was attained. The immense pyramids of Cheops, Chephren, and Mycerinus in Giza speak eloquently of the greatness of the kingdom, of the splendid organization of the state and the power of religion over the people, who in these monuments declared their faith in the divine kingship and hence in the state itself.

With the beginning of the 5th Dynasty a great change occurred. According to the Heliopolitan story of creation, which then came to the fore, the sun-god Re had been the creator of all life on earth. In the guise of the reigning king he begat an heir to the throne—called simply "Son of Re." Thus the kingship was brought down to the terrestrial sphere. At the same time the administration changed to a feudal one, and breakaway forces sought to gain power at the expense of the crown. This development led gradually to a loss of the cohesive power of the idea of the divine kingship. The kings of the 6th Dynasty tried unsuccessfully to create a royal dynastic power as a substitute. Around 2150 B.C. total collapse ensued, as the machinery of the state dissolved into chaos.

During the Middle Kingdom (11th to 14th Dynasties), after a period of confusion and bloody struggles for power between separate states, princes from Upper Egypt united the

*Dates for the various dynasties are only approximate.

country again. The 12th Dynasty under Ammenemes and Sesostris led to new prosperity. The skill of several generations of assiduous rulers was required to quell the regional nomarchs, who had established themselves all over the country, and to bring central government into effect. The new foundation resulted, among other things, in greater significance for the Upper Egyptian prince of Thebes and the god Amun with him. Apart from the annexing of lower Nubia, it was in their efforts toward internal prosperity that the humane kings of the 12th Dynasty made a name for themselves. These struggles also established the middle class. About 1800 B.C., however, the strength of the dynasty was exhausted. In the course of the next century, after gradual infiltration across the Delta, an Asiatic group referred to as the Hyksos managed to dominate Lower Egypt, and they remained in power for more than a hundred years.

Strength again came from the south. The princes of Upper Egypt drove out the Hyksos and founded the New Kingdom (18th to 20th Dynasties). Many of the 18th Dynasty kings were possessed by a powerful urge to expand and promote Egypt in a short time to leadership in the contemporary world. Under Thutmose III the greatest spread of power was achieved, and under Amenhotep III the greatest splendor. Amenhotep IV, who renamed himself Akhnaton, was reigning when the crisis came. His attempts at religious reform, including the founding of Amarna as the seat of his voluntary exile, brought the kingdom to the brink of destruction.

The kings of the 19th Dynasty reversed the situation completely, managing to make the position of the kingdom properly secure. Ramses III of the 20th Dynasty successfully fought back assaults from various "sea peoples" in a final concerted effort. Thereafter, Egyptian imperial power waned. The snatching of power by the high priests of Amun in Thebes led to a division of Egypt into northern and southern kingdoms. An Ethiopian people from the Sudan moved into Egypt in hordes, convinced that they were upholding true belief and ancient custom; their rulers constituted the 25th Dynasty. After an Assyrian interlude during which the old capital city of Thebes was destroyed and the Ethiopians were forced back to the south, the 26th Dynasty in 664 B.C. saw new prosperity under native Egyptian princes. The Persians ended this in 525 B.C. Their oppressive control, interrupted by six decades of Egyptian independence, was thrown off in 332 B.C. by the Macedonian conqueror Alexander the Great. After his early death, his successors divided his empire, and for the next three centuries Egypt was ruled by the Ptolemies. In 30 B.C., after the Battle of Actium and the death of Cleopatra, Egypt became plunder for the Romans. Finally, with the division of the Roman Empire in the 4th century A.D., Egypt fell to the rulers of the Eastern Roman Empire.

ARCHITECTURE

With the start of recorded time, the unification of the Egyptian kingdom, and a politico-religious order in the making, the foundations were laid for expressing in monuments the idea of the divine kingship and translating its claims into artistic structures. In the prehistoric period the nomadically oriented south had been distinct from the largely agricultural north. Their diametrically opposed ways of life and thought influenced the early dynastic period and were apparent in the royal tombs of the first two dynasties. The nomad buried his dead where they fell and erected an abstract memorial to them in the form of a burial mound. But the farmer originally buried his dead in a house; when he started to separate his dwelling from his graves he gave his dead a grave in the form of a tangible, functional house. As soon as the desire to monumentalize became active, the burial mound turned into a prism with sheer, featureless outer walls, and the house grave became a palace of brick. In contrast to the abstract outer surface of the nomad's grave, that of the farmer suggests the concrete quality of a wall through the rhythm of its front and rear projections. We meet both these forms in the false graves of the early kings in Upper Egyptian Abydos and in the contemporary royal tombs in the Memphis district. They attest the presence of two fundamentally different inclinations of style, one tending to abstraction, the other toward the concrete.

Although stone had already been included in small quantities in a few brick buildings of the prehistoric period, the stone memorial architecture of the 3d Dynasty, in particular the edifice King Zoser erected around his Step Pyramid at Saqqara (*Ills. 2, 3*), suddenly presents us with a mirror image of the kingship's magnified prestige. Inside an enclosing wall stand buildings that are replicas of the king's terrestrial residence reproduced in carved stone, to be offered to the ruler in a rather more solid form for use in the afterworld. Their models in this world are seen in the brick buildings of Lower Egypt and the wood-matting buildings of Upper Egypt as the nomads developed them. Accordingly, the first task of stone architecture was to replace the transient material of the residential buildings with durable stone and to create a framework for certain cults involved in the death of the king.

Soon afterward they succeeded in giving the stone its own language of form. The idea of giving the dead king a palace was dropped and with it the necessity of translating ancient building methods into stone. The planning design demanded by the cult resulted in a firm link with an abstract tendency in style that was a product of the Upper Egyptian genius. The tomb itself was no longer built up in steps. With a few intermediary stages, the most important being the unfinished and hence especially instructive building at Medum (*4*), the pure form of the pyramid was achieved. We see it at its most impressive on the plateau of Giza (*5*) with its accompanying pyramid temples. Abstract mathematical regularity is just as predominant in the pyramid temples. The ground plan and elevation are governed by the right angle. The framework takes the form of inorganic, crystalline rectangular pillars (*8*). The stone, chiefly granite and alabaster, is worked with real feeling and technical mastery. The halls—sometimes wide, sometimes deep—evoke an atmosphere of ceremony, royal dignity, and divine timelessness.

With the 5th Dynasty there is a complete change. Severity turns into joy, somber colors into bright fullness of hue (6). Characteristically the inorganic pillar is replaced by the plant-like column copied from nature. Columns in the shape of palm trees, papyrus bundles, and lotus stems give credence to the idea that they "meant" something and provided scenery for a ceremonial event, but they also represent a modification of style. These Egyptian types of column, unlike the Greek ones, do not involve the idea of supporting weight. Admittedly they are stylized in an attempt to replace organic movement with inorganic permanence. However, in contrast to the pillars, they show a return to natural form, a switch from the abstract to the concrete extreme, just as in religious thinking of the time the center of gravity shifted from an actual basis in reality to the revelation of the sun-god in the physical, external world. A sequence of 5th Dynasty kings built temples to this sun-god, the only known religious temples of the Old Kingdom. Two have been discovered through excavations: They follow the pattern of the pyramid burial temples in that a similar covered path leads up to the actual temple from a valley temple, lying at the edge of the fertile land. The main temple consists of an open courtyard within which an obelisk rises up on strong gigantic foundations, the sun seeming to have lighted on its gilded tip. An altar made of alabaster stands before it. (See 1.)

The royal buildings determined the development of style. But since the high officials of the kingdom tried to follow royal example as far as they could, something must be said about their designs. The form they aimed at was the prism-shaped mastaba, as it is called, in whose eastern wall a worshiping niche was carved. This runs deeper and deeper into the center and finally develops into a sequence of rooms with pictures on the walls. An almost inaccessible chamber contains the statue of the deceased, while the burial chamber lies deep under the rock.

The architectural history of the Middle Kingdom begins with the mortuary temple King Mentuhotep II of the 11th Dynasty erected for himself in his native Thebes. The temple stands on the western bank of the Nile before rising cliffs and is reached by a ramp. An entrance hall embraces three sides of a chamber with 140 octagonal pillars, in the middle of which stands a pyramid. Connected to a courtyard behind it is a hall with 80 pillars. The burial chamber lies deep within the cliff, while in the middle of the pyramid there is a statue of the king wearing the crown of Lower Egypt. We are therefore dealing with a double-level royal tomb (16).

Unlike the buildings of the Old Kingdom, those of the Middle Kingdom return to human scale; instead of a forbidding exterior, they offer the visitor open halls. Only scanty relics of architecture from the 12th Dynasty remain: a jubilee chapel at Karnak dedicated to Sesostris I (7) has been completely reconstructed from the original dismantled blocks. Some compensation for lost buildings is offered by the various kinds of rock tombs of the nomarchs. Those at Beni Hasan are particularly impressive; their 16-sided pillars have been called proto-Doric although they were conceived as completely inorganic. Perhaps the most beautifully preserved inner chamber is the rock tomb of the nomarch Sarenput II of Aswan (9). The return to the pillar as the dominant structural form can be seen as a recognition of renewed commitment.

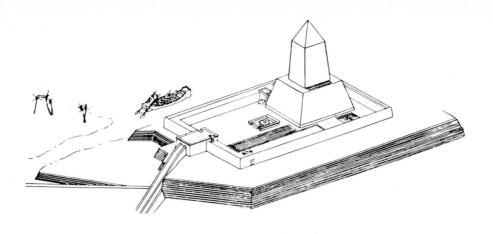

1 Sun Temple of King Ni-User-Re. 5th Dynasty, c. 2400 b.c. Reconstruction

The hallmark of the New Kingdom was an enormous passion for building. Indisputably the finest work is the mortuary temple that Queen Hatshepsut built for herself and her father Thutmose I near the older temple of Mentuhotep on the west side of Thebes (16). Its terraces ascend through linking ramps with supporting walls fronted by pillared hallways; everything conspires with the towering cliffs to produce a magnificent union of art and nature. Another unique formation is the Festival Hall of Thutmose III in the Temple of Amun at Karnak (10). The most common type of temple at that time was the jubilee temple designed with its avenues of sphinxes, pylons, and rows of columns to direct the masses of celebrants along the path of holiness. The open courtyard is followed by a hall of columns and the rooms behind are kept for the worship of holy images. The best example is the temple of Amenhotep III in Luxor (12, 13) whose style is marked by the harmonious proportions and gently undulating forms of the papyrus columns. The great temple at Karnak also belongs to this type, but less clearly so because of two thousand years of additional building. Its famous columned hall (11), a forest of 134 columns, is a work of the Ramessid era designed to make man feel in the sheer weight of enormity the power of the divine compared with his own smallness. The papyrus columns adapted for functional use at this time became overheavy and betray a neglect of any sense of form. The same is true of the Rock Temple at Abu Simbel (15).

The so-called peripteral temple, a style of building surviving in a number of examples, was reserved for a special purpose. In the Middle Kingdom it was used as a shrine for the altar during processions (7). It is given a new role in the Late Period as a "birth house" in which the divine mother conceived and reared her son. This type has columns of lush proliferation: bundles of plants whose form reveals a great richness of fantasy. The giant Late Period temples of the Ptolemies and the Romans in Edfu (14), Kom Ombo, Dendera, Philae, and Esna follow a largely codified pattern of layout.

11

2 PORTAL, from the perimeter wall of the enclosure around the Step Pyramid, Saqqara. King Zoser, c. 2600 B.C. The wall of white limestone (10 meters high) encloses a rectangle (545 × 278 meters) and represents the brick wall that surrounded the earthly residence in Memphis. Of the 15 double doors only one is an entrance; all the others are false.

3 PAPYRUS COLUMNS, from building inside the enclosure around the Step Pyramid, Saqqara. King Zoser, c. 2600 B.C. Height c. 3.25 meters. Two massive buildings in stone are possibly to be seen as a copy of two administrative buildings for both halves of the kingdom. On the northerly one of these two halls three papyrus columns appear as a symbol of Lower Egypt. The columns retain the triangular cross-section of a papyrus stem and for the first time show the elegant, stylized shape of the umbel.

4 UNFINISHED PYRAMID, MEDUM. c. 2575 B.C. Limestone. Height 65 meters. The original plan was to build a seven-stepped pyramid. In a second design the entire outer casing was raised and a new step was laid around the outside. After the completion of the plan it was decided to turn the building into a real pyramid. The lowest stages are buried in the earth.

5 PYRAMID COMPLEX, GIZA. c. 2550–2500 B.C. Reconstruction. Left: Chephren's Pyramid with mortuary temple, ramp, and valley temple (the so-called Sphinx Temple); beside it, the Sphinx. Right: the Pyramid of Cheops. On its eastern side three small pyramids of queens and the mastabas of the royal family. Left foreground: a small pyramid under construction by means of brick ramps.

6 HALL OF PILLARS, in the mortuary temple of King Sahurê, Abusir. 5th Dynasty, c. 2450 B.C. Reconstruction. The hall represents a grove whose palms are growing out of the black earth, thus the palm pillars of red granite stand on a black basalt floor.

The enclosing walls display brightly colored reliefs on a basalt base.

7 CHAPEL, KARNAK. King Sesostris I, c. 1950 B.C. Reconstruction. A central house surrounded by pillars. Inside stands a resting altar for the barge with a statue of the god. There are identical steps on the other side.

8 VALLEY TEMPLE BESIDE THE PYRAMID OF CHEPHREN, GIZA. 4th Dynasty, c. 2500 B.C. Reconstruction. Height of the pillars 4.1 meters. The ceiling of the deep hall is supported by five pairs of monolithic granite pillars. Twenty-three statues of the king stood on the polished granite walls. The floor is of alabaster.

9 ROCK TOMB OF SARENPUT II, ASWAN. Time of Ammenemes II, c. 1900 B.C. Height of the front pillars 4.1 meters. The ceiling of the reception hall is supported by six pillars.

10 FESTIVAL HALL OF THUTMOSE III, in the Temple of Amun, Karnak. c. 1450 B.C. The ceiling of the three middle naves is supported by ten pairs of tent-pole pillars that lend the hall the character of a festival hall. On both of the open sides a row of pillars marks off a lower subsidiary nave. Windows are set in the supports, creating a basilican structure.

11 COLUMNED HALL, in the Temple of Amun, Karnak. 19th Dynasty. Ramses II, c. 1280 B.C. A view from the high middle nave into the lower side naves. Height of the columns behind, 13 meters.

12, 13 TEMPLE AT LUXOR. 18th Dynasty. Amenhotep III, c. 1380 B.C. A double row of (13) papyrus umbel columns 16 meters high leads to the great courtyard, which is surrounded by (12) papyrus bundle columns. In the background a Roman addition with a rounded arch.

14 TEMPLE OF HORUS, EDFU. Ptolemaic, 237–147 B.C. View from the courtyard of the actual temple house. The panels reaching halfway up between the columns and the composite capitals are architectural forms typical of the Late Period.

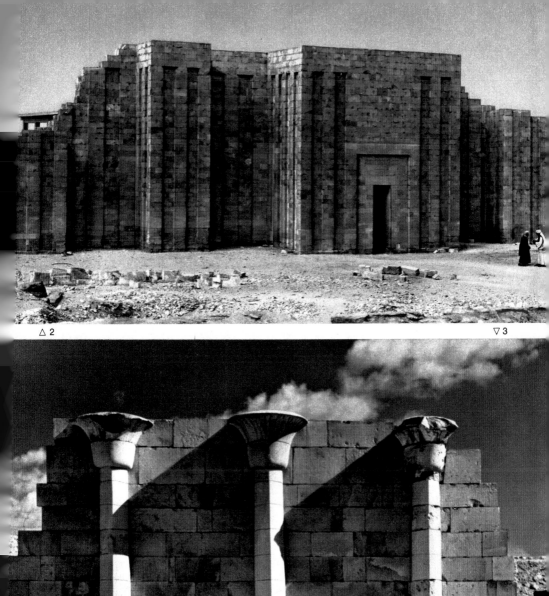

△ 2

▽ 3

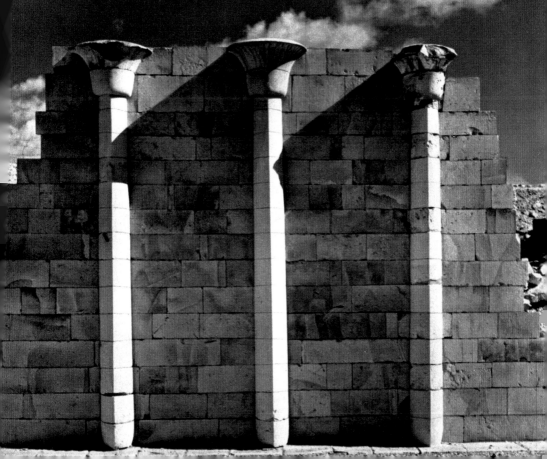

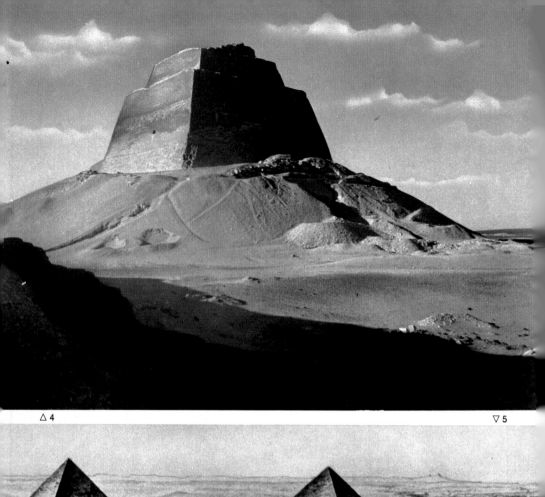

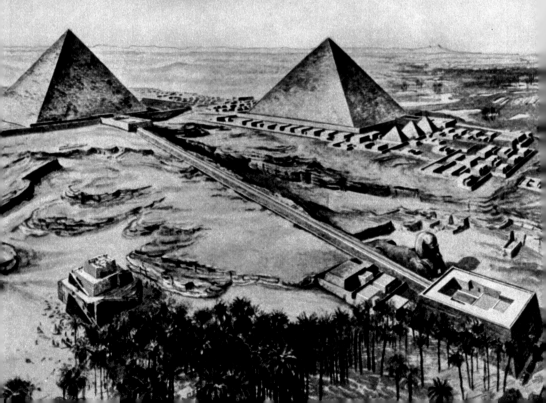

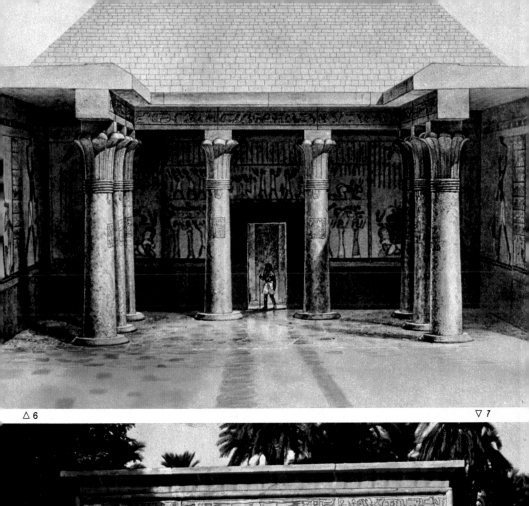

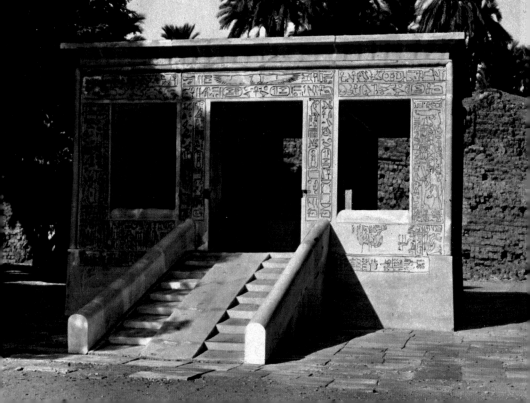

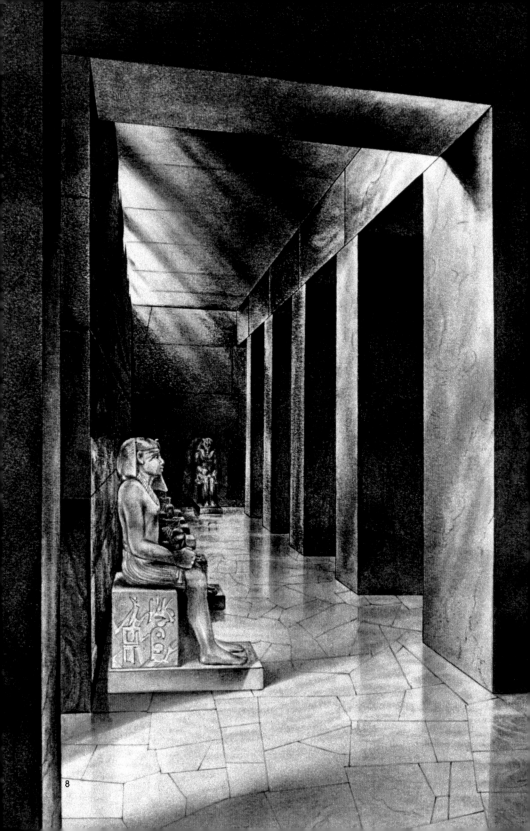

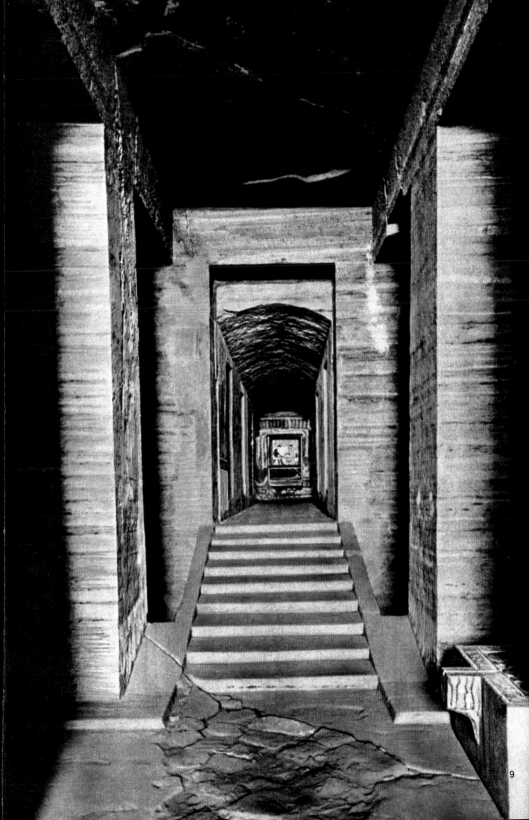

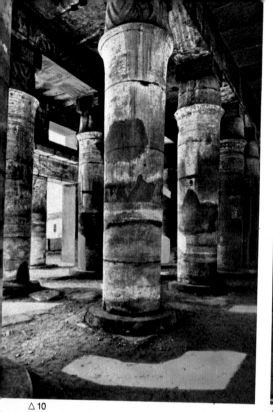

△ 10

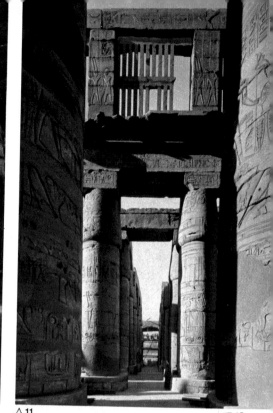

△ 11

▽ 12

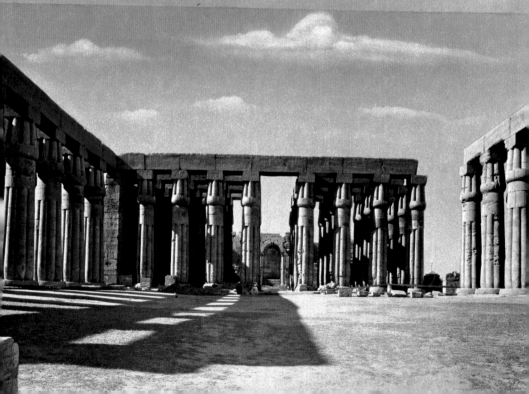

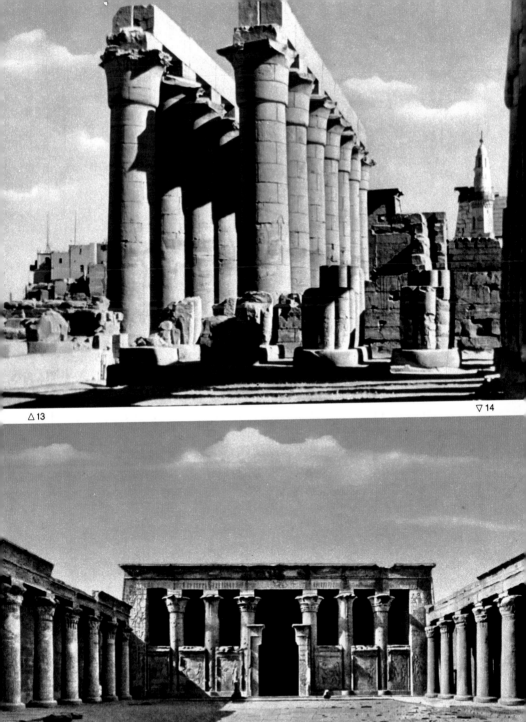

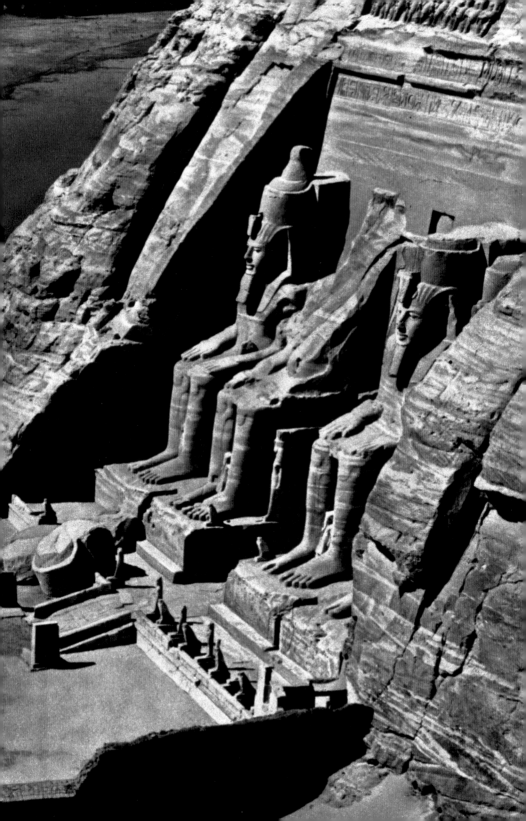

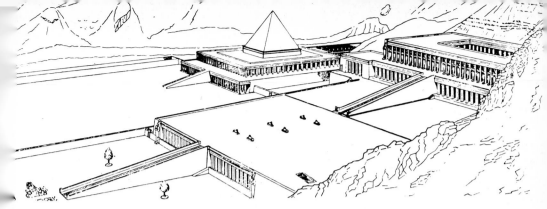

16 MORTUARY TEMPLES, THEBES. Temple of
Hatshepsut (18th Dynasty) with that of
Mentuhotep (11th Dynasty) in the back-
ground. Reconstruction.

15 ROCK TEMPLE, ABU SIMBEL (Nubia). 19th
Dynasty. Ramses II, c. 1280 B.C. Height of
the rock-hewn sitting colossi that flank the
entrance in pairs, 20 meters. In spite of
their exaggeration they have balanced pro-
portions. The temple extended over 60
meters into the rock. In 1966 the temple
and statues were moved to another location
to save them from flooding.

As early as the Prehistoric Period sculpture in the round was done in a variety of forms. Besides figures carved from bone there were those that were formed by hand from Nile mud or clay, and so in a strict sense plastic works (*17*). Their main subject is woman, sometimes a mother and child, their purpose not the representation of reality but the creation of an effective symbol that could fulfill its magic function through its mere existence, buried in the sand of a grave. While clay-modeling disappeared with the beginning of the historic era, bone-carving (*18*) continued for a time, evolving into stone sculpture. The earliest examples of this are two robed figures (*21*).

The animal form also appealed to the prehistoric mind. At the beginning of the 1st Dynasty several lion types appeared that express unbridled savagery and bloodthirstiness (*20*). Characteristically they were replaced, still in the prehistoric period, by another type expressing the majestic calm of the king of the beasts, and this became the prevailing form. The earliest animal monument in Egyptian art is the baboon bearing the name of King Narmer (*19*). In spite of a diligent observation of nature, it retains the cubic form completely.

17 DANCING WOMAN. Prehistoric, c. 3700 B.C. Clay. Height 29 cm. Brooklyn Museum. The upraised arms suggest an attitude of mourning. The naked upper body is painted reddish brown; the rest is clothed and painted white.

18 WOMAN WITH CHILD. Beginning of the Early Period, c. 3000 B.C. Ivory. Height 6.6 cm. Staatliche Museen, Berlin. The child is stretching its legs and fumbling for the breasts.

19 BABOON. 1st Dynasty, c. 2900 B.C. Alabaster. Height 52 cm. Staatliche Museen, Berlin. The ape-god squats on a base that is ringed by its tails. The statue bears the name of King Narmer.

20 LION. Beginning of the Early Period, c. 3000 B.C. Granite. Length 32 cm. Staatliche Museen, Berlin. The statue has no base. Fangs and lower incisors have been modeled by drilling.

21 ROBED FIGURE OF A GOD. 1st Dynasty, c. 2900 B.C. Limestone. Height 29.8 cm. Kofler-Truniger Collection, Lucerne. The word "city" on the round base means "city god." Like its rather larger female companion (Ägyptische Staatssammlung, Mu-nich), this standing statue comes from the oldest temple enclosure at Abydos.

22 SITTING MAN. 2d–3d Dynasty, c. 2760 to 2575 B.C. Granite. Height 44 cm. Museo Nazionale, Naples. The block is still sharply angular.

23 ANKH-APER. 3d Dynasty, c. 2630–2575 B.C. Granite. Height 79 cm. Rijksmuseum van Oudheden, Leiden. The sitting man wears a panther skin as a token of his dignity.

24 KING KHASEKHEM. 2d Dynasty, c. 2630 B.C. Green stone. Height 56 cm. National Museum, Cairo. The sitting statue comes from the temple at Hierakonpolis, where it was presented in memory of the victory over the northern kingdom. The clenched right fist held a symbol of rule.

25 PRINCE RAHOTEP AND PRINCESS NOFRET. Detail. Early 4th Dynasty, c. 2575 B.C. Limestone. Height 1.2 meters and 1.18 meters, respectively. National Museum, Cairo. The two statues painted in contrasting ways are to be seen as a single unit and come from their common grave at Medum. The woman's wig (worn over her natural hair) is held together by a headband. (See also 79.)

17 ▷

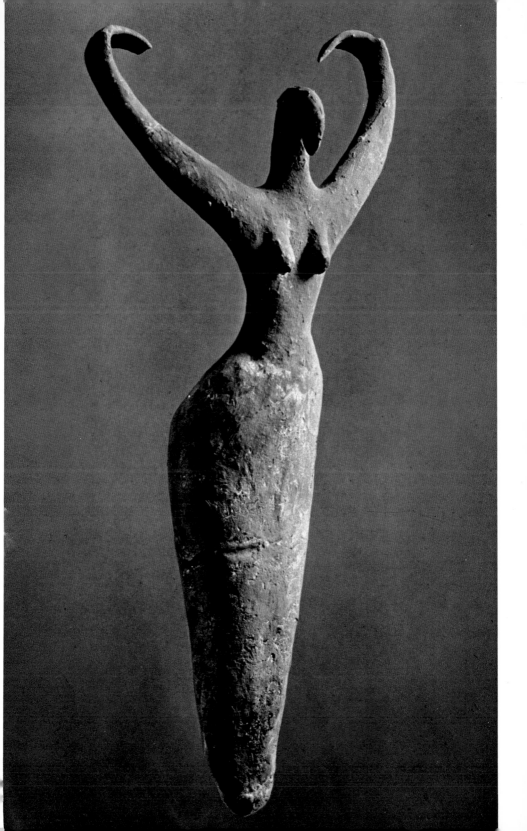

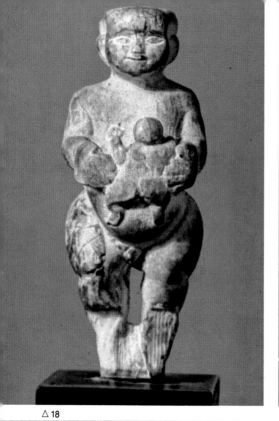

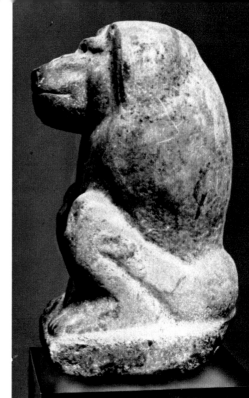

△ 18 △ 19 ▽ 20

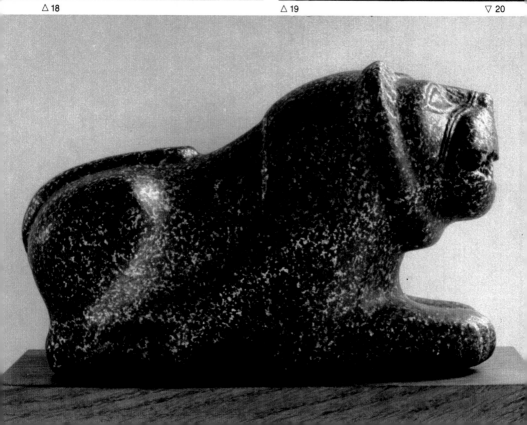

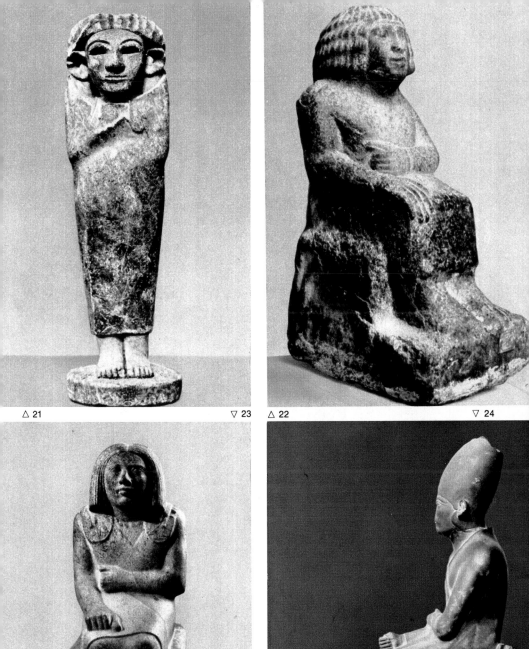

△ 21 ▽ 23 △ 22 ▽ 24

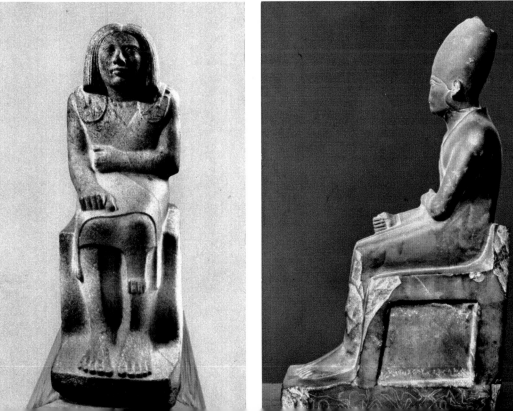

The placement of the robed figure (*21*) on a pedestal offers important evidence that, simultaneous with the beginning of architecture, sculpture was now subject to tectonization—that is, it was being treated architecturally, becoming more integrated, organized, and structured. By this means it was lifted out of the natural order of things and exalted to a higher form of art. The same is also true of a number of sitting statues that were emancipated stage by stage from their archaic clumsiness (*22–24*).

Tectonization, whose hallmark is the pedestal, determined the proportions of sculpture. A cube is seen as a framework of vertically intersecting axes, a symbol of permanence. The statues share this immortal character insofar as they are arranged within the cubic form as symbol. In this mathematical, mechanical structure, number is the unit of measure. With its help the Egyptians surmounted chaos and created order. By subordinating the organic proportions of the human physique to inorganic cubism the human figure is transformed into a building. Because man desires immortality he turns his thoughts back to the organic. Related to this is the fact that in the Egyptian figure all the parts are conceived according to their form and significance but do not appear to be activated or held together by a nucleus of life. Their four sides are presented as the sides of a cube boxed together, whose unity is based not in the function of the whole but in the concept of the cube. It is not the aim of the Egyptian sculptor to create an image as close to reality as possible. He is far more concerned with an awareness of things beyond their appearance. The form imposed on the organism of the human body is represented by the object itself and is independent of any change in the original model. It embodies those characteristics that an object has of itself and ignores those that a beholder attributes to it at a particular time from a particular viewpoint. It is the expression of an objective approach. In other words, Egyptian sculpture exists for its own sake and is not striving toward a goal. As a result, the object itself is significant and not the artistic effect it aims at. For example, no one side is developed as *the* view for the observer, but all four sides of the statue have equal value. The Egyptian statue is not an aesthetic monument but a magical commodity, which—when the priest of the dead calls upon it—must serve as a substitute for the decayed body by housing the souls of the interred man.

If the composition of the statue has the aim of giving it the character of immortal permanence and of extinguishing all subjective or incidental features, the chosen material, on the other hand, must try to avoid the same effect. The Egyptian consciously selected his stone and learned to subject even the hardest types such as granite and diorite to his creative will, but without violating it. On the same level the concept of form led to the development of a technique that was best suited to creating the desired composition. The sculptor started with the rectangular hewn block on whose four sides he had sketched in the dimensions of the figure. Then he worked symmetrically down all sides with his chisel, layer by layer, so that the figure grew out of the block, constantly improving in shape. Even when the cubic form aspired to was simple and plain he needed a strong sense of dimension and a technical mastery that could be achieved only after a long apprenticeship. Later, when Greek art of the 5th century adopted a freer representation of the human form according to different ideas of proportion, a new technique was needed, for even the mightiest genius of dimension

25

could not work in this type of many-sided statuary with sketches on the surface of the block. The plaster model cast in gypsum was invented, transposed into stone by means of a measuring tool. This step led to a growing dependence on the plaster model, based as it was on a contradictory technique, and finally to the development of the dotting pen, which signaled the end of free sculpture. But in Egypt the principles of form and the technical means remained in complete harmony.

The Old Kingdom begins with the almost-life-size statue of King Zoser (26), in which for the first time the god-king's claims to power are expressed in the form of a monument. The impression of dark severity would be less oppressive if the original eyes inlaid with colored stone had survived. An exciting drama takes place as the limbs of the contemporary private statues gradually become distinct from each other, as dullness is overcome, and as the face grows more detailed. This stylistic development is even clearer in cases where the sculptor has chosen the more tractable limestone instead of the hard primeval rock, as for example in the life-size statues of Sepa and Nesi-Ames in Paris. An early peak is reached in the sitting statues of Prince Rahotep and his consort Nofret (25, 79). In addition to a pedestal they have been given a backrest that underlies the structure of the artistic condi-

26 KING ZOSER. Detail. 3d Dynasty, c. 2600 B.C. Limestone. Slightly less than life-size. National Museum, Cairo. The statue was found in the enclosure near the Step Pyramid at Saqqara in a stone chamber sealed on all sides. There are traces of painting.

27 KING CHEPHREN. Detail. 4th Dynasty, c. 2525 B.C. Diorite. Height of the whole statue 1.68 meters. National Museum, Cairo. The statue is the best preserved among 23 in the valley temple of the Second Pyramid at Giza. It was originally painted. The monarch sits on a lion throne. On the backrest squats the falcon of Horus, enfolding the head of the god-king from behind with its wings.

28 PRINCE ANKH-HAF. 4th Dynasty, c. 2525 B.C. Limestone. Height 50.6 cm. Museum of Fine Arts, Boston. The work, presumably a provisional rather than a final artistic form, comes from a prince's grave at Giza. Part of the lifelike face and the hair were modeled in plaster; beard and ears were added in plaster.

29 KING MYCERINUS. Detail. 4th Dynasty, c. 2500 B.C. National Museum, Cairo. The life-size alabaster head was found in fragments near the king's pyramid in Giza.

30 SCRIBE, from Saqqara. 5th Dynasty, c. 2400 B.C. Limestone. Height 53 cm. Louvre, Paris. The flesh is painted reddish brown, the hair and base black, the skirt white, the papyrus bright yellow.

31 SHEIKH EL-BELED, from Saqqara. 5th Dynasty, c. 2400 B.C. Wood. Height 1.1 meters. National Museum, Cairo. The right hand held a short scepter of dignity, the left a smooth staff (poorly restored) reaching to eye-level.

32 PRINCE MERENRÊ, from the temple at Hierakonpolis. 6th Dynasty, c. 2250 B.C. Copper. Height 75 cm. National Museum, Cairo. Found together with the copper statue of Pepi I. The separate copper parts appear to have been beaten out and nailed onto a wooden core.

33 QUEEN - MOTHER ANKHNES - MERIRÊ WITH HER SON PEPI II. 6th Dynasty, c. 2240 B.C. Alabaster. Height 39.4 cm. Brooklyn Museum.

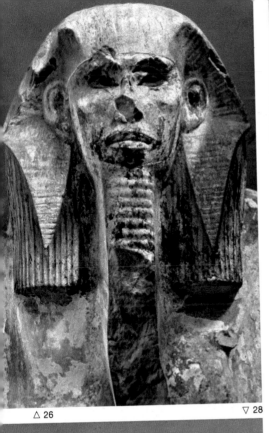

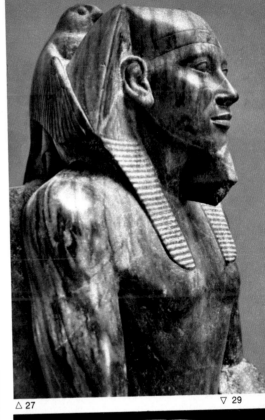

△ 26

△ 27

▽ 28

▽ 29

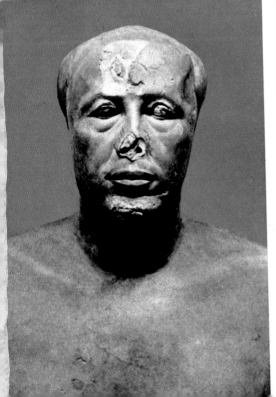

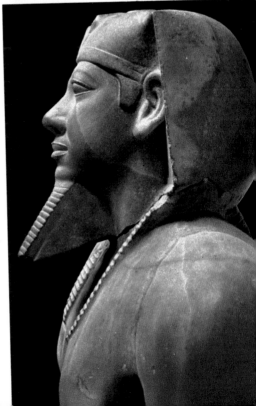

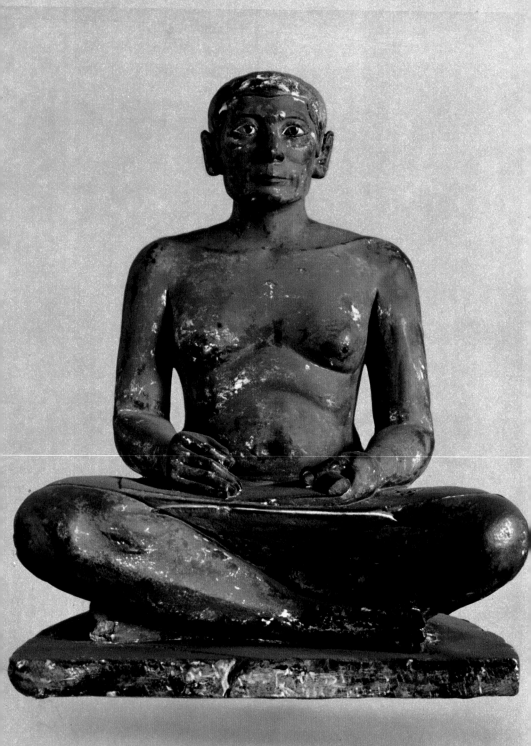

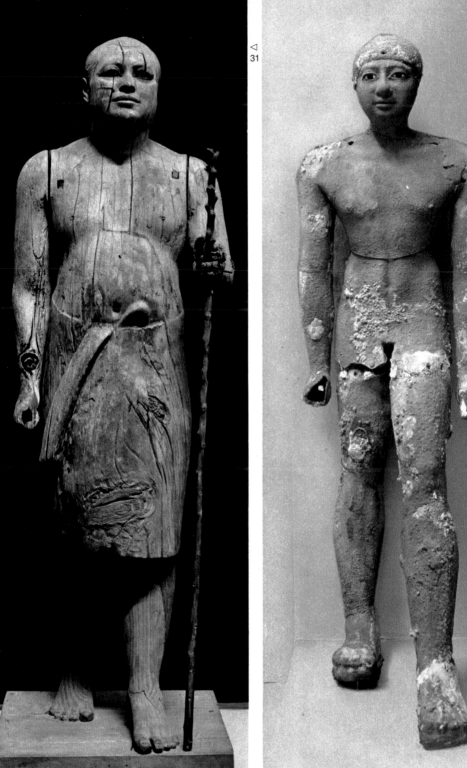

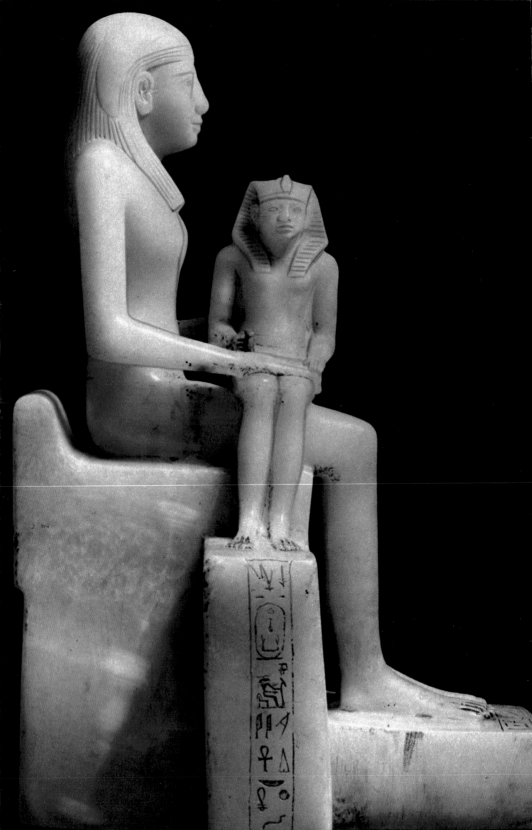

tions imposed on them and that proves to be an effective means of tectonization. There is still a hint of the archaic in the rather awkward position of the man's hands. In the woman the beauty of the female body is shown for the first time and not without refinement.

No statue, at least during the Old Kingdom, was left unpainted. This was also a time of works in such colorful stone as alabaster or granite, which were chosen for their durability rather than for their color. For the Egyptian the painting of a statue was necessary for the sort of realism demanded in his sculpture; it was necessary too because the living world is also rich in color. For this reason it is hardly a question of a naturalistic blending of color but of an idealistic one bound up with the system of all things, just as the Egyptian statue itself is not intended as a copy of nature but rather as a symbol. This explains among other things why the flesh of the man is painted a reddish brown while the woman's is yellow. (Greek sculpture also was painted and to a much greater extent than was imagined in Goethe's time and later.)

From the abundance of royal portraits of the 4th Dynasty, the one of Chephren with the falcon (27) stands out as the work in which the idea of the god-king received fullest expression. The cubic spatial existence is so completely realized in the shape of the body that life is inseparably united with the essence of eternity. If one compares it with the portraits of his successor Mycerinus, one can see how they reflect the changing idea of the monarchy: a subtle neglect of divine energy and a move toward the human sphere.

A unique work is the limestone bust of Prince Ankh-haf (28) in which part of the face has been modeled with a plaster overlay to achieve an astonishing vitality.

The tendency toward realistic features understandably enjoys greater possibilities in the private portraits than in the royal ones. The best examples belong to the 5th Dynasty, when gentlemen were happy to have themselves portrayed in the pose of a writer. The most famous writing figure is one in the Louvre (30). The bony face with eyes artfully inset is the visage of a man of understanding whose uncanny alertness shows how far along the path of consciousness Egyptian man had progressed.

The shift of style closer toward actual appearance meant that wood became the chosen material rather than stone, for it allowed greater freedom. But it also led to a weakening of the urge for timeless permanence and a consequent disillusionment with traditional values. The most important wood carving of the Old Kingdom is the so-called Sheikh el-Beled (31). The statue was originally covered with stucco and painted, so that at first glance it seemed no different from a stone work. Although it sticks to the stereotyped form of the standing man, the freedom of the original model is nevertheless apparent.

The last great work of the Old Kingdom is a life-size copper of King Pepi I of the 6th Dynasty and of his son Prince Merenrê (32), the earliest evidence of the metalworking technique, which has been traced back to the 2d Dynasty. Other examples from this era of royal and private statues show a desire to experiment and to moderate the strong cubic structure, but at the same time leave a little quality to be desired and led in the end to the dissolution of sculptural form and to a total crisis in the art of sculpture. The movement from suprapersonal to personal thought, from the collective to the individual as a result of the rise of ◁ 33 the bourgeoisie and of skepticism about the worth of the burial cult, removed the historic

mission of art for a century. The debased idea of the king is emphasized in an alabaster statuette showing the queen-mother Ankhnes-Merirê (*33*) as a nomarch's daughter, holding King Pepi II, who is depicted as a helpless child, in her lap.

Two questions have been much debated. The first concerns the problem of a rule of proportion. An art like that of the Egyptians, which springs from an idea and corrects itself with reference to nature, may be expected to produce an ideal rule of proportion for the human body, which can be expressed numerically as a basic unit and may be applied to

34 MENTUHOTEP II. 11th Dynasty, c. 2040 B.C. Sandstone. Height 1.83 meters. National Museum, Cairo. The painted sitting statue comes from a chamber beneath the pyramid of the king's mortuary temple in Thebes.

35 KHERTIHOTEP. 12th Dynasty, c. 1850 B.C. Sandstone. Height 75 cm. Staatliche Museen, Berlin. In its powerful masculinity and ethic humanity the work, conceived on a large scale, embodies completely the spiritual attitude of the Middle Kingdom.

36 SESOSTRIS III. 12th Dynasty, c. 1850 B.C. Gray granite. Height 29 cm. National Museum, Cairo. The body belonging to it has also survived.

37 SPHINX OF AMMENEMES III. Detail. 12th Dynasty, c. 1800 B.C. Black granite. Length of the recumbent sphinx including base 2.25 meters. National Museum, Cairo. In contrast to the usual sphinx, the stylized lion's mane surrounds the face. King and lion have achieved a convincing union.

38 HEAD OF A SPHINX'S QUEEN. 12th Dynasty, c. 1880 B.C. Green stone. Height 38.9 cm. Brooklyn Museum.

39 SESOSTRIS-SENEBEFNI. 12th Dynasty, c. 1850 B.C. Brown quartzite. Height 68.6 cm. Brooklyn Museum. Between the feet of the squatting cubic statue whose front side is covered with a hieroglyphic inscription stands a depiction of his wife in high relief.

40 COFFIN OF QUEEN MERIT-AMUN. Detail. 18th Dynasty, c. 1520 B.C. Cedar. Length of the entire coffin 3.14 meters. The indentations were filled with blue glass inlay work, the rest covered with gold leaf.

41 LADY FROM A FAMILY GROUP. Late 18th Dynasty, c. 1340 B.C. Limestone. Height 85 cm. National Museum, Cairo. The piece is influenced by Amarna art.

42 AMENHOTEP HAPU. 18th Dynasty, c. 1370 B.C. Granite. Height 1.42 meters. National Museum, Cairo. This famous sage was given divine status in the Ptolemaic era.

43 RECUMBENT LION. Late 18th Dynasty, c. 1370 B.C. Red granite found at Gebel Barkal (Nubia). Height 2.13 meters. British Museum, London. Two lions survive, one made under Amenhotep III, the other under Tutankhamun.

44 THUTMOSE III. 18th Dynasty, c. 1475 B.C. White marble. Height 38.7 cm. National Museum, Cairo. The king sacrifices two spherical libation vessels.

45 AMENHOTEP IV. Detail. Late 18th Dynasty, c. 1360 B.C. Sandstone. Original height c. 4 meters. National Museum, Cairo. The piece comes with others from a pillared courtyard built by the king in Thebes to his god Aten at the beginning of his reign.

46 STUCCO MASK OF AMENHOTEP IV, from a sculptor's workshop in Amarna. Late 18th Dynasty, c. 1350 B.C. Height 30 cm. Staatliche Museen, Berlin.

47, 48 HEAD OF A QUEEN. Late 18th Dynasty, c. 1350 B.C. Brown sandstone. Height to the top of the headband 19 cm. Staatliche Museen, Berlin. Same origin as *46*. Not quite finished; the final stage has been sketched in. Pegs above and below were intended to fasten a crown and a body of different materials to the head.

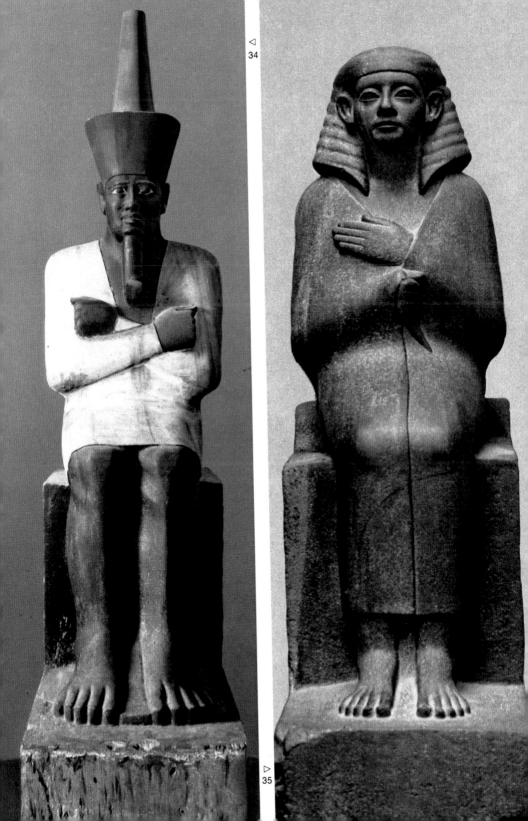

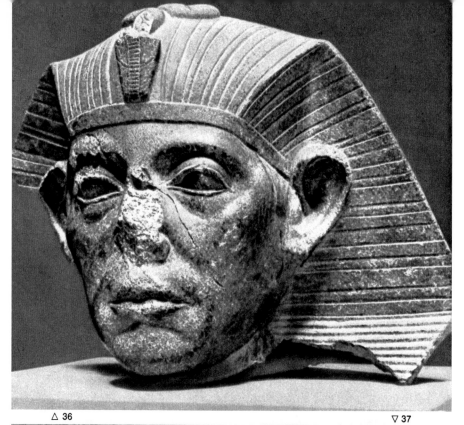

△ 36

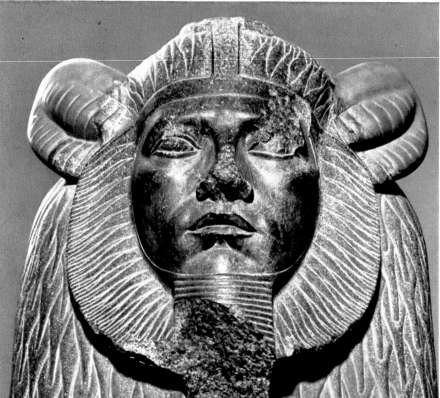

▽ 37

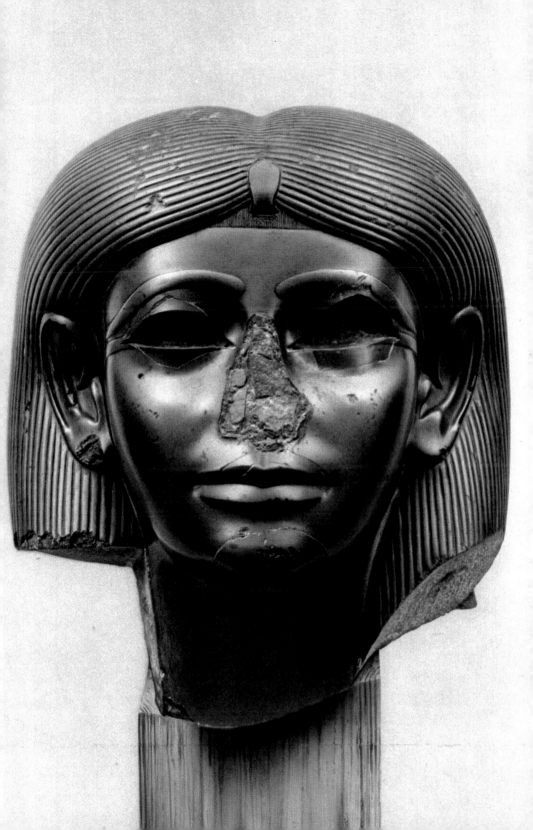

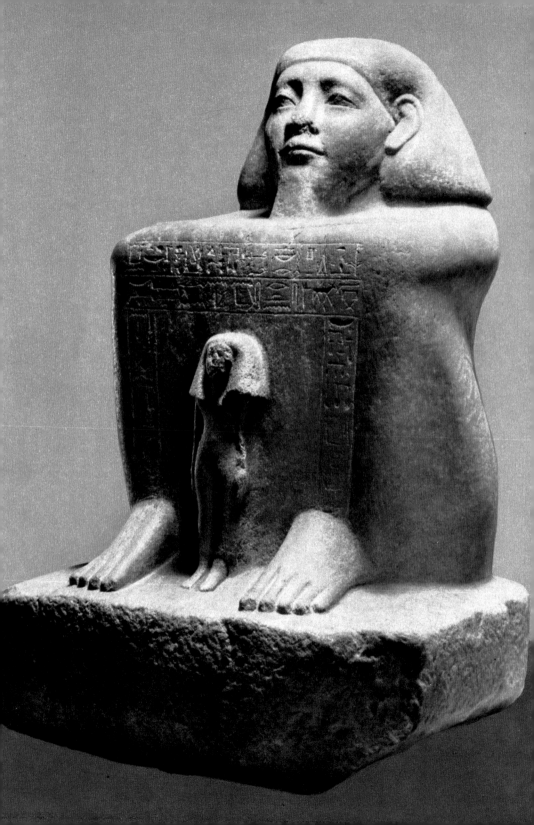

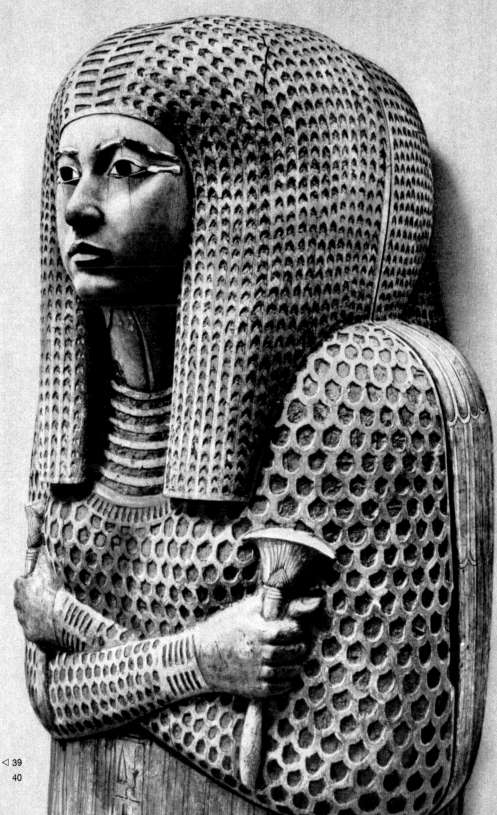

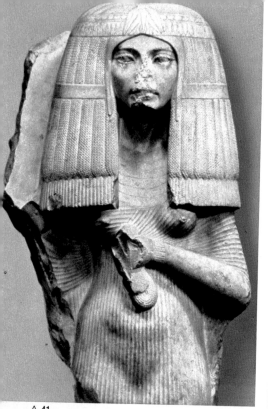

△ 41

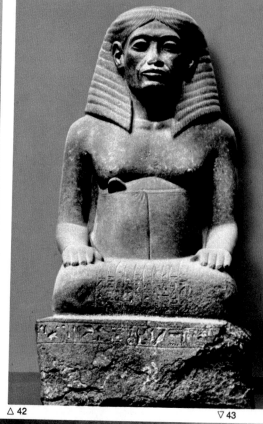

△ 42

▽ 43

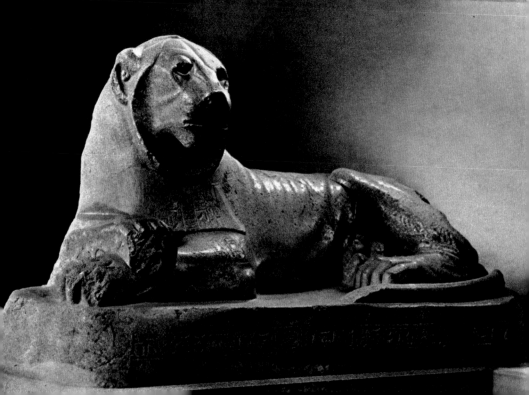

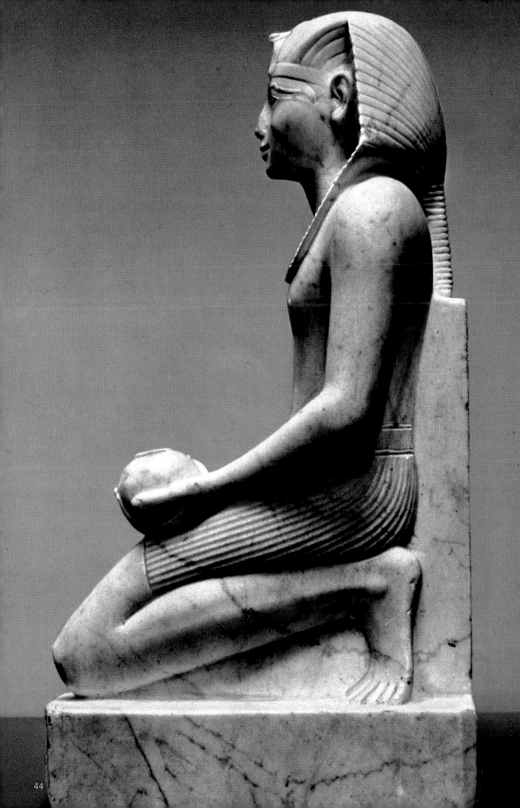

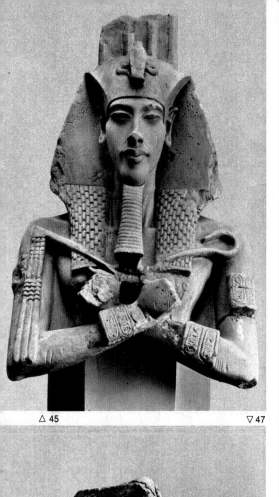

△ 45

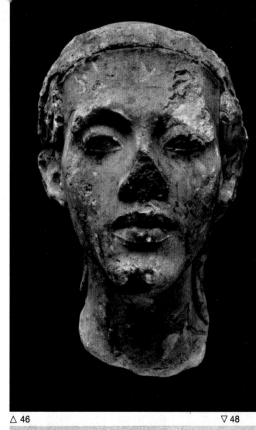

△ 46

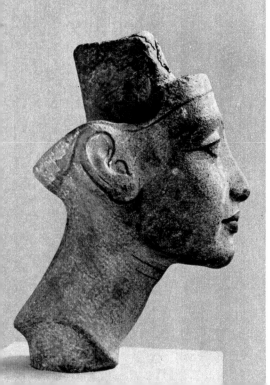

▽ 47

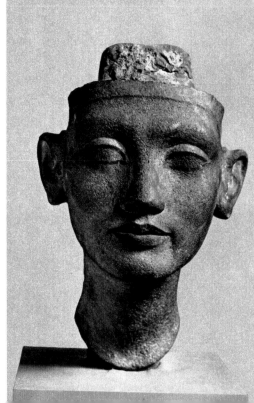

▽ 48

works of sculpture. Since (according to Erwin Panofsky) the history of the law of proportion is the blueprint of the history of art, it may be assumed from the start that the Egyptian principle of proportion attempted to establish those rules of measure that were relevant to the object being represented and ignored those that dealt with the changes of the body in action and from the point of view of the beholder. For this reason the principles were taken empirically from a standing male figure and expressed in terms of the "little cubit." The basic unit is the "fist" ($= \frac{1}{4}$ cubit), which is $\frac{1}{18}$th of the total height from the soles of the feet to the roots of the hair. This principle has the material effect of creating the figure of a man purged of arbitrariness in his appearance and of maintaining a high average of artistic achievement. From this viewpoint, it becomes obvious that the classical art of the Greeks had to free itself from the Egyptian system if it wanted to bring into its artistic scope the very conditions the Egyptian was determined to avoid.

Finally the question of portraits arises. Are the portraits of the Old Kingdom to be seen as more or less accurate renderings of the appearance of the subject? The statue in the round certainly has the purpose of housing the wandering soul, but its magic effectiveness is in no way dependent on its accuracy as a portrait. Experience shows rather that the stronger the belief in the magic function of the statue, the less important it is whether the statue is a "likeness," and that a likeness is striven for only when belief in the magic of the statue disappears. So in Egypt statues could be taken over without being remodeled, private citizens could adapt their portraits to that of the reigning king, and statues could be made to order in the workshop. And yet the statues always represented one particular man, never—as in classical antiquity—man in general. However, they did not represent the past reality of his appearance, but the lasting idea of his existence. The Egyptian portrait seeks a timeless substantial existence, and that is its secret. It is the most significant example of the idealized portrait in the history of art. Only as an ideal image can it fulfill its task of guaranteeing the eternal duration of life. This symbolic portrait naturally presupposes a common spiritual feeling in both the sculptor and his subject. Increased awareness and the growing recognition that each man is unique encouraged the attempt to bring the portraits closer to actual appearance and to fill them with a higher personal content.

The Middle Kingdom found itself with the problem of winning back lost "form." It solved this by harking back to the models of the Old Kingdom, being conscious of how necessary this step was. Hence the strange coldness exuded by the statues of the Middle Kingdom. The first great work is the sandstone statue of King Mentuhotep II of the 11th Dynasty (34), which helped the ideal simplicity of essence to break through again. The 12th Dynasty made an innovation that turned out to be especially momentous. While the sculpture of the Old Kingdom had been statuary for tombs, sitting in inaccessible chambers or poorly lit mortuary temples never seen by any beholder, there now arose besides tomb sculpture royal memorial sculptures that stood in the temple courtyard in full sunlight (36–38). Their purpose was the living communion felt by the people gathered in the courtyard with their ruler as figurehead of the state. But because this state is on the way to directing its ethical principles according to worldly rather than divine standards, and because the monarchy has come to symbolize heroic mankind, the idea of the state and human destiny

find expression simultaneously in the royal portraits. Stylistically this means that visual values join tactile ones and that light and shade come into play. In other words, in the sculpture of the Middle Kingdom form and fullness of nature were in balance. In the adjustment between the stereometric-crystalline and the pictorial methods of modeling the real sculptural values come to the fore. In this is seen the signature of classical form. The Middle Kingdom is the Egyptian classical age, and its dominating genre is sculptural art.

In the long sequence of magnificent portraits of the two last great kings of the dynasty —Sesostris III (36) and Ammenemes III (37)—this development reaches its conclusion. The heads reveal a deep spiritual vitalization of sculpture. New creative techniques carve signs of bodily decay and tiredness into the face. No longer eternal youth but mortal transience has become the symbol of an era in which human existence has become strongly secularized and man sees himself turned in on his own resources.

The private sculpture of the Middle Kingdom developed along similar lines. It began to popularize the royal custom of giving a statue to a deserving official with permission to install it in the temple courtyard as an aid to daily sacrifice. In this fashion, the dead man was cared for when his cult at the graveside faded out. Two results can be seen: these temple statues also have characteristics of marked realism, and, in their case, too, the living engage in a real visual communication. A great number of private statues of the Middle Kingdom are unassuming works of the bourgeoisie, having nothing in common with the life-size sculpture of the Old Kingdom. But again there are a number of more impressive works even if they do have a smaller format. Their favorite stylistic hallmark is a heavy robe enveloping almost the whole body, in order to express the spirit of the age—introverted, cut off from the world, far removed from the open-heartedness of the Old Kingdom (Khertihotep, 35). The invention of the block statue must be applauded as an artistic feat. The subject—for example, Sesostris Senebefni (39)—squats on the ground completely wrapped in his cloak. There no other art form whose aim is so completely fulfilled; it gives the organic human body an inorganic being without distortion of the natural model.

A look at the royal portraits of the 12th Dynasty leads again to the question of their nature as portraits; for they are indisputably the product of a heightened consciousness and increased personal feeling. The contemporary theories of kingship found their upshot in these heads. Yet they do not have to dispense with every personal reference to the subject. It is more important to realize that the humanization of the ruler, who carries the burden of the crown in terrible loneliness, also led to the inclusion of personal features in his statues. The sculptor earned himself recognition in the same way, contributing on his side to the process of individualization. The scope of his artistic effect had expanded since the Old Kingdom; and the considerable number of excellent and varied types of portraits of the last two great kings may be attributed to some important artistic celebrities. Therefore the portraits contain no image of an ideal interchangeable at will, but neither are they realistic likenesses. Like all the art of the Middle Kingdom they take a middle road.

If Egypt found its way back after the confusion of the Hyksos era to a new spiritual cohesion, then it had the contemplation of its great past to thank. After some cautious attempts seen in only a few works, the era of Queen Hatshepsut and Thutmose III (her stepson and

son-in-law) saw a rich collection of portraits of these two great rulers. As well as all imitation of the royal statues of the early 12th Dynasty they singled out particularly the reconception of the face, which is now more graceful and pleasing and even at times has an expression of amiable cheerfulness (Queen Merit-Amun, *40*). The portraits announce that the god-king of the Old Kingdom and the tragic hero of the Middle Kingdom have become a man who embodies a courtly ideal. The kneeling form—for example, in the marble statue of Thutmose III (*44*)—possesses a nobility, the lively silhouette has a resonance, the technical treatment has a completeness that can only be achieved by very mature art. Almost all the statues of the New Kingdom come from temples that are now filled with an array of sculpture. They become ornamentation, and the aesthetic viewpoint is given its due. Egyptian art can now really be called "art" in the modern sense, but it runs the danger of losing its religious roots.

A work whose influence can be recognized into our own time is a crouching lion of Amenhotep III (*43*). Because the head is turned to the side at a right angle, the strict law of cubism has been broken. The characteristically lazy pose of the lion gives him an air of evident superiority. All energy is concentrated in the head, which is turned alertly to the side, the mane stylized into a smooth ruff.

The portraits of private citizens—portraits of a lady (*41*) and of Amenhotep Hapu(*42*)—sometimes reveal in their depth of psychological insight and sharpness of observation individual characteristics that become possible only with the cool consciousness and experienced farsightedness of the New Kingdom. It is also significant that we possess of one and the same person portraits that are conceived both realistically and idealistically—proof that man was no longer creating by instinct only and was consciously taking models from various epochs of the past.

The portraits that have come down from early in the reign of Amenhotep IV (the religious reformer called Akhnaton) from the old residence at Thebes (*45*) reveal at first glance a break in style caused by events outside art. They reflect the will of an asthenic zealot, exaggerated to a pathological extent, who wishes to destroy the world of forms he finds before him and to establish instead of it his own religious ideas arising from missionary asceticism. In the statues (most of which derive from the excavation of his later residence at Amarna, originating mainly from sculptors' workshops), probably belonging to the end of his seventeen-year reign, the early style has been moderated and all exaggeration and distortion have been discarded. In his portraits, as in those of his wife Nefertiti and his daughters, the desire for psychological animation and emphasis on feeling, which had been developed for several generations, comes fully to the fore, so that unusually attractive portraits result, such as the famous colored bust of Nefertiti (*84*) in Berlin and, of equal merit, the head of a queen in brown sandstone (*47, 48*), in which charm and amiability are mingled with feminine diffidence. The torso of a girl (*49*) in London shows how most intensive natural observation and increased interest in the beauty of the female body had led to a sensitive portrayal of the attractiveness of the skin. From a number of stucco masks that the sculptor made from his clay models to help him with his portraits, one may select a head in which the personality of the fanatic visionary is most clearly reflected (*46*).

Among the scattered surviving portraits of the Amarna era the most important is the Berlin tombstone of the master sculptor Bak and his wife (*50*). Bak was a leading architect of his time "who received instruction from the king himself"—the first sculptural self-portrait in the entire history of art.

In the marvelous sitting portrait of Ramses II at Turin (*51*), the Ramessid era—trying to restore order within and without after the confusion of the Amarna years—brilliantly solved the problem of giving new form to the weakened idea of the king and at the same time gave complete expression to its own intellectual standpoint. After the demise of Amenhotep IV the ideal of the ruler returned to impervious majesty but at the same time contained a streak of human warmth and understanding generosity, which is doubtless an aftereffect of the Amarna era. Ramessid art could not maintain this peak for long. The mass production of giant sculptures and their hollow pathos can only be reckoned as a progressive decline in taste.

The temple statues of the high priests of Amun in the late New Kingdom—for example, that of Khai (*52*)—introduce revivals of age-old motifs and an abundance of new ones. The latter usually force incompatible elements together.

The sculptures from the Late Period are innumerable not only by virtue of the materials, techniques, and motifs used but also because of the different styles running together. It is no wonder that a period inclined to look nostalgically at the past should have taken over

49 PRINCESS, from Amarna. Late 18th Dynasty, c. 1350 B.C. Torso, sandstone. Height 15 cm. University College, London. The girl seems to be standing on her mother's lap.

50 TOMBSTONE OF THE MASTER SCULPTOR BAK AND HIS WIFE. Late 18th Dynasty, c. 1350 B.C. Reddish sandstone. Height just over 60 cm. Staatliche Museen, Berlin. In this sensitive group typical of the Amarna era, the woman stands marginally behind her husband with her left arm placed over his shoulder.

51 RAMSES II. 19th Dynasty, c. 1275 B.C. Black granite. Height 1.94 meters. Museo di Antichità, Turin. To the left and right of the king's legs stand his wife and a son.

52 KHAI. 19th Dynasty, 13th century B.C. Granite. Height 73 cm. National Museum, Cairo. In the niche let into the body of the crouching priest of Amun stand the divine couple Amun and Mut.

53 NESPEKASHUTI. 26th Dynasty, c. 600 B.C. Green stone. National Museum, Cairo.

54 MENTUEMHET. 25th Dynasty, c. 665 B.C. Gray granite. Height 1.35 meters. National Museum, Cairo. Its model was a private statue of the 5th Dynasty. The form of the wig and skirt and the abundance of inscription attest among other things a stylistic deviation from the original.

55 HEAD OF AN OLD MAN. 25th Dynasty, c. 700 B.C. Sandstone. Height 22.7 cm. British Museum, London.

56 BUST FROM THE PERSIAN ERA. 27th Dynasty, c. 450 B.C. Gray-green slate. Height 25.1 cm. Louvre, Paris. Apparently part of a kneeling statue with a naos in front of it.

57 "GREEN HEAD." Presumed Ptolemaic, 2d–1st century B.C. Green stone. Height 21 cm. Staatliche Museen, Berlin. The subtle natural observation and ornamental use of line are of ancient heritage. The most mature work of Late Egyptian art.

58 "BLACK HEAD," from Memphis. Ptolemaic, 100–50 B.C. Diorite. Height 41.4 cm. Brooklyn Museum. Its relationship to Roman Republican portraits is obvious.

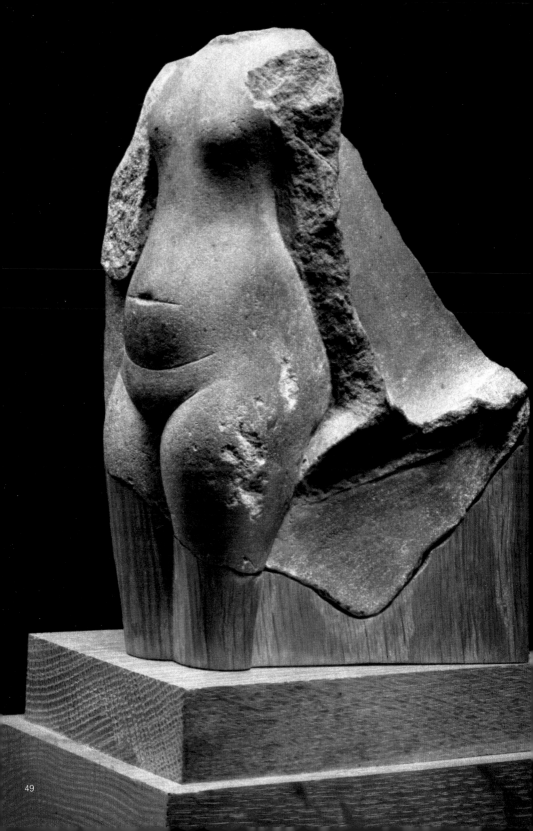

51 ▷

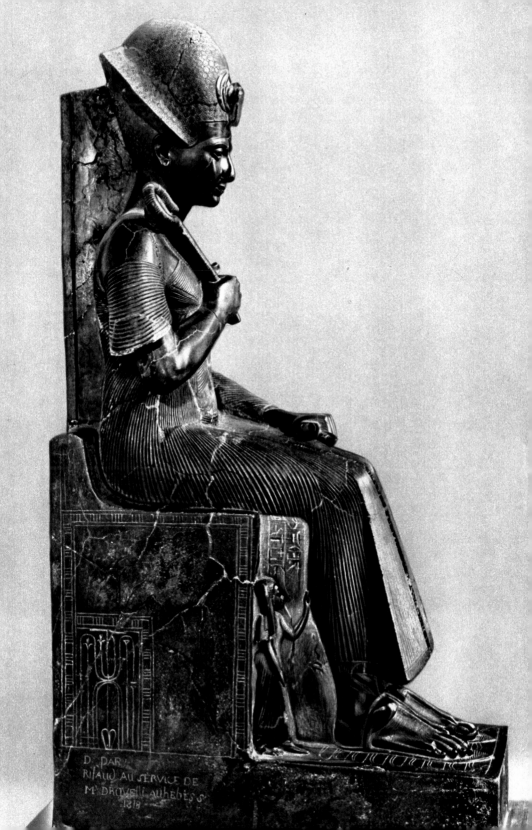

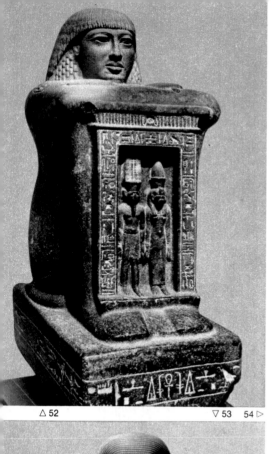

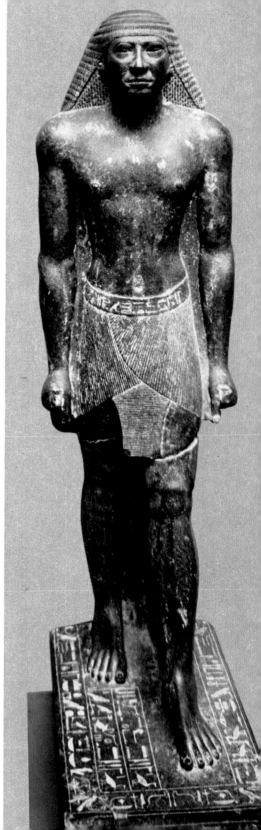

△ 52 ▽ 53 54 ▷

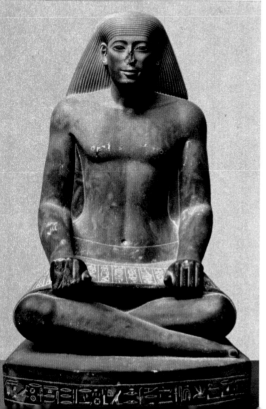

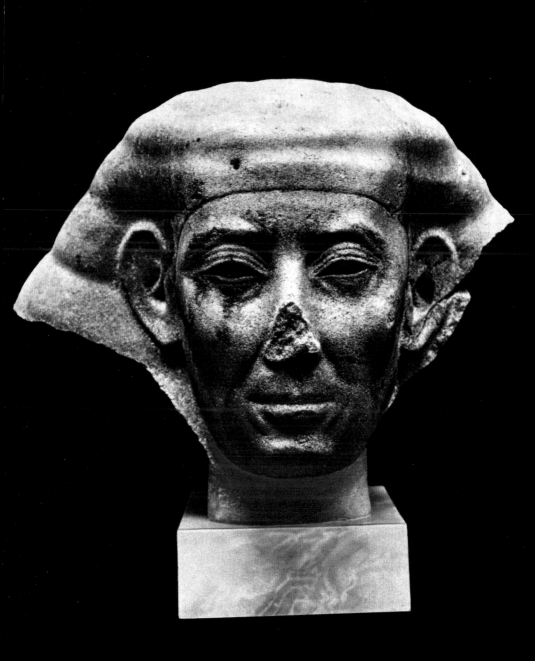

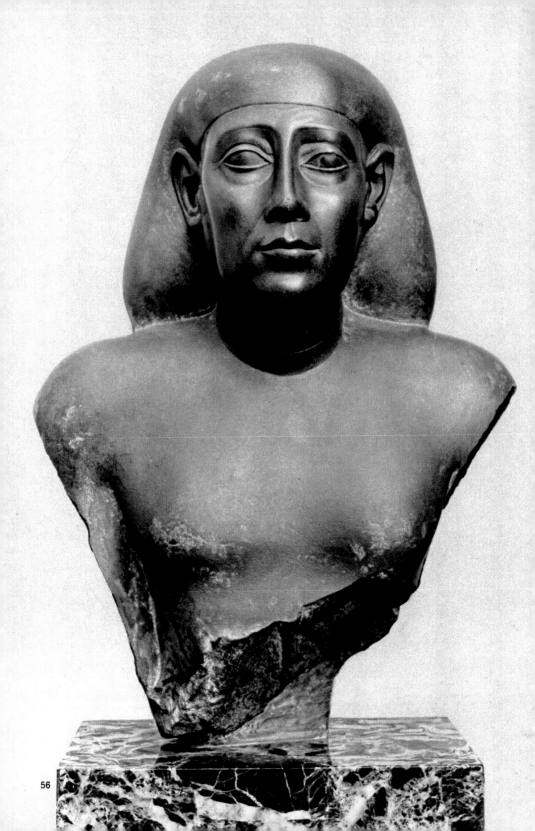

56

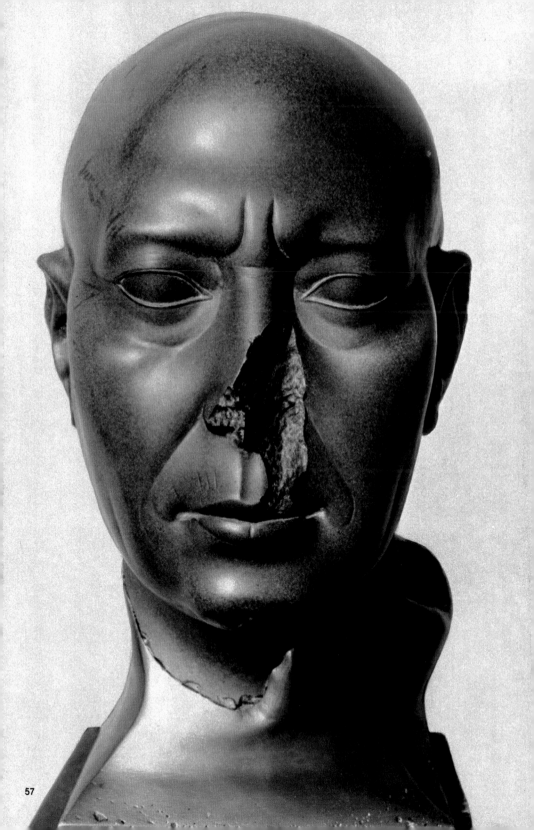

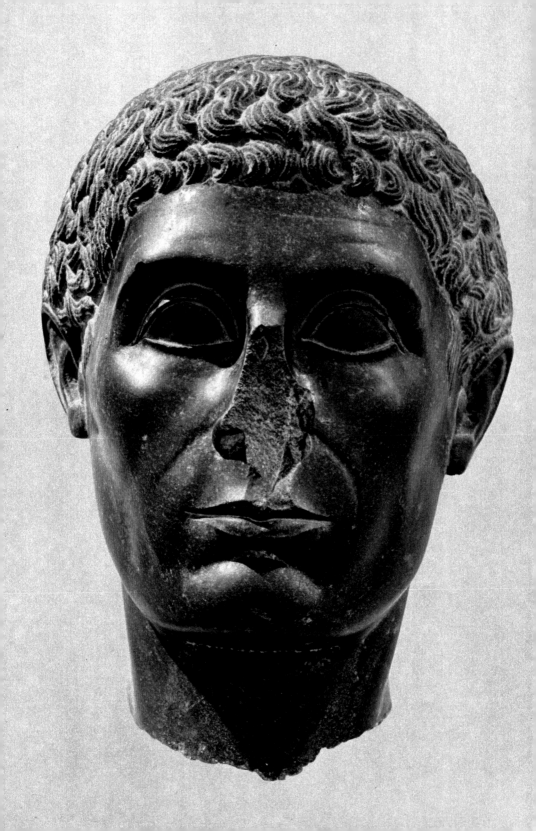

and touched up old statues, masterfully copied others, and revived motifs long since forgotten. It is far more astonishing that in the case of portraits they performed some of the greatest feats of Egyptian art. With the 25th Dynasty of the Ethiopians a completely new and realistic type of sculpture begins, which is interested in the individual marks on old faces and seeks to understand the subject in terms of character and physiognomy. It seems that the liberation of the collective spirit after the end of the New Kingdom opened up fresh possibilities in the development of individualism.

The statue of Mentuemhet (54), the regent of Thebes between the 25th and 26th Dynasties, might have come from a mastaba of the 5th Dynasty, had it not differed from the art of the Old Kingdom in a number of details. The face decides the issue, with its flat crown, fleshy nose, wide mouth, and narrow eyes showing a sullen expression; nothing like it was seen in the Old Kingdom. The head of an old man (55) harks back to the Middle Kingdom, as can be seen from its wig with horizontal waves. The narrow, rather slanting eyes bespeak the intelligence and slightly arrogant superiority of a superannuated culture. In the 26th Dynasty there is an increased tendency to archaism and the number of possible forms is limited in favor of an idealistic style. A typical example of this tendency is the Nespekashuti (53), which revives a rare motif of the Old Kingdom and through its apparently facile technique cannot avoid the impression of barren coldness.

The time of oppressive Persian rule led to a new series of magnificent individual portraits that continued to be carved until the end of Egyptian art. One of the earliest and at the same time one of the greatest examples of this sequence is a bust (56) in Paris in which one seems to see an intellectual personality of meaningful substance. The most famous piece of Late Period portraiture, the "Green Head" in Berlin (57), is still a much debated work. It undoubtedly possesses a primeval Egyptian aloofness and is strongly related to the realistic heads of the Ethiopian age, but it seems at the same time to be under the spell of the Hellenic and hence Roman Republican conception of form. In the Brooklyn Museum's "Black Head" (58), dating from the 1st century B.C., the clear gaze, energetic mouth, and firm chin point to an outstanding personality of intellectual superiority and real force of character.

◁ 58

Contemporary with the beginning of architecture was the start of a tectonization of sculpture, announcing itself in pedestals and backrests. The same process introduced the relief as an artistic genre in its own right, in which the figures were bound architecturally to a background surface and linked to each other on it. The relief was painted, but it was rare for the relief work to be left out and the picture simply to be painted. Such painting was no more than "painted relief"—a cheaper method, not an artistic genre with aims of its own. For that reason relief and painting in Egyptian art history are brought together under the heading "relief art." Only for a short time was there a tendency in Egypt toward the illusory technique of painting and the development of painting as a separate art style.

There is a group of monuments in which the progress of the relief style can be clearly seen: a series of slate palettes decorated with reliefs that were presented as offerings in the temple. They belong to the end of the 4th millennium B.C., that is, to the last few generations before the 1st Dynasty. Their form is that of the cosmetic palettes on which eye-paint was ground. Presumably they were used for cosmetically adorning the statues of gods or divine animals. The Lion Hunt Palette (60) depicts two ranks of warriors on a lion hunt. The space between the ranks is filled with wild animals in flight. The composition is determined by the shape of the palette and still lacks the fusion between a given tectonic form and a tectonic composition. The Battlefield Palette (59) describes a historic event: A lion—already it seems a symbol of the king—together with carrion fowl, plays havoc among corpses while the conquered enemy is led away. For the first time in Egyptian art, history and symbol are linked together.

The latest and largest cosmetic palette, that of King Narmer (62, 63), is nothing less than a memorial to the founding of the kingdom. The decisive stylistic change since the pre-historic period is the introduction of the base-line—a decision of great consequence, for it puts an end to the composition of the Battlefield Palette, abandons the unruliness of the natural, and subjects it to the idea of order. Such free composition could have led to the mastery of the third dimension, but the base-line tied the figures to the surface and limited their consideration to the plane of the relief. It led to the breaking up of the surface into zones that could be "read" one after the other but did not provide any kind of depth. By disregarding the illusion of depth, Egyptian art continued with instinctive certainty along its chosen path toward the representation of an objective, substantive existence.

Besides the cosmetic palette there are two other groups of memorial work that may help to explain the development of planar representation during the transition from the Pre-historic Period to the Early Dynastic Period. There are a number of ivory knife-handles; some show bands of animals marching in a row, with apparently magic and religious signi-ficance. The most outstanding piece, the knife-handle of Gebel el-Arak (61), shows on one side a man with a turban and a long gown standing between two lions that are clutching at his hips—a motif, undoubtedly from Mesopotamia, of the hero and protector of the herd. Beneath it, carefully divided up, are figures of huntsmen and animals. On the other side there are battle scenes, presumably from the history of the unification of the kingdom.

Also Mesopotamian-inspired was the custom of decorating mace-heads with meaningful reliefs and of presenting them as offerings in the temple. The most significant piece is a mace-head of King "Scorpion" (64), Narmer's predecessor. The unusual thing about the picture is the richness of detail in the landscape, which binds nature and man into a pictorial unity. Even here Egyptian art could have decided in favor of natural description. In fact, it chose the strict, symbolic form that denies itself the company of descriptive additions. It was fifteen hundred years before such a detailed treatment of landscape came to the fore again as it did here.

From the tombstone of King "Serpent" (65), in which relief art reached its first peak, one can tell how quickly and surely composition developed during the rest of the Early Period. Above the double-doored façade of the palace, with its three towers, the name of the king in the form of a viper is inscribed inside a rectangle. Above that stands the divine falcon erect and bold. The powerful eye, the sharp claws, the broad folded wings, and the tail twisted onto the same plane as the relief—everything is seen on a large scale. Although the original subject is unmistakable, it has been wholly adapted to the style. The palace is displaced from the axis, the falcon redresses the balance with its sheer size and thereby rescues the composition from the stiffness of a coat of arms. Egyptian art here fully proves its ability to transform life into an eternal type of existence, to create monumental symbols that radiate a magical power through their very presence.

The human figure is fully developed in the wood reliefs of Hesy-rê (66). Note what fine feeling is used not only to work the picture and the hieroglyphs together, but how even the composition of the hieroglyphs patently follows a tectonic pattern. The close relationship between picture and writing is also shown by the "fishermen" from the tomb of Prince Rahotep (67), for the three fishermen and the three fish represent "a great number," as in the most ancient hieroglyphs. A tall, sharply edged relief appears in the earliest stone burial chapels at the beginning of the 4th Dynasty. The concise depictions with fewer scenes suited a heavier, stronger style.

Painting remained only as a simpler technique beside the painted relief. Naturally this did not prevent it from striving from the beginning toward its own, if rather distant, goal. Since painting appeals more strongly to sight than touch, it tends to free the object from its isolation and work it into the surrounding space. The technique of painting is thus related to that which is both subjective and spatial. The famous geese of Medum (80) with their subtle brushwork and fine grading of color would lose a good deal of their fresh directness if they were translated into relief.

Few relief paintings date from the time of the great pyramid builders. This is not due simply to the fortunes of survival but also to the fact that the normal type of mastaba in Giza provided no cult chamber, having instead an offering table let into the front, as in the burial tablet of Wepemnofret (68). There are several others like it, which are distinguished (especially in comparison with older pieces) by their deliberate partition of the surface and their lucidity. By contrast, the pictorial material offered by the mastabas of the 5th and 6th Dynasties at Saqqara is so rich that one can trace in them the development in the style and nature of the relief up to the end of the Old Kingdom. This also applies to the reliefs from

59 BATTLEFIELD PALETTE. Late Prehistoric. Slate. British Museum, London, and Ashmolean Museum, Oxford. The scene is evenly strewn with figures. Between the forehead of the lion and the bowed marching prisoners are visible the remains of script giving the name of the enemy nation, thus placing the picture in the realm of historical record.

60 LION HUNT PALETTE. Late Prehistoric. Slate. Length 67 cm. Louvre, Paris, and British Museum, London. In the upper right-hand corner of the densely spread scene are two written signs not yet clearly decipherable.

61 KNIFE-HANDLE, from Gebel el-Arak. Late Prehistoric. Ivory. Height 9.5 cm. Louvre, Paris. The knob with a hole in it served to hang the dagger on a belt. The arrangement of figures already points to a tectonic principle of composition.

62, 63 COSMETIC PALETTE OF KING NARMER, from Hierakonpolis. 1st Dynasty, c. 2900 B.C. Slate. Height 64 cm. National Museum, Cairo. Heads of the cow-goddess Hathor flank the king's name above on both sides. On the concave side (62) the triumphal procession of the king with the newly won crown of Lower Egypt, according to the annotation, moves toward the state temple of conquered Lower Egypt. The chancellor strides ahead of him in a panther skin with four standard bearers; following him is a servant with washing pitcher and sandals. On the right lie some headless enemies. The picture below is probably intended to show that the enemy are not in a position to destroy the unification of the two lands, symbolized by the intertwined mythical beasts. Below that the king—depicted as a strong bull—overruns a fortress. On the reverse (63) the king beats with a raised club opponents who have sunk to their knees (a symbol that from then on belongs to the fixed repertoire of Egyptian symbolism). Again the sandal bearer on the left. In the upper right-hand corner the divine falcon delivers "the papyrus land" to the king, beside him the name of a nome. The two conquered enemies lying suspended underneath seem (according to the annotation) to represent Memphis and Sais. The work shows a clear method of composition in zones by means of base lines.

64 MACE-HEAD OF KING "SCORPION." End of the Prehistoric Period, c. 2900 B.C. Limestone. Height 31.5 cm. Ashmolean Museum, Oxford. The upper part of the picture is taken up by standards on which lapwings are hung to symbolize the people of Lower Egypt. In the main scene the king, followed by fan bearers, stands with a mattock in his hand by an expanse of water that flows around several islands. A man with a basket approaches him and another carries ears of corn. On one island a palm tree stands, and two men are shown at work.

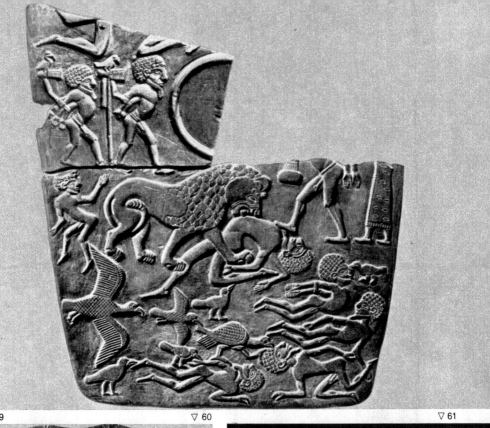

△ 59

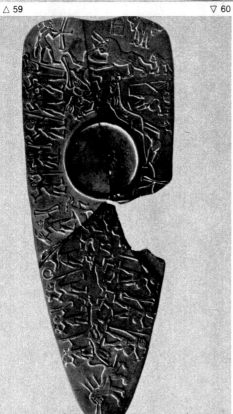

▽ 60

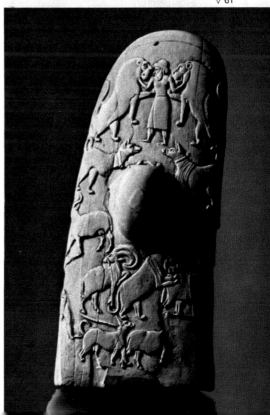

▽ 61

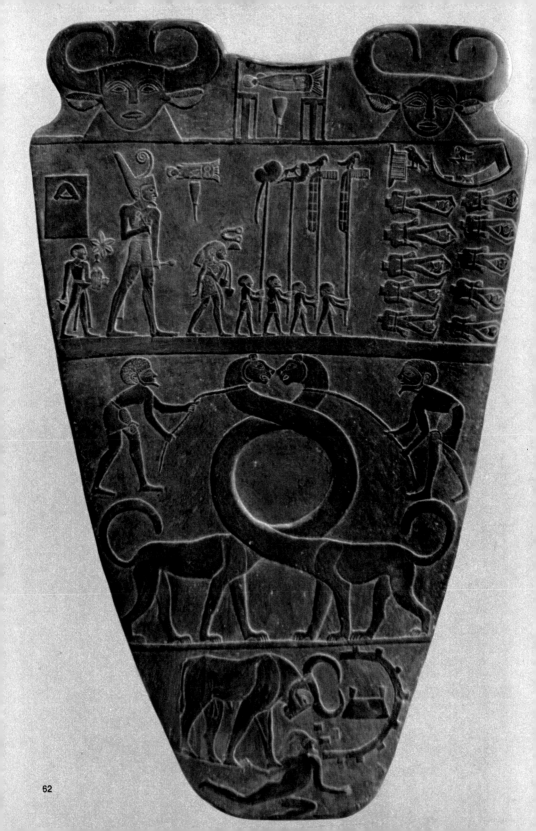

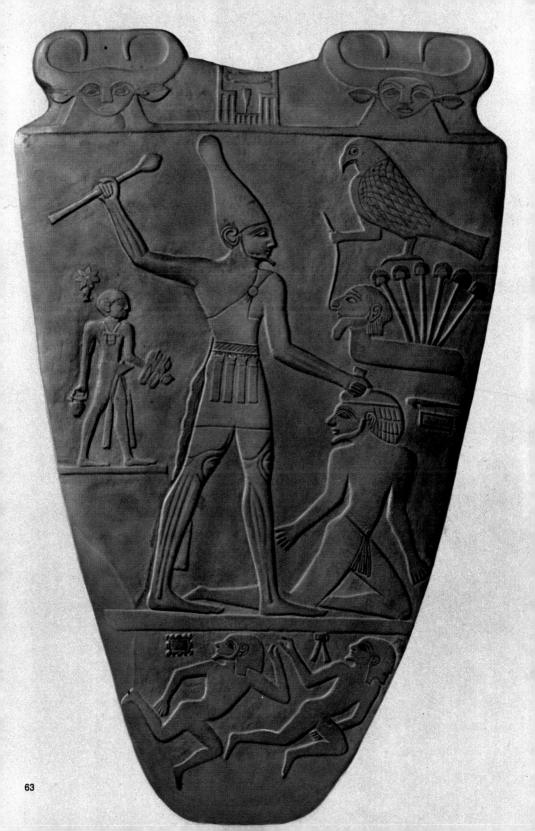

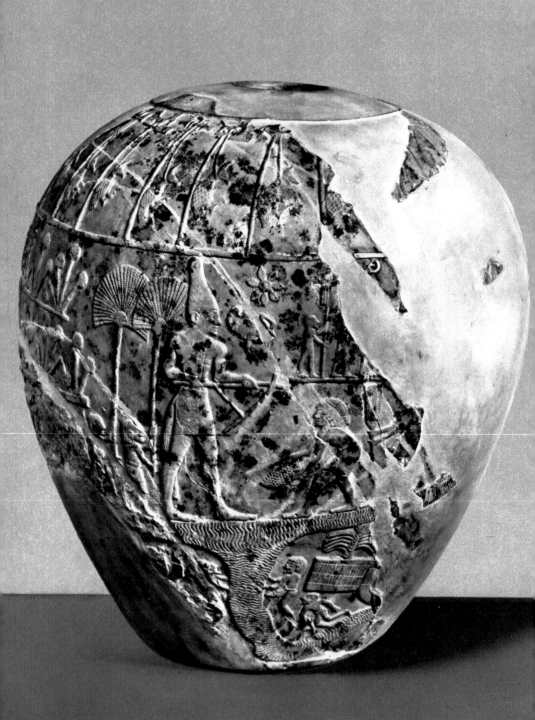

65 ▷

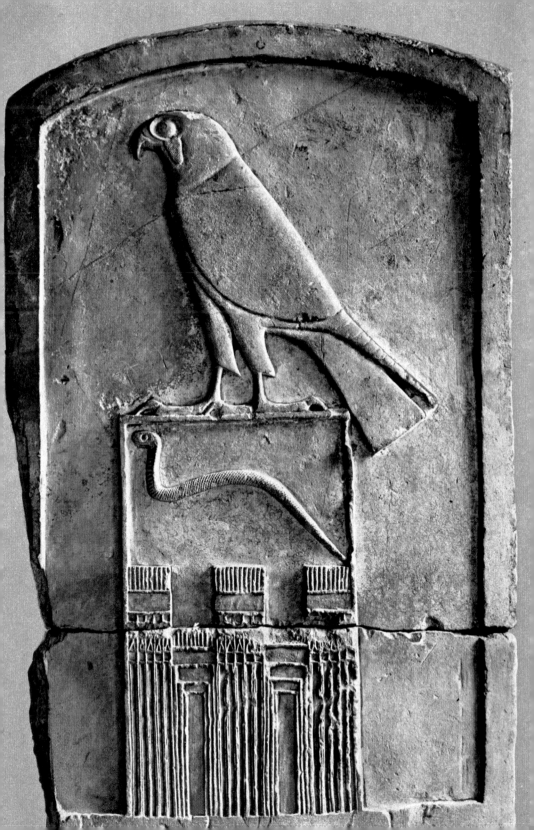

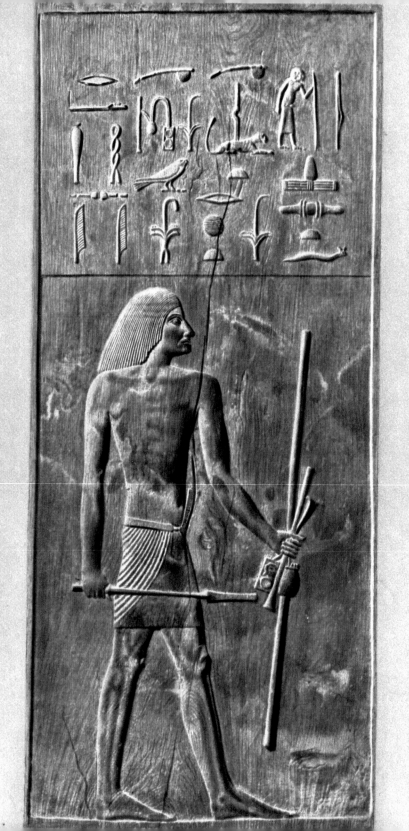

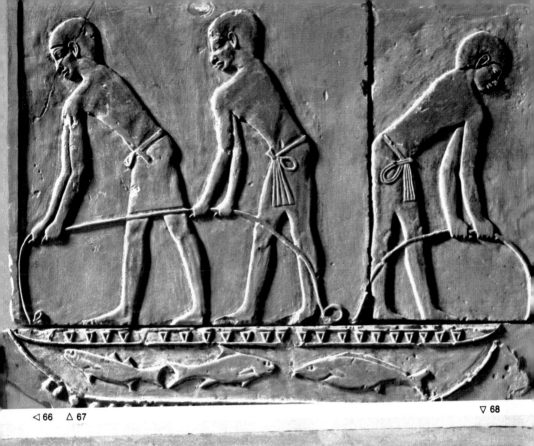

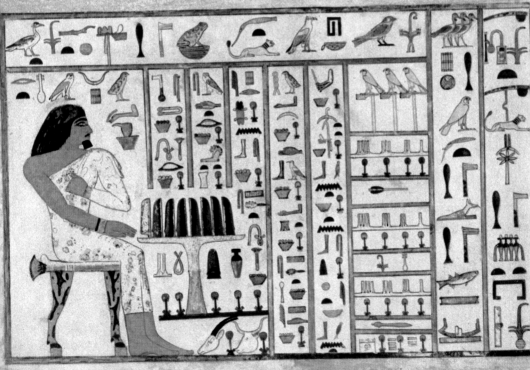

65 UPPER PART OF THE TOMBSTONE OF KING "SERPENT." 1st Dynasty, c. 2800 B.C. Limestone. Width 65 cm. Louvre, Paris. Note that the falcon cowers on the ground by nature; the oldest Egyptian art portrayed him thus. But from now on he is raised upright, since he embodies the idea of the god of heaven who rules Egypt through the king. The double door of the palace indicates the amalgamation of Upper and Lower Egypt.

66 WOODEN TABLET OF HESY-RÊ. 3d Dynasty, c. 2600 B.C. Height 1.15 meters. National Museum, Cairo. The tablet was fitted into a niche on the superstructure of the tomb. Hesy-rê holds a scepter in his right hand and a staff and scribal apparatus in the left.

67 NET FISHERMEN, from the tomb of Prince Rahotep, Medum. Beginning of the 4th Dynasty, c. 2575 B.C. Limestone. Width 92 cm. Staatliche Museen, Berlin. The men are about to lift the full net out of the water.

68 BURIAL TABLET OF WEPEMNOFRET. 4th Dynasty, c. 2560 B.C. Limestone. Width 66 cm. University of California, Berkeley. On the left, the deceased before the offering table; above and right, his title and name; above, under, and behind the table, an account of the gifts offered; on the right, the list of titles.

69 HIPPOPOTAMUS HUNT, from the tomb of the vizier Mereruka, Saqqara. Detail. 6th Dynasty, c. 2320 B.C. Limestone. On the water plants (*potamogeton lucens*), which lie flat on the water by nature, sit two locusts and a toad.

the royal mortuary temples and sun temples. One ought, in fact, to start there, because the best sculptors were engaged on them and it was in them that the first notions of picture cycles originated. However, first the stock of themes on the private tombs is wider and the surviving collection of reliefs is more comprehensive; there is room here for only a very broad survey of stylistic development.

The modest burial chambers of the early 5th Dynasty at Giza limit themselves to scenes such as the funeral feast, the bringing of sacrifices, and the procession of representatives of the land grants. Everything is performed with ceremonious dignity, but soon the simple scene of the deceased on the altar becomes a celebratory feast with music and dancing. The formal and uniform processional entries become active and rich in variety. After the middle of the 5th Dynasty, designs with far wider scope appear at Saqqara; among them the Tomb of Ti (*83*), a typical representative of the bureaucratic elite and the great landowners, is deservedly the most famous. From now on, the walls are filled with details of land-tilling and cattle-grazing, fishing and fowling, hunting in swampland and desert, shipbuilding, carpentry and metalwork, baking and brewing, merchants and musicians. Everything is so minutely detailed that the whole constitutes a giant encyclopedia of Egyptian culture. The rather later Tomb of Ptahhotep (*82*) shows a more forcibly modeled, more sculptural relief with a preference for larger figures.

In the 6th Dynasty there is a noticeable effort to invent newer and newer themes. The tomb of the vizier Mereruka at Saqqara contains 32 rooms obviously intended to advertise ◁ 69 the incumbent as a great lord. They contain portrayals of pompous obsequies permitting

outbursts of emotion that more ancient times had firmly avoided. The intrinsic yields place to the apparent, the static to the dynamic, the general to the particular, and form is subordinated to the copiousness of nature. The growing preference for the stylized scenes is also worth noting. For example, in the hippopotamus hunt from Mereruka's tomb (69) attention is also given to such small creatures as locusts, frogs, and butterflies. But in the end there is a certain staleness of form. Endless repetitions of fishermen tugging at net or cattle swimming across a tributary show that form has become mannered and is no longer the product of experience.

What actually is the purpose of the pictures on the wall of the cult chambers? Without doubt they were originally supposed by their "presence" to provide the deceased with a means of living on inside the tomb. This still remained true in cases where instead of a store of bread and beer, baking and brewing were depicted in order to make what were basically static objects more dramatic. They imagined the dead man crossing to a second world of the living, apparently taking part but not really actively involved. Therefore the content of the reliefs is universal, without biographical reference to the occupant. Only gradually in the course of the intellectual transition from idea to reality and the change in form from the schematized to the individual does the occupant, who originally saw a purely objective picture of the world, begin to look at scenes from a place in which he once personally had a function. And in this way they become personalized in form and content.

Let us now attempt to analyze the style of the Egyptian relief and ask at the same time how the works solved the artistic problems posed by every art form. We may start with the assumption that a work of art successfully performs the task of portraying the physical world only when it tempers the complexity of the physical world with the discipline of "form," striking a balance between the two extremes. Since everything that we perceive appears in space, every attempt to give it artistic form must begin by assessing its spatial value in terms of flatness and depth. Even a very flat figure needs a background to make its flatness convincing, and a very three-dimensional figure must take the surface plane into account if it is to have an actual perspective congruence. Consequently, there is a tension between the opposite extremes of surface and depth. The Egyptian relief decided firmly in favor of surface values. All living things appear only in the front plane of the picture; each object is spread out flat to show the greatest surface area. Because partial concealment of one object by another is related to the representation of depth, it is avoided as much as possible, as is foreshortening. The background from which the figures stand out offers no illusion of space; it merely serves the purpose of carrying the images.

With the preference for surface rather than depth values came a choice in favor of tactile rather than visual values. If these are regarded as opposite extremes as well, then a predominance of tactile values means that outlines are strengthened and emphasized and a predominance of visual values means that outlines are softened and dissolved to give a natural, illusionistic effect. In Egyptian relief painting the outline surrounds the object in such a marked way that it helps to reinforce all its essential qualities. Great care is taken in the execution of a clear outline, which is seldom sacrificed to pictorial values. The play of light and shadow is excluded. The Egyptian relief therefore exploits only a light modeling

shadow on the body to reinforce the edge of the outline. There is no evidence in Egyptian reliefs of a natural or artificial source of light, hence no casting of shadows, let alone three-dimensional shading.

The linear, two-dimensional character of Egyptian reliefs is based on an isolating method of composition, in which the separate parts are largely independent of one another. This is true not only of groups and scenes but also of single human figures (66) whose limbs are built up piece by piece and retain their independent value. A solution tending to the opposite extreme—an integration of the parts of the picture instead of a juxtaposition—would mean that the parts had been welded into a complete whole at the expense of their self-sufficiency. But this would require the parts to fall into perspective either partly or entirely and lose their outline.

A definite solution to the problem of coloring is necessarily bound up with the basic possibilities in the expressions of bodies and space. A shallow, isolating type of form with an emphatic outline is suited to polychrome coloring, in which the color spreads cohesively over the surface of the figures. In this way the binding force of the outline is increased and the figure stands out from the background. The Egyptians chose direct, strongly symbolic colors that conformed to their conception of things in terms of color (i.e., trees were painted green, water blue). They obtained their coloration not from observation of nature, but instead followed a standardized color scheme. The opposite solution to the problem, coloristic handling of color, loosens the bond between color and object and softens the outlines. Light distorts the intrinsic color of things and drowns it with a diffusing tone. Colorism is intent on optical appearance and is in fact the painter's approach to the problem of color.

A work of art is not merely a contest between "form" and "nature," but it also reveals the world view behind it. The gap between external and internal existence can be bridged if the relationship of the work of art to time and space is considered, that is, if its spatial and temporal characteristics are examined. Thus, Egyptian art avoids all reference to transitory things. It never portrays a moment of time to be read at a single glance. No Egyptian relief refers to a particular time of day. Transitory motifs are avoided and a world of completed actions is always depicted. A pair of scales is always in equilibrium, any ship in the builder's yard has just been completed, and so on. The Egyptian artist always showed every action *in potentia* and not *in actu* (to use Panofsky's terminology). Frightened by time because it is transitory, he sought to overcome time through space.

Basically there are two possible attitudes that man can have toward the surrounding world: It is either objective, in which case it appears to him as a pure object independent of him, or it is subjective, meaning that he has a conception of the world inside his consciousness. In the first case the artistic purpose is directed toward portraying the object for its own sake, in the second to describing the experience that the object evokes in the observer. This means that the objective Egyptian draftsman emphasizes those aspects of the object that are traditional to it and suppresses those an observer could attribute to a particular time or a particular point of view. Therein lies the root of all methods of representation in Egyptian art, ignoring as they do any type of natural observation. In Egyptian art there is no

70 RELIEF, on the pedestal of a royal statue of Sesostris I. 12th Dynasty, c. 1950 B.C. Granite. Height of the relief 98 cm. Staatliche Museen, Berlin. The binding of the heraldic plant by two male figures is purely symbolic, since a papyrus stem cannot in fact be knotted.

71 DECORATIVE WRITTEN SIGNS, on a pillar of Sesostris I. 12th Dynasty, c. 1950 B.C. Height 1.35 meters. National Museum, Cairo. The relief is high and sharply defined with scanty drawing inside. By this means it forms a surface flush with the edges of the pillar, revealing a fine sense of the tectonic qualities of the pillar.

72 QUEEN HATSHEPSUT'S EXPEDITION TO PUNT, in her mortuary temple west of Thebes. 18th Dynasty, c. 1480 B.C. Limestone. Height of the middle palm tree 60 cm. The people of Punt lived in stilt dwellings on the Red Sea.

73 BERLIN MOURNERS' RELIEF. Detail. End of the 18th Dynasty, c. 1340 B.C. Limestone. Length c. 17 cm. The psychological subtlety lies in the degrees of mourning, from the sons walking behind the bier, to the high officials of the kingdom, to the temple attendants at the end of the procession.

74 WEDDED COUPLE, from a banquet scene in the tomb of the vizier Ramose, Thebes.

enignBing of Amenhotep IV's reign, c. 1364 B.C., before the breakthrough of the Amarna style. Limestone. Only the eyes and eyebrows have received their black coloring.

75 WALK IN THE GARDEN. Amarna period, c. 1360–1345 B.C. Limestone. Height 24 cm. Staatliche Museen, Berlin. Note the flowing neckbands, which in other periods lay on the outline of the shoulders.

76 PILLARS, from the tomb of Seti I, Thebes. 19th Dynasty, c. 1300 B.C. Limestone. Width 1.2 meters. Museo Archeologico, Florence. The goddess Hathor holds her necklace out to the king in a symbolic gesture. The folds of the royal robes are not worked in relief but only painted.

77 BATTLE NEAR KADESH. Relief on the outer wall of Ramses II's temple at Abydos. 19th Dynasty, c. 1280 B.C. Limestone. Left, a gravely wounded Syrian; right, a dead Hittite; below, corpses borne along by the Orontes River.

78 RELIEF, from the tomb of Mentuemhet, Thebes. 26th Dynasty, c. 660 B.C. Limestone. Width 28.7 cm. Metropolitan Museum, New York. Late Period adaptation of an 18th Dynasty model.

70 ▷

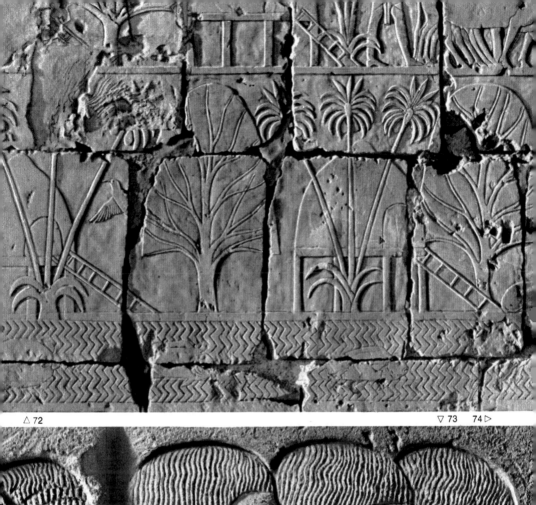

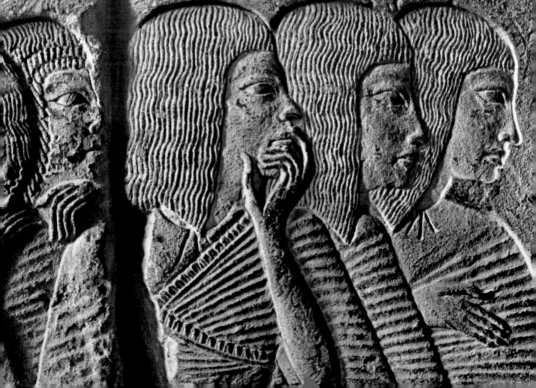

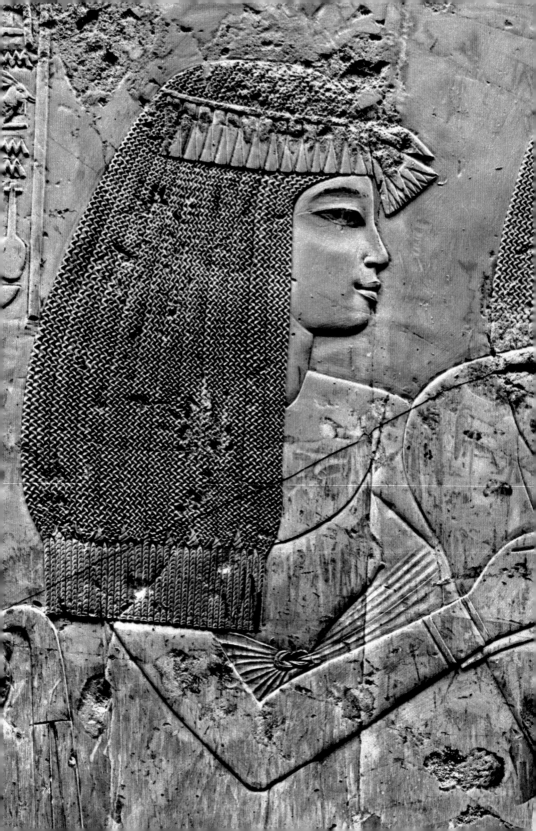

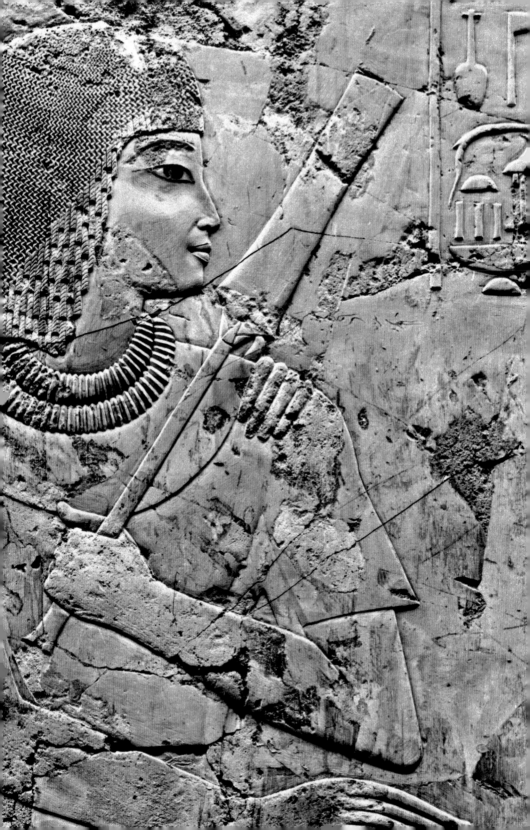

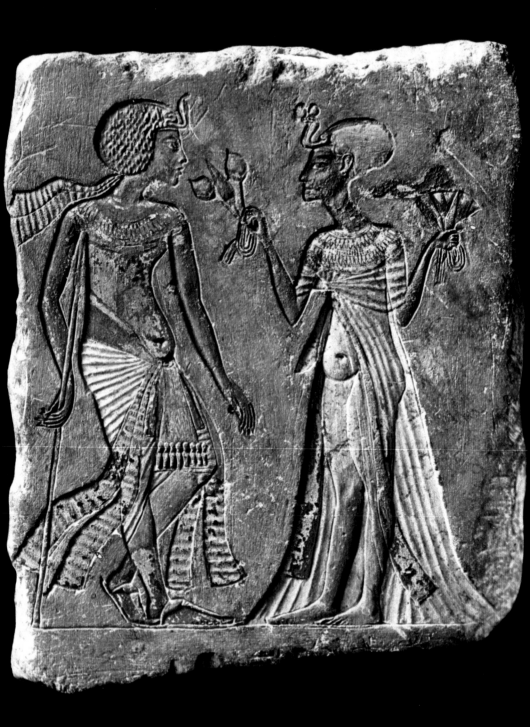

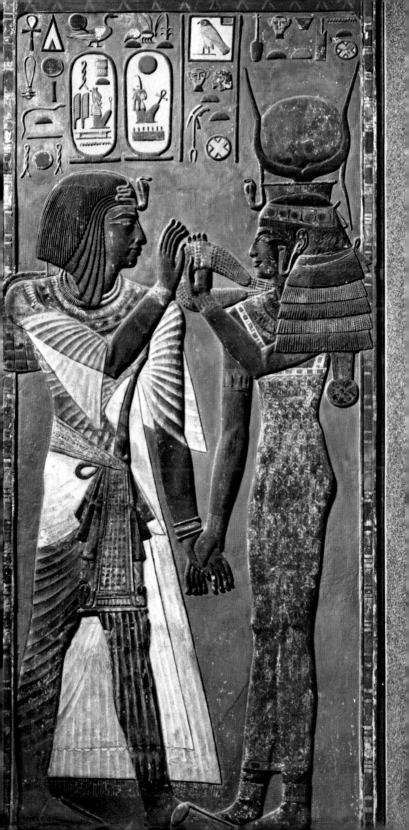

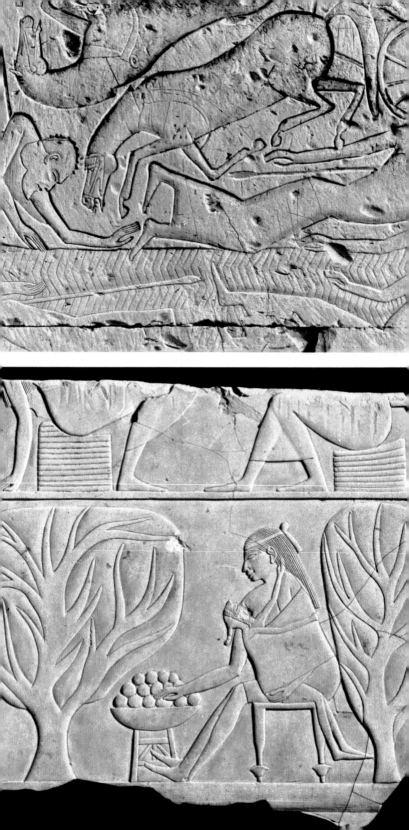

question of "result" diffusing from an object; it is more a matter of a "presence" as complete as possible. Hence, for example, the changing scale of the figures within one and the same picture is determined by reason of their thematic meaning and not because of their spatial relation to an observer. Objects are included in a picture to satisfy the theme without any consideration for their spatial relation to the other parts of the picture. (Western art, on the contrary, developed perspective while striving to subordinate the nature of things to the visual demands of an observing subject and attempting to order space according to the laws of natural observation.) The Egyptian does not portray what he sees, but what he thinks. He creates thought pictures rather than sight pictures. With him it is thoughts that apply to the work first, eyes later.

As with sculpture in the round, the Egyptian developed a technique suited to relief painting. First of all, a preliminary sketch was made by the draftsman, establishing the division of strips and the network of squares for the figures. Then the outlines of the individual pictures followed. The network of squares was adapted to the system of proportion so that the height of a standing man was standardized to 24 handbreadths, 6 hands across the shoulders, 1 ⅓ for the fist, and so on. The length of the fist was a basic unit to determine the size of the squares. If one wanted to change the scale of the figures one had only to change the size of the square. The network could also be used to copy figures from a sketchbook onto the wall. After the outline-sketcher came the turn of the sculptor, who removed the background surrounding the figure, while another modeled the interior surfaces. The painter was the last to work on the relief, adding color, not *al fresco* but onto a dry plaster dressing.

This observation shows that the role of the Egyptian artist bears no comparison with that of the Western artist. Who, among those concerned, could be called the "artist" of a relief? Moreover, in an objective art, which deals with things and not with subjective experience, the artist as a creative individual must subordinate himself to the object. In the pursuit of objective form, firm rules of procedure are needed and could only be possible within the framework of a studio team in which each man is a serving member. If they succeeded in finding a useful form it was put into production. So the artist was the perfector of a suprapersonal artistic aim. Finally, the evaluation of the artist is dependent on the value that the work of art has in society. Egyptian relief paintings are magical functional objects that existed for a practical religious purpose. But the more important the object is in itself, the more lowly is the role of the artist, and vice versa. The progressive step of giving the work of art not just an representative role but the role of an independent subject was taken later by classical antiquity.

The reliefs on the pedestals of the royal statues of the 12th Dynasty (*70*) help to explain the style of the era. The symbol for the "unification of the two lands" (the national plants of the two halves of the kingdom knotted around the hieroglyph for "unite") is very ancient. The Middle Kingdom built up this motif to monumental proportions and modeled the figures that are pulling the knot in sunken relief. The strongly symmetrical composition, in which the idea of interconnection resolves the isolation, is typical of the symbolic emphasis of the Middle Kingdom. This is also seen in the writings on the pillar of Sesostris I

79 PRINCESS NOFRET. Detail. Early 4th Dynasty, c. 2575 B.C. Limestone. Height of the whole statue 1.18 meters. National Museum, Cairo. (See *25*.)

80 GEESE OF MEDUM. Detail. 4th Dynasty, c. 2570 B.C. Painting on plaster. Height 28 cm. National Museum, Cairo. Although it seems to be observation from nature, the strictly symmetrical construction proves that this is a "thought picture."

81 PAINTING, on the wooden coffin of an Upper Egyptian nomarch. 12th Dynasty, c. 1850 B.C. Detail from a depiction of sacrificial gifts; painted directly onto the wood without an undercoating of stucco. Museum of Fine Arts, Boston.

82 RELIEF, on the tomb of Ptahhotep, Saqqara. Procession of offering bearers. Detail. 5th Dynasty, c. 2330 B.C. Limestone. The bearers in this strictly rhythmic scene move toward the false door, where the sacrifice will be made and through which the deceased will enter his cult chamber.

83 RELIEF, in the tomb of Ti, Saqqara. Two boys take a herd of cattle through knee-deep water. 5th Dynasty, c. 2370 B.C. Limestone pictorial touch is the way the legs of the boys and cattle appear through the water.

84 QUEEN NEFERTITI. Amarna Era, c. 1360-to 1345 B.C. Limestone. Height 50 cm. Staatliche Museen, Berlin. The painted work is a sculptor's working model. Egyptians thought the bust as a final product was incomplete and senseless.

85 THE NOMARCH SARENPUT II OF ASWAN AT THE SACRIFICIAL TABLE. 12th Dynasty, c. 1900 B.C. Wall painting on white stucco. His son approaches with a bouquet of lotus flowers.

86, 87 HUNTING SCENE, in the tomb of Userhet, Thebes. 18th Dynasty, c. 1420 B.C. Detail. In the picture (which shows sympathy for the suffering of the animals) a hare, hit by arrows, leaps over a dying hyena, and a fox expires with blood streaming from his mouth and eyes.

88 WALL FRIEZE, in the tomb of Ammenemes, Thebes. Bringing on of the funerary offering. 18th Dynasty, c. 1460 B.C. Painting on stucco. In the old fashion the painter has drawn a cross-section of the basket carried by the woman on the left, in order to show the contents.

89 BRICKWORKERS, from a wall painting on stucco in the tomb of the vizier Rekhmire, Thebes. 18th Dynasty, c. 1440 B.C. In the color of their bodies and short kilts, these figures have a flattened effect and are apparently distinguished by race. The one kneeling with the hoe has gray hair, a stubbly beard, and blue eyes.

90 MOURNERS, from a funeral procession in the tomb of two sculptors, Thebes. 18th Dynasty, c. 1370 B.C. Wall painting on stucco. The language of gesture, in which the clothing also plays a part, is given strong expression; the technique of painting is beginning to decline.

79 ▷

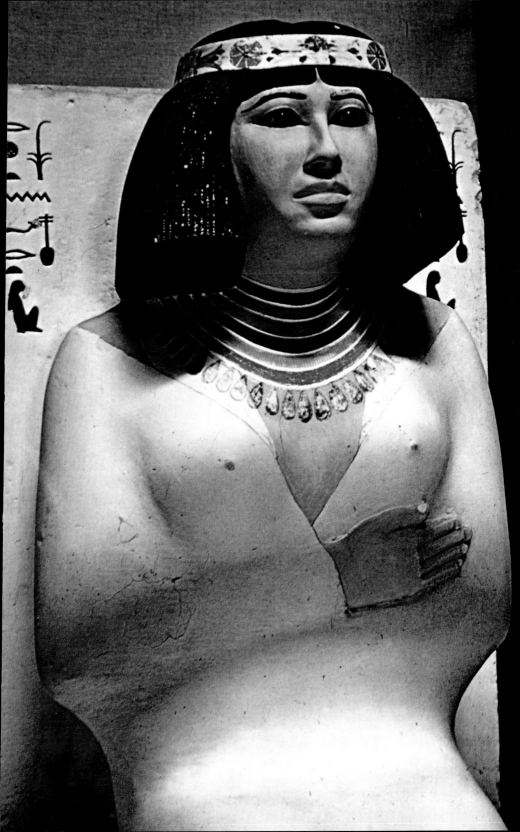

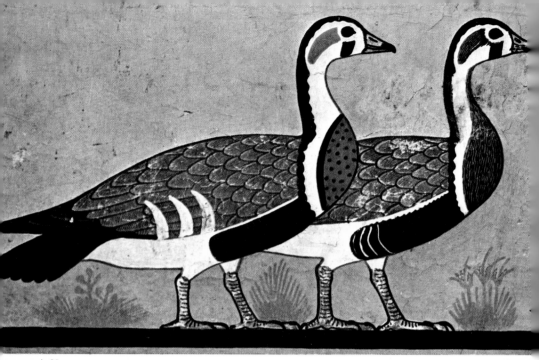

△ 80

▽ 81

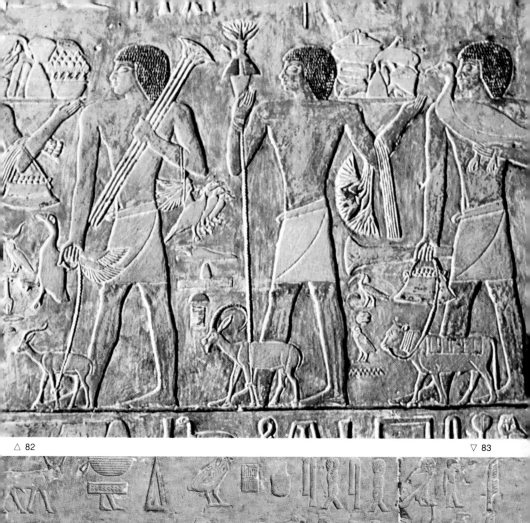

△ 82

▽ 83

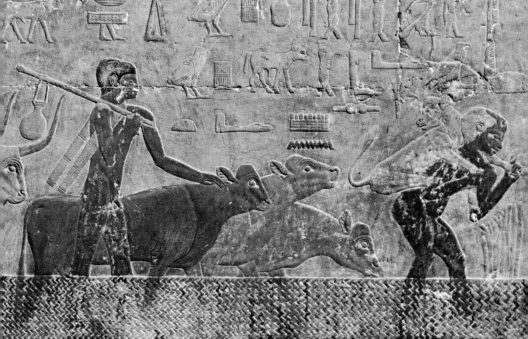

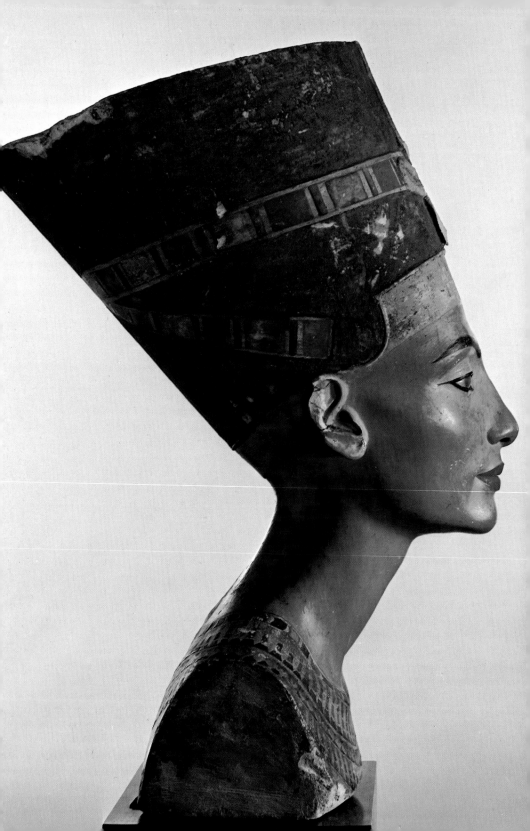

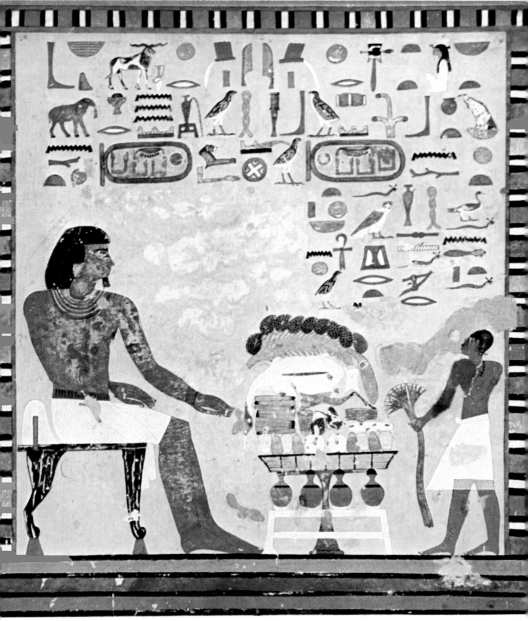

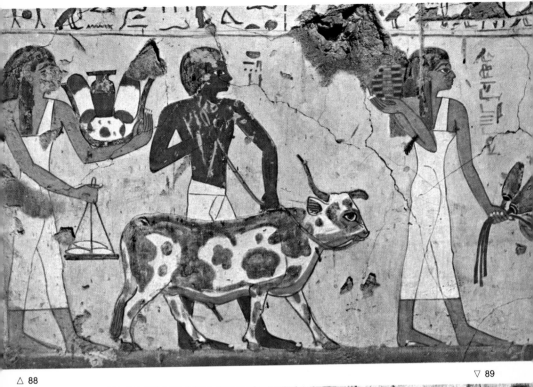

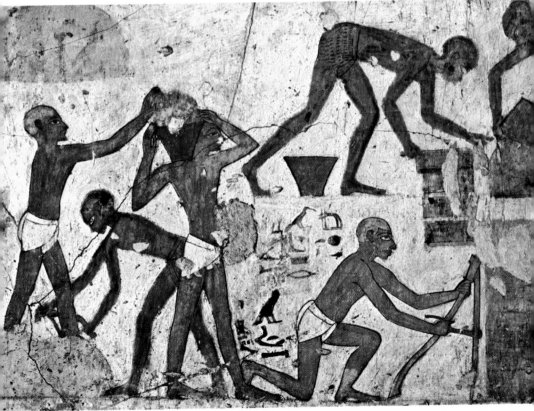

(71), which are more abstract in form compared with those of the Old Kingdom and occasionally achieve a highly decorative ornamental effect.

The private relief painting of the time can be seen primarily in the groups of nomarchs' tombs of the 12th Dynasty that are scattered about the country. Here following conservative local tradition, there the avant-garde anticipating future trends, they are extremely varied in style. Where the painting is so well preserved that it permits judgment, one can see that the colors had begun to be blended with each other. This occurs, for example, on the back wall in the tomb of the nomarch Sarenput II at Aswan (85), and even more markedly in the painting on the wooden coffin of another nomarch of Upper Egypt (81). The outline has mostly been done away with; the plumage of a pigeon is dotted in an almost impressionistic fashion. The attractiveness of the immediate visual impact is given greater attention.

In the Old Kingdom architecture was the leading art genre; in the Middle Kingdom it was sculpture in the round. The New Kingdom found its greatest artistic achievement in relief painting. The most brilliant examples of the style of the early 18th Dynasty are the great picture cycles Queen Hatshepsut used to decorate the colonnades of her mortuary temple, among them the description of an expedition to Punt, the land of incense on the Red Sea (72). A rather too scientific interest is shown in the people and the country, far exceeding the natural observation of former times. The relief is finely modeled, and there is a plain strictness of line. The beautiful festive atmosphere and the courtly brilliance that pervade the pictures are supported by light, bright colors. There is no doubt that a love of beauty and an aesthetic sense now have a bearing on the execution of the pictures. Royal reliefs of this type have not been found in later times. The ancient and traditional reliefs from the holy temples, which endlessly portrayed the ruler in communion with the gods, are not helpful in tracing the development of style. More relevant are the reliefs from the private tombs, which were hewn by the hundreds inside the cliffs to the west of Thebes—an astonishing wealth of pictures that develop the mastaba motifs of the Old Kingdom, with numerous innovations added. There are some among these that refer to the office held by the deceased. The king is also represented sitting on the throne receiving the occupant. There are also pictures of embassies from foreign lands, whose bearing of tribute is carefully reproduced, and much more besides. At the beginning and end of the 18th Dynasty, the relief technique was used most of all; in the middle of that period, painting on stucco came to the fore. Dating from the early 18th Dynasty, the tomb of Ammenemes (88) is a model example of the plain, rather austere style of the time. The wonderfully observed bull is borne unwittingly to the slaughter by a procession of male and female sacrificers. The famous tomb of the vizier Rekhmire (89) belongs to the same period. Since among other things he was in charge of the public buildings in the land, his burial chamber contains a picture of brickbuilding, describing the separate stages of production. There is no attempt at spatial depth, and the rule of composition is loose coordination.

The hunting scene in the tomb of Userhet (86, 87) is quite different, with the desert no longer divided into strips like a thought picture but appearing almost as a visual picture, like a field looked at from above. With brisk, sure brushstrokes the hare is captured by the ◁ 90 painter in mid-flight as it flees before the arrows of Userhet, charging along in a horse-

drawn wagon. The coloring is no longer strict polychromy, with an emphasis on symbolic values—it is intent on harmonious blending.

The second half of the 15th century B.C. is marked by increasing grace, refinement, and sensitivity. The depiction of the feast, more and more luxuriously conceived, provided this tendency of style with the best opportunities. The charming picture of girl musicians in the tomb of Nakht (*91*), a lute-playing dancer between a harpist and a flutist, makes it clear that the nakedness of a beautiful body has assumed a physical attraction unknown in earlier times. Equally instructive is the rendering of movement, given an effect of volume by the twisting action of the body, and pointing to an organic conception of form. The clothing of the women is extremely sumptuous: many-pleated garments of finest Syrian linen, tasteful wigs with ornaments, broad necklaces, costly jewels as on the portrait of a lady in the tomb of Menna at Thebes (*92*). A short period begins now in which individual artists develop personal styles distinguishable from each other by close investigation, even though the names of the artists are not known. The hand of these individual artists and their coloring style are detectable in other places.

The leap into three-dimensional space is demonstrated in the feast from the tomb of Neb-Amun (*93*). Two female musicians turn their faces away from the plane of the painting to look straight at the observer. This means no more than that the observer no longer sees the exterior world purely objectively but begins to receive it into his subjective consciousness. The way is thus prepared for a transformation from an objective to a subjective standpoint. Now the expression of emotion so long dammed up begins to demand its rights. The funeral march, vigorously increasing in size all the time, is the main seat of this development. A weeping daughter stands by her father's coffin. While the mourners (*90*) beat their heads with their left hands, she stretches out her left arm in a gesture of lamentation. Her eyes are streaming with tears, which flow down her cheeks from the middle of her eyes, exactly like the actual hieroglyph for the word "weeping."

When the monarchy changed hands from Amenhotep III to Amenhotep IV there was a further flowering of relief-tombs, of which the tomb of the vizier Ramose (*74*) is outstanding in its incomparable tenderness and delicacy of execution. The harmonious and sophisticated faces of the guests at the feast, the gauzy veils, the lotus flowers in the finely formed hands of a refined society attest to the sensitive, sickly exponents of a decadent latter-day culture.

The struggle toward three-dimensionality and cohesive composition, a love for natural observation, expression of emotion, gently molded outlines, and painting-type methods characterize the style at the turn of the 14th century B.C. These trends are a preparation for the advent of what we call Amarna art, that is, the style Amenhotep IV (Akhnaton) inaugurated in order to give meaning to his ideas of reform. Amarna art represents a breakthrough in style that cannot be explained by the whims of stylistic change alone, but must be seen in terms of monarchical influence. Akhnaton employed artists who consciously took up and emphasized modern trends bent on expression and who rejected what seemed to them mere "beauty."

If one examines the reliefs found in the tombs of the courtiers at Amarna, the prominence of the king and his family as a theme is immediately apparent. The occupant of the tomb

is relegated to the background. This can be taken as evidence of Amenhotep IV's autocratic nature, which speaks to us from all his decrees. The great scenes of the murals, such as the royal family rewarding the lord with gold and gifts before the palace gates, all occur in a clearly recognizable place. The groups of figures on the picture strips are all involved in the same event, and so one is no longer obliged to consider them successively. A simultaneous conception is in fact their very basis. By this means they come closer to giving a visual picture and a certain illusion of empty space. Admittedly, the attempt was only an anticipation of possibilities realized by Hellenism a thousand years later. A hallmark of Amarna art is its preference for intimate subjects and such scenes as the "walk in the garden" (75), in which the queen holds a bunch of flowers up to the nose of her husband, who stands idly beside her, a picture of detached charm. A detail from the Berlin relief of Mourners (73) is an example of the growing interest in psychological studies. Three high state officials follow the coffin of a high priest. Their faces reveal a mixture of official grief, engaged curiosity, and expression.

The Ramessid era, particularly in the mortuary temple and tomb of Seti I, developed a relief style that lent worldly elegance to time-honored holy themes. The impressive sophistication of the figures is executed with sureness and refinement, but also with academic coldness.

The powerful picture cycles on the walls of the temples are among the outstanding achievements of the age. They were intended to present the military exploits of the king before the eyes of the people, thus completing the transition from generalized subject matter to that reflecting unique actual events. With this change in attitude there was necessarily a change of form. Here in the full light of the sun the technique of the sunken relief was the most obvious choice, for its sharp edges have better definition and are useful because the size of the tasks demanded speedy work. Thematic interest outweighs the artistic; the latter holds true mainly for the composition of the sketch. From this point of view the battle reliefs of Seti I go as far as Egyptian art was prepared to in the treatment of free space. The old division into strips was dropped completely; instead, a single landscape was intended. Artistic composition was already falling off by Ramses II's time, although there are still a number of interesting details to be found in the depiction of the battle against the Hittites at Kadesh (77).

The reliefs in the private tombs turn more and more to the themes of the funeral procession, the burial cult, and the other world. Toward the end one or two tombs betray dry stereotypes and shoddy work. The tomb of Queen Nefertiri, wife of Ramses II, in which the colors have come down to us in their full splendor (94), gives us an impressive example of how strong the force of this tradition is but at the same time of how there are still far-reaching turns of style in the best workshops of the Ramessid era. In some of the tomb portraits of the queen not only are the pleated folds in the transparent robes carefully reproduced by the brush but so is the shading, perhaps not quite accurately yet nevertheless with observation and meaning. The painter excluded this innovation from the pictures of the goddesses, well aware that shading draws the figures into a temporal, subjective sphere not appropriate to the realm of the divine.

91 GIRL MUSICIANS, from a banquet scene in the tomb of Nakht, Thebes. 18th Dynasty, c. 1410 B.C. Wall painting on stucco. Height of the first figure c. 42 cm. The artist deviates from the usual method of drawing the left breast in profile and shows it fully from the front. In this way he strives to reproduce a visual impression.

92 PORTRAIT OF A LADY, in the tomb of Menna, Thebes. 18th Dynasty, c. 1410 B.C. This portrait of the deceased's wife reveals its creator to have been one of Egypt's greatest painters.

93 BANQUET, from the tomb of Neb-Amun, Thebes. 18th Dynasty, c. 1380 B.C. Wall painting on stucco. British Museum, London. All four musicians in the lower frieze have their hips and lower body turned to the right and show the naked soles of their feet with all five toes, which are even given shading.

94 QUEEN NEFERTIRI, wife of Ramses II, in her tomb in the Valley of Queens, Thebes. Detail. 19th Dynasty, c. 1250 B.C. The walls of the tomb are covered with a thick layer of plaster; the relief with its almost-life-size figures was modeled with plaster and then painted.

91 ▷

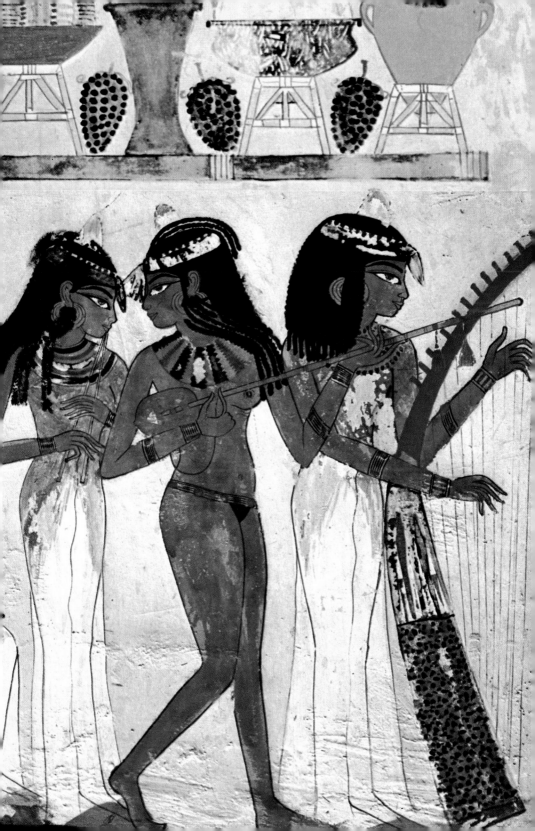

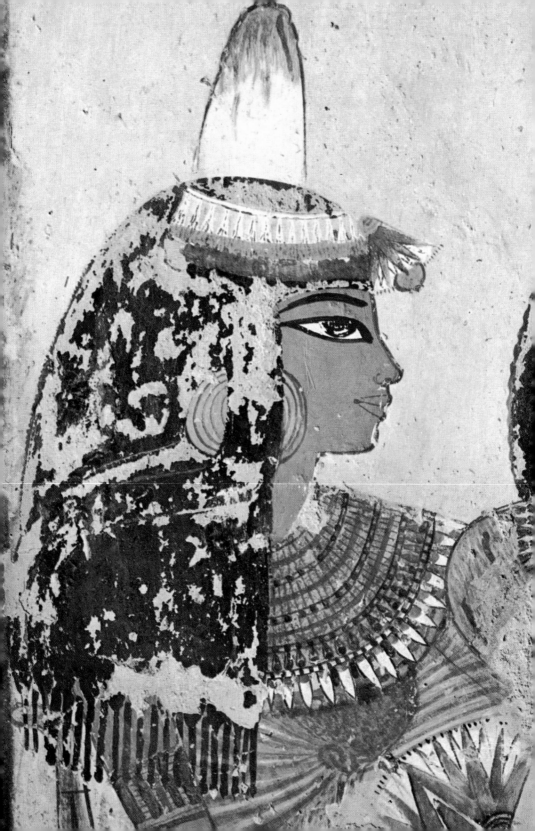

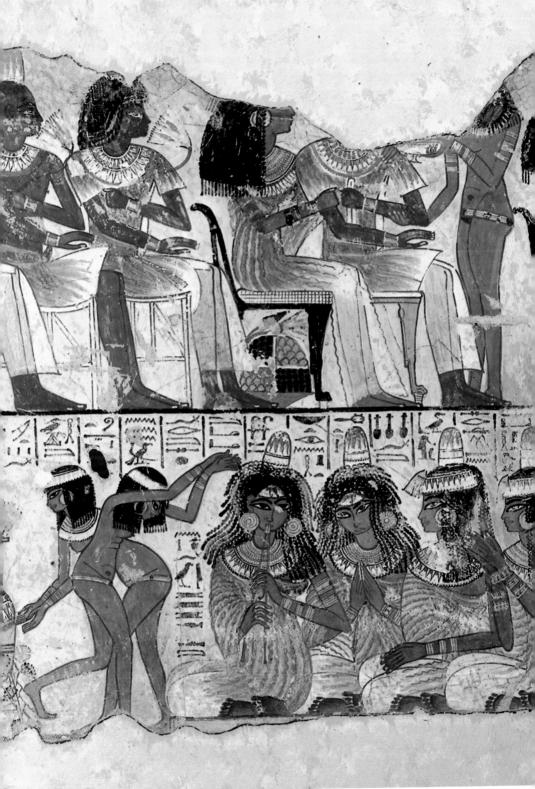

The stylistic tendencies of Late Period relief painting are, if possible, even more varied and incoherent than those of its sculpture in the round. Archaizing inclinations led to copying old pictures. So, for instance, in the chambers under the step pyramids at Saqqara the reliefs have been gridded with a network of squares for copying purposes. A relief from the tomb of Mentuemhet (78) dating from the 26th Dynasty, recently transported with other pieces to New York, is particularly informative about details of method. In the lower picture strip we see a woman under a tree carrying her child in a sling and putting picked fruit into a dish; in the upper picture two girls, one pulling a thorn out of the other's foot. The motifs had already appeared, both on the same wall, in a tomb of the 18th Dynasty, but only in painted form. The simple hair style of the woman is turned into a careful coiffure, her face transposed into an aristocratic one. The original naturalistic tree is stylized in the fashion of the Middle Kingdom, and the girls no longer sit on brushwood but on leather stools. Thus the imitator created a new and harmonious whole out of a New Kingdom original, with the help of borrowings from the Middle Kingdom and the stimulus of his own time.

Toward the end of the 4th century B.C. a Philhellenic Egyptian called Petoriris had his tomb decorated by artists who had previously worked in a Greek studio. For scenes of daily life they chose a remarkable mixture of Greek and Egyptian styles, yet with the religious pictures still formulated in the pure Egyptian manner. Under Greek influence form becomes expression itself and a conscious choice has been made between two possibilities. So ends the history of the Egyptian style.

94

MESOPOTAMIA

INTRODUCTION

The culture of ancient Mesopotamia (Greek: "between the rivers") was determined by the courses of the Tigris and Euphrates. The area dealt with principally here is bordered in the south by the Persian Gulf, in the north by the Kurdish hills. In the east it is divided from the Iranian highlands by the Zagros Mountains; in the west it stretches into the wastes of the Syrian Desert. The south—Babylon, in fact—between the Tigris and Euphrates has an upper region of steppe land with scanty vegetation, while the lower region, in ancient times nothing like it is today, had been developed by artificial irrigation and drainage into a land of great fertility. The north, roughly the region between Samarra and Mosul, gets abundant rain. As in Egypt, there was no useful timber in the country, and wood had to be imported from Lebanon and the Amanus Mountains. The metal situation was no better, for there was no gold, silver, or copper in the land. Even the coveted semiprecious stones like lapis lazuli, cornelian, rock crystal, and turquoise had to be gotten by trading. Important to the development of architecture and sculpture was the complete lack of usable types of stone in the south, unlike Egypt where it was so plentiful. While the clear course of Egyptian history, relatively undisturbed by outside events, seems almost the model example of a civilization, the story of Mesopotamia is confusing and difficult to comprehend. The excavation of a great number of dwellings has shown how the transition was made from collecting and hunting for food to land-tilling and cattle-rearing and how wide provinces of culture were built up, where the use of copper gradually increased and from which the potter's wheel and molds for brick-making appear. In this way noticeable differences become clear in ceramics, burial rites, and architectural forms. But how much cultural changes were influenced by the development of an inner consciousness or by the invasion of new ethnic groups remains unknown despite the researches of archeologists, historians, and other scholars.

The decisive turning point came before 3000 B.C. with the arrival of the Sumerians, who were destined to become the heralds of Mesopotamian civilization and to construct a tradition of forms embracing all aspects of life. It is now generally agreed that the Sumerians can be traced back with certainty to a phase of civilization called Uruk IV, that is, in the fourth of nineteen layers that German archeologists discovered in Uruk (Warka), the Erech of the Old Testament. With the arrival of the Sumerians the cultural center of gravity shifted southeast to the Persian Gulf seaboard, where Eridu, the cult place of the water-god Enki, seems to have been the most ancient city in the area. Cuneiform script appears to have been the most important innovation in Uruk IV. In the course of history over a thousand signs were reduced to half that number and stripped of their pictorial features. The Sumerian tongue, belonging to the agglutinative group of languages, has not yet been found to relate to any other. Their origin is not known, but there is growing support for the theory that they infiltrated from the east.

The Sumerian occupation led to the founding of a number of city-states. Uruk was a dominant center. The god of heaven Anu and the mother-goddess Inanna were greatly revered there. A new era, named Jamdat Nasr after the site of its first discovery, is marked by colorful pottery and the use of the so-called plano-convex brick. It led to an extraordinary expansion of the Sumerian sphere of influence and spread trade contacts as far as Elam in the east and Egypt in the west. If Mesopotamian motifs appear in Egypt at the turn of the 1st Dynasty they are in fact witness to the long-range effects of Jamdat Nasr culture.

Characteristic of the Sumerian city states was their religious state socialism. Everything centered around the temple, whose god owned not only every inch of land but also the people, whether they served him as priests or soldiers, officials or artisans, farmers or hunters. They all worked on contract to the god and delivered to him everything they gained or made, receiving a wage for it. The system required a highly sophisticated temple administration; not surprisingly, 95 per cent of all Sumerian texts surviving today are administrative reports. The *ensi*—arch-priest, general, and judge—was the head of state and a representative of the god.

If the center of gravity had previously rested in Uruk, it now—in the Mesilim and Ur I Period (2600 – 2350 B.C.)—moved north with King Mesilim of Kish into the area that later became Babylon. There are signs that Semitic infiltrators, forerunners of the Akkadians, pressed in from the Syrian steppes, and the massive double wall of Uruk (5 km. long with more than 800 towers), said to have been built by the legendary Gilgamesh, may possibly have been connected with this threat. On the lower Diyala, which flows into the Tigris not far from Baghdad, excavations have revealed several examples of Sumerian culture. About 2500 B.C., two sophisticated cultures, whose relation to each other is not completely clear, blossomed simultaneously in two places: first in Ur, southeast of Uruk, where the moon-god Nanna and the mother-goddess Ningal were honored, and where the shaft graves of the so-called 1st Dynasty of Ur have revealed not only rich treasures but also significant evidence concerning their religion; second, north of Ur, in Lagash, a rich trading town whose ensis, particularly Ur-Nanshe, Eannatum, and Entemena, left behind monuments of great historical and artistic interest.

At about this time the ancient Sumerian unity of priesthood and state turned into a duality of priest and king. Temple and palace, the two powers, strove symbolically against each other. The change involved difficulties, as can be seen, for example, in the rise of the reformer King Urukagina. Finally there was an attempt by Lugalzaggesi to create a united Sumer with Uruk as its capital. But Sargon (Sharrukin), a Semitic usurper, had already appeared, conquering Uruk and putting an end not only to the capital but to the whole Sumerian age.

With the Semitic invasion a quite different ethnic group came to the fore. Sargon built himself a new residence, Agade or Akkad, not far from Kish. By fierce campaigning he conquered all of Mesopotamia and added the neighboring countries to his empire, from the Amanus Mountains to the Persian Gulf and from the Zagros to the Mediterranean coast. His grandson Naram-Sin continued his conquests. Both kings claimed to be divine and bore the title "king of the four regions of the earth." A quarter of a century after Naram-Sin's

death, the kingdom collapsed. After the Akkadian era the Semitic dialect impinged more and more on the Sumerian, although the Akkadians used the cuneiform writing of the Sumerians. From then on, Mesopotamian culture was bilingual, as in the culture of the Middle Ages, when Latin duplicated the vernacular not only as the language of the church and learning but also in part as a creative literary language.

The collapse of unity in the kingdom enabled the Guti, a mountain people, to destroy Akkad, Uruk, and Ur. Utuchengal of Uruk fought off the foreign rulers but was overthrown by his viceroy Ur-Nammu, who founded the 3d Dynasty of Ur and stimulated a Sumero-Akkadian revival (the New Sumerian Period, c. 2100–1950 B.C.), which expressed itself, among other things, in restorations and expansions of the old temples. Ur-Nammu's son Shulgi, along with his successor, assumed the earlier title of "king of the four regions of the earth."

Simultaneously with the Ur dynasty, ancient Lagash rose up anew. It was the pious Gudea in particular, well-known because of his statues and offerings and extensive inscriptions, who undertook to put the Sumerian temple city back on its feet. But again infiltrators arrived—Semites from the west, led by a prince of Mari (Tell Hariri) on the Euphrates, which already seems to have been an important Semitic center toward the end of the Jamdat Nasr Period. Around 1950 B.C. they destroyed Ur and put an end to Sumer.

After an interval during which western Semites ruled from Mari to Ur and divided power with the Elamites who had spread from Susa and the hill country of Anzan, the 1st Babylonian Dynasty was founded. Hammurabi has gone down in history as its most celebrated ruler. After defeating many of the neighboring kingdoms, Hammurabi managed to rule a united empire stretching from the Persian Gulf to the Mediterranean coast, which he governed from Babylon with a firm hand, equally distinguished as lawgiver, politician, and administrator. Under his successors, unity was lost again. The southern seaboard area became independent, while the north was oppressed by Kassites and the west by Hurrians. About 1531 B.C. Mursilis I, king of the Hittites in Asia Minor, took Babylon after a swift campaign and brought Hammurabi's dynasty to an end.

The vacuum created by the Hittite invasion was filled by the Kassites, a people from the east, who for some time had exerted pressure on Babylon, and they took over the Akkadian culture already there. Their supremacy, which lasted for about four centuries, was brought to an end by struggles with the Assyrians and a massive influx of Elamites.

Meanwhile, yet another ethnic group, the Assyrians—who comprised both western Semitic and Hurrian elements—were growing in strength. Using all their resources of weaponry and strategy, the Assyrians conquered the Hurrian kingdom of Mitanni and its Hittite allies and, under Tukulti-Ninurta I, defeated the Kassites and took Babylon. A resulting period of decline allowed a short Babylonian revival, with political independence. But later rulers of Ashur conquered in the west, and in the north up to Lake Van, in unbelievably cruel campaigns. After another decline caused by disputes of succession and the infiltration of Aramaean nomads from the Arabian Desert, the New Assyrian Kingdom was set up in the mid-10th century B.C. In the following century—under Ashurnasirpal II, the founder of Nimrud (Kalakh)—the kingdom regained its former size, strangled Babylon, and decisively

defeated the Aramaeans. In the 8th century B.C. the great Tiglath-Pileser III warred successfully against the Aramaeans and against the kingdom of Urartu, which at one time had stretched from the Araxes River to northern Syria. He made himself king of Babylon and combined it with Ashur by means of a personal pact.

The Assyrians left a trail of massacre, terror, and mass deportation. The army was the ruling force in the state, and the later rulers of Assyria—men of extraordinary ability—were virtually soldier-emperors: Sargon II, founder of Dur-Sharrukin (Khorsabad); Sennacherib, who sacked Babylon in 689 B.C.; Esarhaddon, who rebuilt Babylon and later conquered Memphis in 671 during his Egyptian campaign; and the gifted Ashurbanipal, who captured and plundered the southern Egyptian city of Thebes. Two decades after the death of Ashurbanipal, the Medes (who had been threatening from Lake Urmia since the 9th century) and the Chaldeans conquered Nineveh in 612 B.C. The fate of the kingdom was sealed.

Nabopolassar succeeded by skillful strategy in securing Chaldean supremacy over Babylon, at the same time fighting Assyria in a pact with the Medes. As king of Babylon, Sumer, and Akkad he began to renew the old splendor. His son Nebuchadnezzar II, who conquered Jerusalem, carried on his father's work in splendid fashion and gave Babylon the brilliant stature that excavations have made familiar to us. It was a relatively short-lived revival: After defeating the Lydians, Cyrus, a Persian from the house of the Achaemenids, entered Babylon in 539 B.C.

If with the Chaldeans yet another racial element had taken the lead—Aramaic script on papyrus had begun to replace cuneiform script on clay tablets as early as the 9th century B.C.—then with the Persians a youthful Indo-European people entered the scene. Now in the limelight, the "kings of kings" took pains to create an imperial art that adapted itself from the Mesopotamian and came to an end when the country was conquered by Alexander the Great, who died in Babylon in 323 B.C.

ARCHITECTURE

Traveling from Egypt through Mesopotamia one notices the almost total lack of impressive buildings of any antiquity. Mesopotamia has nothing like the Pyramids or the giant temples of the New Kingdom or the Late Period, which Egypt exhibits like a gigantic outdoor museum. Yet Mesopotamia also developed a magnificent architecture in honor of the gods, and—particularly after the Assyrian era—in honor of the king. But since the land could offer only clay-yielding earth, almost everything has perished with time.

In earliest times, buildings were constructed from reeds, in which a framework of reed bundles was covered with woven mats, a technique still practiced there in parts of Iraq. After primitive buildings with lumps of mud, as can be seen in the oldest layers of the temple of Enki at Eridu, there was an early transition to bricks, which were reinforced with straw and dried in the open air and which in the course of time were made in various shapes and sizes. As early as the beginning of the 3d millennium B.C. bricks had occasionally been fired and used for floors, fountains, palaces, and the covering of temple towers. With the Early Period around 3000 B.C. there began the oldest of the large cult buildings of mankind, whose consecutive stages have been illustrated in exemplary fashion by excavations at Uruk. The high temple of the temple of Anu at Uruk inherited a platform as a result of many collapses and rebuildings on the same site, and thus provided a model for the later, very characteristic ziggurat (96). Temple D covers an area of 55 × 80 meters. Outer and inner surfaces are decorated with niches at regular intervals. This feature probably derives from the use of wood-frame construction; at any rate, it is the expression of an architectural design that has nothing to do with the exposure of structural elements, but with a decorative façade. For this reason Sumerian architecture gave no aesthetic function to the column or the arch, both of which were known; on the other hand, a significant decoration of the surface was invented in the cone mosaic (95). Clay cones, mostly black, white, and red, were set in a fresh layer of mud, imitating the pattern of reed matting that was originally used to protect the mud walls.

In the Mesilim Period there were far-reaching changes in architecture, as in other fields. Plano-convex bricks formed the new building material. Rounded on one of their long sides, they could be placed one on top of another only in oblique rows. No suggestions have offered a convincing explanation for this impractical shape.

The temples were no longer built on level ground but set on raised mounds and separated from the profane world by a perimeter wall—symbolic of the separation between spiritual and secular power that occurred at this time. In the Diyala region a series of temples has been studied whose different periods of construction point to the development of a type of building based on a courtyard against the walls of which are a number of covered rooms. The rectangular cell with an altar on one of the short sides is attached to the wall farthest from the entrance.

It is certainly no coincidence that the time of the god-kings of Akkad is marked by a palace that Naram-Sin built for himself in Tell Brak, a four-sided building based on a centralized plan, protected by a surrounding wall 10 meters thick and accessible through an impres-

sive gateway. It is no less a hallmark of the New Sumerian revival that buildings sprang up all over the land, replacing or enlarging the old temples. Their great achievement was the development of the temple tower, or ziggurat, of which the best preserved example—the one built by Ur-Nammu in Ur—is one of the few impressive architectural remains left in Mesopotamia (97). It owes its good state of preservation to the fact that Ur-Nammu had it faced with fired bricks. It covers a surface area of 62 × 43 meters and stands three stories high, the topmost reaching 20 meters above the ground. The sheer outer walls are articulated with flat projections. The main flight of steps presumably led straight up to the top platform and the high temple itself, while the two flights ascending on either side reached only the lower platform (reconstruction, 98).

But what is the significance of the temple tower in terms of the cult? Since none of the upper stories has survived either here or anywhere else, important questions remain, which researchers attempt to answer on the basis of surviving representations and descriptions of construction, as well as on the report of Herodotus on the Late Babylonian ziggurat at Babylon. Is the high temple the dwelling of the god, from which he descended to the lower temple on feast days at the request of the people, or did the god and goddess represented by king and arch-priestess celebrate a "holy wedding" up there, as described by Herodotus, who talks of a holy wedding between the god and a woman of his choice? The lower temple lying at the foot of the tower is another New Sumerian innovation. Its main feature is the broad cell. One enters through a gate into an open courtyard and walks in a straight line first to a spacious anteroom and behind it to the main cell of equal width.

Only in one case did the kings leave tombs that can claim to have had any great architectural influence. These are the mortuary buildings of the 3d Dynasty in Ur, next to the famous shaft graves of the 1st Dynasty with their magnificent extensions. With their vaulting and steps, they are also particularly interesting from a technical point of view. They are regarded as evidence of the belief that the dead king, as an incarnation of the resurrected fertility god Dumuzi (Tammuz), must be freed from his grave in the subterranean tomb complex (that is, from the underworld) in order to receive the honors and sacrifices due to him in the upper building, in a house of his own.

The broad cell type of temple continued into the Hammurabi era. But one must be cautious, in the light of archeological finds and the present state of research, in going further and describing this as evidence of the western Semites' coming to power and adapting architectural forms developed by the Sumerians. The same impression is given by the largest known palace building of the time, the giant palace of Zimrilim at Mari, which was so greatly admired by his contemporaries that the prince of Ugarit wrote to Hammurabi, hoping to present his son to Zimrilim so that he could see the palace with his own eyes. Although part of the palace is of a much earlier date, there is also evidence here of the continuation of Sumero-Akkadian building forms—the grouping of rooms around an open courtyard—and western Semitic elements are lacking. Indeed, the incursion of western Semites caused no kind of break in style; our look at the sculpture in the round and the palace paintings will support this statement.

95 CONE MOSAIC. Early Period, c. 2900 B.C. Part of the enclosing wall of a temple in the Temple of Eanna at Uruk with a mosaic of greenish-yellow and blue-black clay cones.

96 HIGH TEMPLE OF THE TEMPLE OF ANU, URUK. Early Period, c. 2800 B.C. The so-called white temple, with ramp.

97 ZIGGURAT OF UR-NAMMU, UR. c. 2100 B.C. Surface area 62 × 43 meters. Original total height 26 meters. A center of mud bricks with a covering of fired bricks. The steps end in a gatehouse lying somewhat above the first stage; from there, a further stairway led to the top. Nothing remains of the third stage with the high temple as it appears in Woolley's reconstruction, but natives told the first excavator (Taylor) in 1854 that a third storey had earlier been visible. The ziggurat was the central point of the temple of Nanna.

98 ZIGGURAT OF UR-NAMMU, UR. c. 2100 B.C. Reconstruction after Woolley.

99 RELIEF. Eastern Steps of the Apadana (Audience Chamber), Persepolis. 6th–5th centuries, B.C. Length c. 83 meters. The palace, begun by Darius I, is a magnificent expression of the Persian concept of the ruler. The king is bound by the task, given to him by Ahura Mazda, ruler of the whole world of holding the people together in an ordered state.

100 FRIEZE, from Karaindash's Temple to Inanna, Uruk. c. 1400 B.C. Reconstruction. Molded, fired bricks. Height 2.1 meters. Vorderasiatisches Museum, Berlin. A god and a goddess stand alternately in the niches of this base. They hold vessels to their breasts, from which a stream of water pours to both sides. The male deities are characterized by scales as mountain gods, the female by wavy lines as river goddesses. The same technique is also found in fragments elsewhere. It was used until Achaemenid times.

101 ASHUR. View from the east bank of the Tigris toward the north side of the town. 7th century B.C. Reconstruction after Andrae.

102 CAPITAL WITH A DOUBLE PROTOME OF RECUMBENT BULLS. Time of Darius I, end of the 6th century B.C. Bituminous stone. Length 3.74 meters. Louvre, Paris. The capital comes from one of the 36 columns that supported the roof of the Apadana at Susa. They were 20 meters high, had fluted shafts and double protomes (heads and necks) of bulls at the top. These were inspired by Assyrian models but were not without their own distinct style. They return to an indigenous method of construction whereby a beam of the roof rests on a forked branch.

103 THE ISHTAR GATE OF NEBUCHADNEZZAR II, BABYLON. Seen from the north. 6th century B.C. Reconstruction after Koldewey.

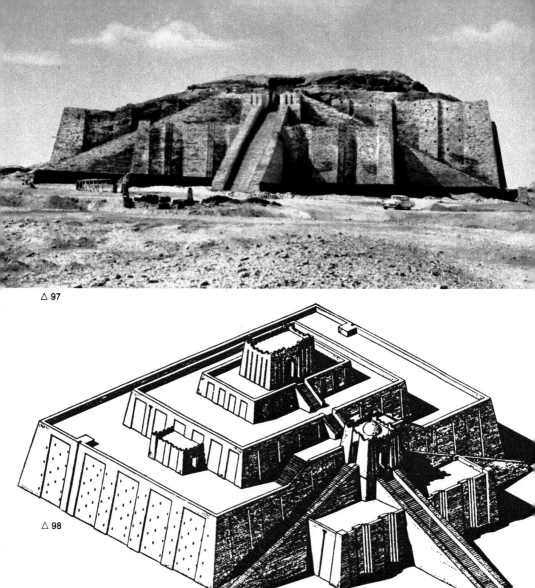

△ 97

△ 98

▽ 99

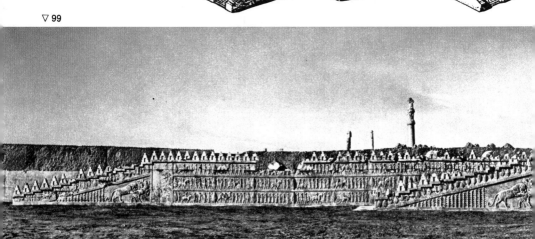

△ 100 ▽ 101

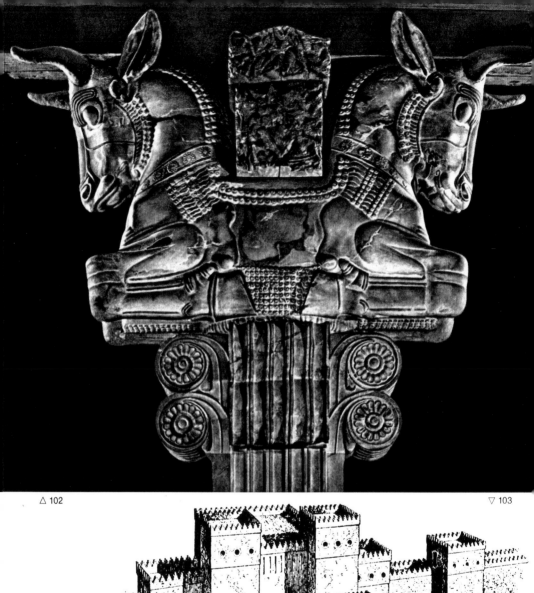

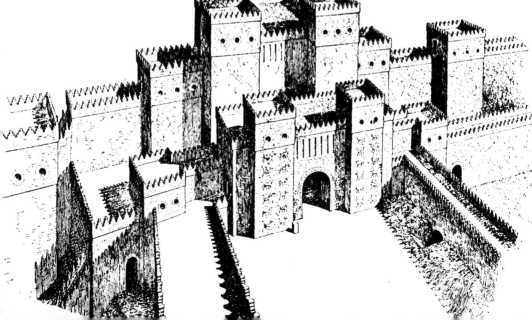

With the Kassites the situation was different. Around 1400 B.C., in the holy enclosure at Uruk, their king Karaindash built a small temple to Inanna which represented something quite new. Standing by itself, the building is a long house with an outer section (a *pronaos*) and a main inner room (a *cella*), and four strengthened corners. The ground plan itself is an independent Kassite achievement, and the same is true of the facade design decorated with niches (*100*). A base 2.1 to 3 meters high consists of fired bricks that have been molded to form a relief picture of two gods—perhaps the earliest existing example of genuine relief work incorporated in architecture. Near present-day Baghdad Karaindash's next successor but one, Kurigalzu, built a residence called Dur Kurigalzu ('Aqar Quf), whose ziggurat stands out today as an impressive ruin in the landscape. This palace of unique design makes one realize that the Kassites brought more to Mesopotamia than scholars were earlier inclined to think.

Assyrian architecture started developing its own features only after the advent of the Middle Assyrian Period, at the time of its breakaway from Babylonian and Mitannian influence. It had its first blossoming in the 13th century B.C., when the temples and palace buildings of the future appeared in prototype. But this was only a prelude to the magnificent architectural feats of the New Assyrian Kingdom. In the 9th century B.C., Ashurnasirpal II opened the series of great royal palaces with the Northwest Palace at Nimrud (Kalakh). Of special significance here is the division of the palace into two main parts, the forecourt and the center court with living quarters in the surrounding rooms. Between the two courtyard complexes is the royal chamber. 50 meters long but only 10 meters wide, with a podium for the royal throne.

In the 8th century Tiglath-Pileser III and Sargon II led the field. The former built the Central Palace at Kalakh. This man, who had brought virtually the whole Middle East under his rule, introduced an architectural feature that he derived from the then Aramaicized succession states of the Hittites. As in Mitannian Alalakh (Tell Atchana) in the 15th century B.C. and again in the northern Syrian-Mesopotamian area, it consisted of a rectangular room with a hall of pillars in front of one of the long sides and an inner hearth. Sargon II, in building his residence Dur-Sharrukin (Khorsabad) not far from Nineveh, gave complete expression to the idea of the Assyrian kingdom as a world empire. In the 7th century, toward the southwest of Nineveh (Kuyunjik), which had been inhabited for centuries by his predecessors, Sennacherib built a new palace with a radically altered ground plan. The palace could be entered on several sides through massive portals. The division and shape of the rooms were also new. The same was true of the last palace of all, Ashurbanipal's North Palace in Nineveh. The endless corridors and courtyards there seem to exist mainly to accommodate the long sequence of mural reliefs.

Turning from the Assyrian theory of monarchy, which conceived palaces with relief cycles telling stories of power and victory, Chaldean Babylon again took up the tradition carried on by the Kassites from the time of Hammurabi, whereby the ruler was portrayed as a pious prince of peace. In Babylon it was the temple that stood at the focal point, principally the Temple of Marduk (the so-called *esangila*) with its famous ziggurat, the Tower of Babel. Nine defensive gates led through the strong double wall of the city; even today

the Ishtar Gate is 12 meters high (reconstruction, *103*). On the north it was decorated with reliefs of 575 holy bulls (*136*) and dragons of glazed bricks. From here to the Temple of Marduk the walls of a 300-meter-long processional road bore 50 lions in glazed yellow bricks against a background of blue. The façade of the throne hall in the southern citadel was also decorated with similar bricks (*134*). This marked the perfection of a technique that had been practiced for a thousand years, while the architecture itself, with its ornamental facing of the mud-brick wall without actual reference to the structure of the building, diverged freely from the spirit of early Sumerian building.

The art of the Achaemenid kingdom is such a colorful mixture of Babylonian-Assyrian, Elamite, Hittite, Urartian, Medean-Scythian, and Ionic elements that it would be absurd to discuss it as a continuation of Mesopotamian art. Most noteworthy was the palace of Persepolis, with its reliefs (*99*) based on Mesopotamian models, while the columns (*102*) and the columned hall are of Mediterranean, or rather Egyptian, inspiration.

SCULPTURE IN THE ROUND

Because newly ascendant ethnic groups sometimes created new forms and sometimes took over old forms, it is difficult to develop a complete picture of architectural precedent in ancient Mesopotamia. The same problem exists in the case of sculpture in the round. Although this book must limit its attention to the mainstream of artistic composition in Mesopotamia and ignore its influence on neighboring Iran, Syria, and Anatolia, other stimuli came into Mesopotamia in the reverse direction—from Elamites, Hurrians, Hittites, West Semites, Aramaeans, and others—stimuli we cannot define separately. There is also another factor worth noting: The main contribution Mesopotamian civilization made to the intellectual history of mankind lies in the verbal sphere. The creation stories of Gilgamesh, the myths of Dumuzi (Tammuz) and Inanna, the hymns and prayers—all have a power and depth that are hardly equaled by the fine arts of the times.

In Egypt, the task of history always devolved upon the written word in times of political and economic decline, and profound writings instead of impressive portraits recorded the country's self-awareness. By analogy, one might well feel that the turbulent course of Mesopotamian history is responsible for keeping pictorial art behind its rival, the written word. There is, however, more to it than that. The development of Egyptian sculpture cannot be understood without knowledge of the role of the Egyptian god-king, to whom the people built pyramids and mortuary temples filled with statues to ensure his blessing even from the other world. Egyptian art is on the whole synonymous with the art of the Pharaohs, and the private art simply grew up in an effort to imitate it. The Sumerian ensi, however, has no comparable claim to being human representative of its god; it says much from this point of view that the greatest known portrait of a ruler in Mesopotamia belongs to one of the Akkadian god-kings.

The art of both areas had its roots in religion. Both started from the portrait's nature as reality—that is, with the conviction that the statue could be filled with real life and was therefore able to represent the living man. But only the Egyptians with their concept of the other world took the idea to its logical conclusion, whereby the statues replaced the transitory corpse and ensured eternal life to the deceased. It must be remembered, however, that in the Sumerian south, because of the dearth of stone and timber, a basic requirement for large sculptural compositions was lacking from the start.

During the early Uruk era, sculptural activity began with some male and female figures of fired clay, with strange animalistic heads, found in graveyards in Ur and Eridu. As in Egypt, they are not to be reckoned as forerunners of the later stone statues. The first important work among them is a votive statuette in gray alabaster (105), which came to light in a remarkable way during the excavations at Uruk. Some Seleucid builders stumbled on them almost three millenniums after their date of origin and carefully reburied them in a clay pot. Originally they must have stood in one of the temples at Uruk. The man, who is preserved down to the waist and is about one-third life-size, has a naked, strikingly muscular torso, wears a robe fastened with a bulging belt, and has a horizontally fluted beard hanging roundly over his chest. Since this feature appears again among the Sumerian priest-

princes, it is evident that the man is an ensi of Uruk. The eyeballs are of mussel-shell fixed into their sockets with asphalt, and the pupils are inlaid with lapis lazuli. The position of the hands is unusual and eludes any sure interpretation; the clenched fists touch each other in front of the chest. This statue marks the beginning of an artistic conception in Sumerian sculpture in the round.

About hundred years later a work appeared that we would unhesitatingly call prodigious—the Lady of Warka (*104*), as she is called. The white marble head, discovered in Uruk, is almost life-size and therefore the oldest piece of large sculpture known. The circumstances of its discovery point to a date in the Jamdat Nasr period. Not quite finished, it was presumably part of a wooden statue into which it was set. This idea is supported by four holes bored into the back. The fact also that the top side is only roughly executed and that further holes have been made around the ears and temples suggests that a wig of some other material, probably gold, was meant to be put on top. The eyebrows, meeting in the middle according to contemporary ideals of beauty, presumably were inlaid with lapis lazuli, and the eyes with several different materials. The lower half of the nose has been broken off; if the head had been preserved in its original condition, it would make a far stranger impression and perhaps have less appeal than it does today. The observer is fascinated by this enigmatic woman's face, feeling obliged to speculate on whom it is supposed to represent—high priestess, queen, goddess? Contemporary Egypt of the 1st Dynasty has nothing of equal merit to compare with this head. It was only centuries later that these portraits were created (and then admittedly in rapidly growing numbers) whose power of expression approaches the standard of the Lady of Warka. It seems all the more incomprehensible that the next Mesopotamian age did not make use of this inheritance.

The Mesilim era has yielded rich material to excavators in the Diyala region, especially in Eshnunna, Khafaje, and Tell Agrab. At that time and even later, the main feature was the votive statue, which was donated as an offering to the temple and often bore the names of the donor and of the god it was invoking. The Sumerian hoped by this means to commend himself to the god in the temple and to enjoy his mercy, a concept that led to the temple statue in Egypt as well but that was eclipsed there in earlier times by the idea of the mortuary statue. As a result of this, the standing version is the usual one, and sitting or other motifs

104 LADY OF WARKA. Jamdat Nasr Period, 3000–2700 B.C. White marble. Height from crown to chin 20.1 cm. Iraq Museum, Baghdad. Found in the Eanna enclosure at Uruk (Warka).

105 VOTIVE STATUETTE. Upper part. Early Period (Uruk IV). Gray alabaster. Height 18 cm. Iraq Museum, Baghdad.

106 STATUETTE OF A PRAYING WOMAN. Ur I Period. Presumably from Lagash. Height

30 cm. British Museum, London. Obtained by trade.

107–8 VOTIVE STATUETTES. From Temple of Abu, Eshnunna (Tell Asmar). Mesilim Era. Gypsum. Height 72 cm. and 59 cm., respectively. Iraq Museum, Baghdad. Both figures carry beakers in their hands. Since hundreds of these beakers were found in an adjacent room, a drinking feast was evidently part of the temple cult of this time.

104

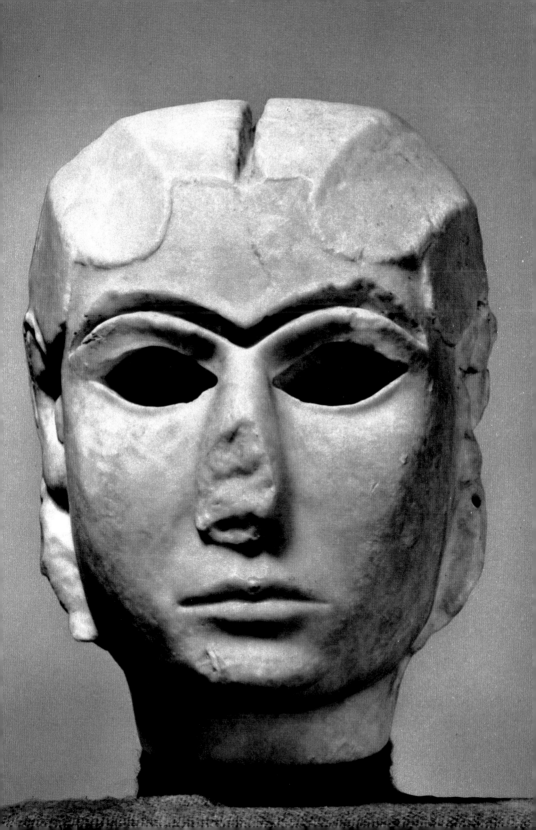

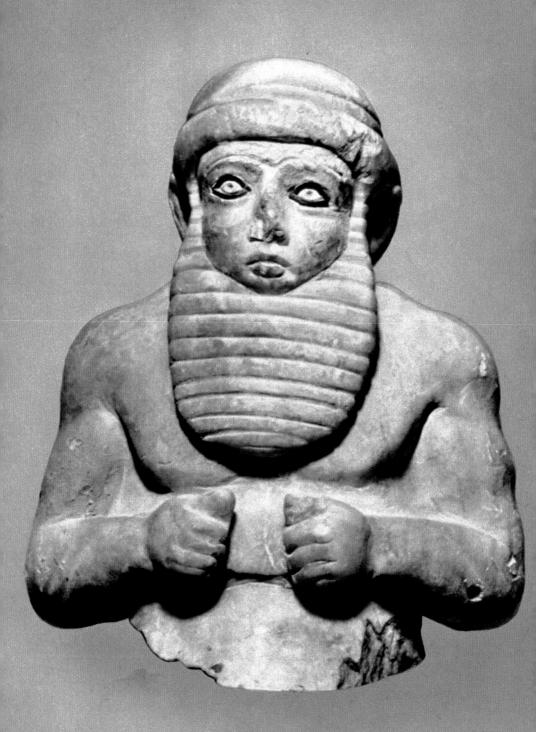

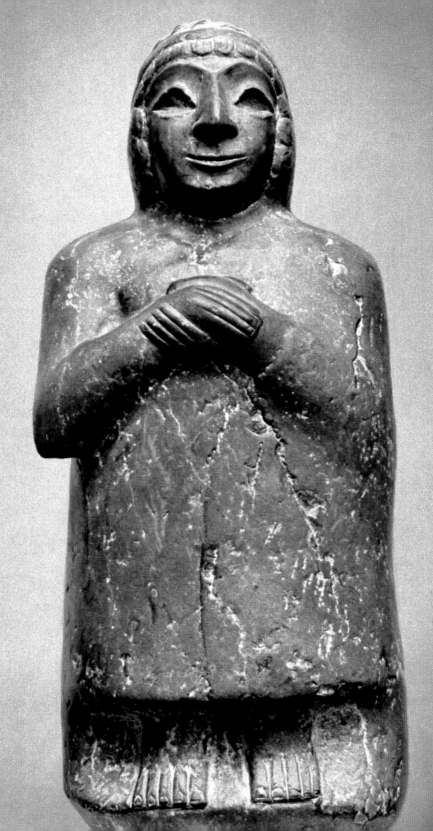

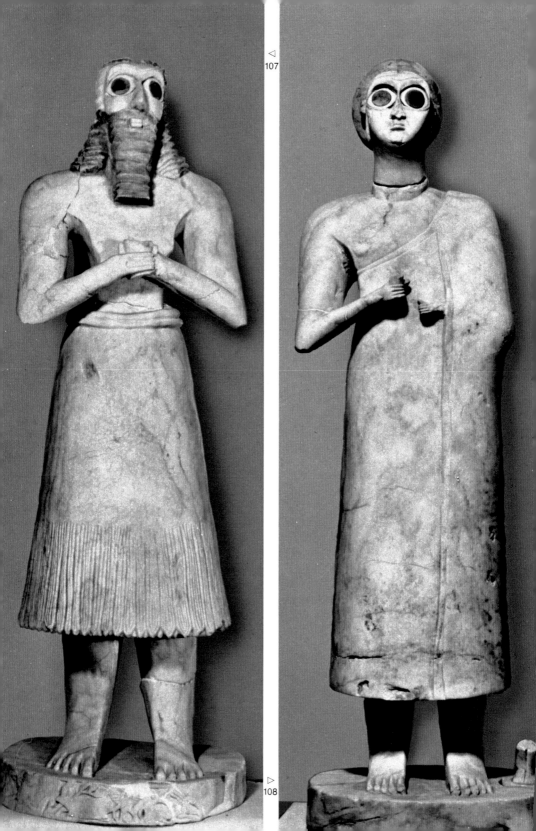

are much rarer than in Egypt. Under the floor of the temple to Abu at Eshnunna, carefully buried near the altar, a cache of twelve votive statuettes (*107–8*) was brought to light in 1934. It is not clear whether the group originally belonged together (perhaps as guests at a holy wedding, as has been suggested) or, more probably, whether on one occasion the multitude of statues standing in the temple could no longer be protected and a number of them were entrusted to the earth, as we have seen to a far greater extent in Egypt. These votive figures (made from alabaster) are between 20 and 72 cm. tall; ten are male, two female. Except for one kneeling in adoration, they stand with hands clasped before their breasts; some hold a sacrificial cup in their fingers. Their quality is irregular. Clearly they were mass-produced to satisfy a commercial market.

The majority of the figures stand on a round pedestal. This points to a cylindrical concept of existence in place of the cubistic one that dominated the whole of Egyptian sculpture; in this way all Mesopotamian sculpture in the round is sharply distinguished from the Egyptian. The aim is identical in both cases: to contain the incoherence of nature within a "form" and to subject it to a strict order—in other words, to stylize it. If—not consciously, of course, but intuitively—a different schema has been chosen, then it undoubtedly expresses a concept of the world sharply divorced from that of Egypt, hence difficult to put down in rigorous terminology. The unity of these statues lies in the predominance of the cylinder and the cone. If in Egypt, especially during the Early Period, the sides of the cube were sharply juxtaposed, then here the roundness of the stone is exaggerated to the utmost in the half- or full-length robe with its surrounding hem of sheepskin tufts.

The pair of votive statues shown (*107–8*) are distinguished by their size and fine execution. The man stands 72 cm. tall, the woman 59 cm. They have been interpreted as god and goddess, or even king and queen, but without any conclusive supporting evidence. The upper arms of the man are freed from the body, and the legs of his half-length skirt stand separately on the pedestal. He holds a cup in his tiny hands. The upper arms are too large in relation to the whole, and the forearms are too thin. His hair falls onto his shoulders in vertical locks; a large, squarely cut, horizontally fluted beard lies on his chest. The woman wears a long robe that leaves her right shoulder free. Beside her on the pedestal stand fragments of a child's figure, which shows the woman to be a mother. Even more than the strong geometric emphasis it is their wide-eyed looking up to the divinity that gives both figures their ecstatic character. The man's giant eyes are inlaid, as are beard and hair, with mussel-shell and black stone. The settings are fixed with asphalt, which has also been used for the eyebrows. The statuettes seem clumsy, even barbaric, to us. Yet they must be understood for their religious purpose. They are symbols, not likenesses, and they are certainly well-suited to their task, however difficult we find it today to feel what they meant to the Sumerians in the middle of the 3d millennium B.C.

The French excavations in 1933 revealed Mari (in present-day Syria) to be a town of Sumerian foundation with a Semitic population. From the great abundance of sculptures found there, two should be especially noted: First is the statue of palace prefect Ebih-il—a work of yellowish alabaster, 52.5 cm. high (*109*). He is sitting on a round woven basket seat, his hands clasped in a gesture of prayer, his gaze directed toward the statue of the goddess

Ishtar, in whose temple the work was found. His head is clean-shaven, and from under the low forehead extends a large fleshy nose. The eyes are inlaid with mother-of-pearl, black stone, and lapis lazuli, the brows with asphalt. The well-kept beard, whose separate locks curl up at the end, has been handled by the sculptor with the utmost precision. No less care has been taken with the wide, shaggy skirt, whose fleece has been reproduced with a genuine delight in detail. The position of the hands is familiar from the votive statues of Eshnunna (*107–8*), but here it is an outcome of the motif itself. This apart, however, there is a change from the abstract and schematic to the particular, with a decisive swing toward the observation of living nature. Although it is hardly a portrait in the real sense, it is certainly a fine observation of the Semitic physical type. This marked change is hardly to be explained simply in terms of one of those diametric reversals from abstract to concrete that are legion in the history of any art; there is in addition the complication that this sitting statue has been dated with certainty by its Semitic dedicatory inscription to the same Mesilim era as the group of votive statues, although they possibly belong to the end of that period. Furthermore, it must be explained that in Mari another ethnic group and another artistic school were at work. But there are too many gaps in knowledge for scholars to understand the change completely.

Urnanshe, the "great songstress" from Mari (*110*), provides Ebih-il with a female companion. This highly amusing work is closely related to it in style. The figure sits on a round

109 EBIH-IL, of Mari. Mesilim Era. Detail. Alabaster. Height 52.5 cm. Louvre, Paris. According to the inscription, the statue with staring eyes is dedicated to the goddess Ishtar.

110 URNANSHE, a female singer of Mari. Mesilim Era. Gypsum. Height 26 cm. Damascus Museum. This statuette is also dedicated to Ishtar.

111 THE SCRIBE DUDU. Ur I Era. Dark gray stone. Height 39 cm. Iraq Museum, Baghdad. Obtained by trade.

112 SARGON. Akkadian era, 2350–2150 B.C. Bronze. Height from crown to tip of beard 36.6 cm. Iraq Museum, Baghdad. Between the eyebrows two furrows appear for the first time.

113 HAMMURABI (attrib.). Hammurabi Dynasty, 1830–1530 B.C. Found at Susa, looted from Babylon. Diorite. Height 15 cm. Louvre, Paris.

114 STATUE FROM THE GUDEA PERIOD. New Sumerian Period. Dolorite. Height 1.05 meters. Louvre, Paris. Since the sculptures of this time are very uniform, this statue without an inscription cannot be clearly identified.

115 ASHURNASIRPAL II (883–859 B.C.). New Assyrian Period. From Nimrud (Kalakh). Limestone. Height without pedestal 1.06 meters. British Museum, London.

116 GUDEA. New Sumerian Period. Diorite. Height 45 cm. Louvre, Paris. According to the inscription, the statue is praying for the life of Gudea.

117 WINGED COMPOSITE BEAST, from a doorway in the Northwest Palace of Ashurnasirpal II in Nimrud. Alabaster. Height 3.14 meters. British Museum, London. Works like this, composed of bull, lion, and bird of prey, were made partly as full sculpture, partly as relief, and were to be looked at from the side or the front. The oblique view shows five legs.

109 ▷

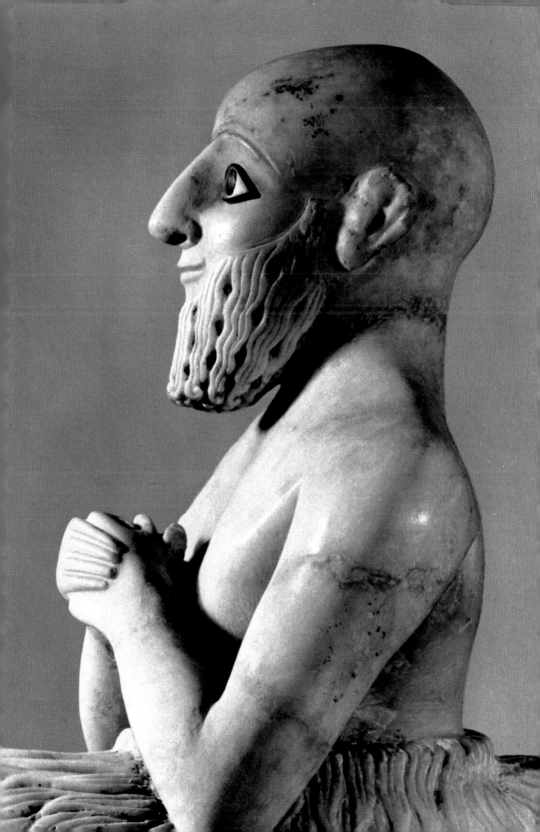

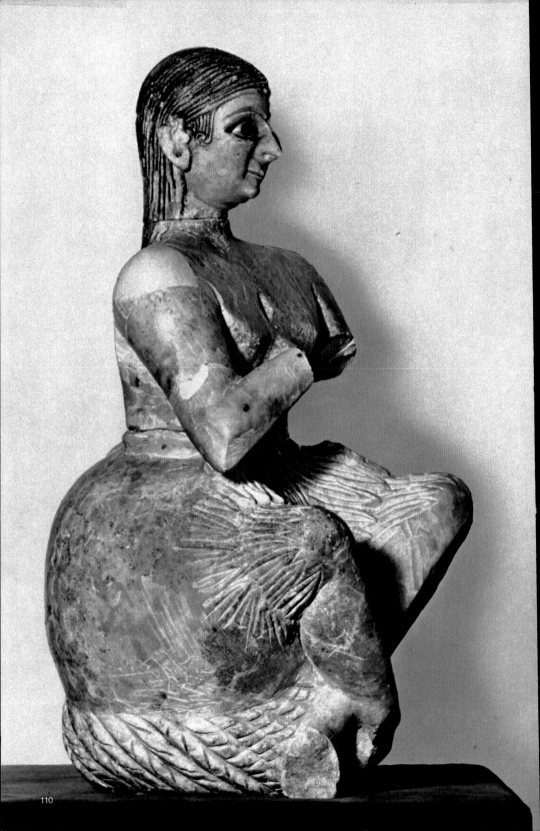

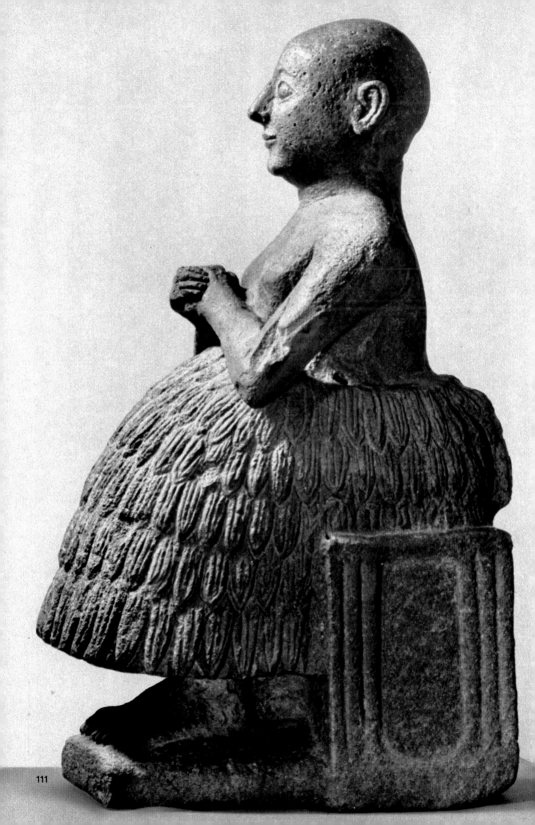

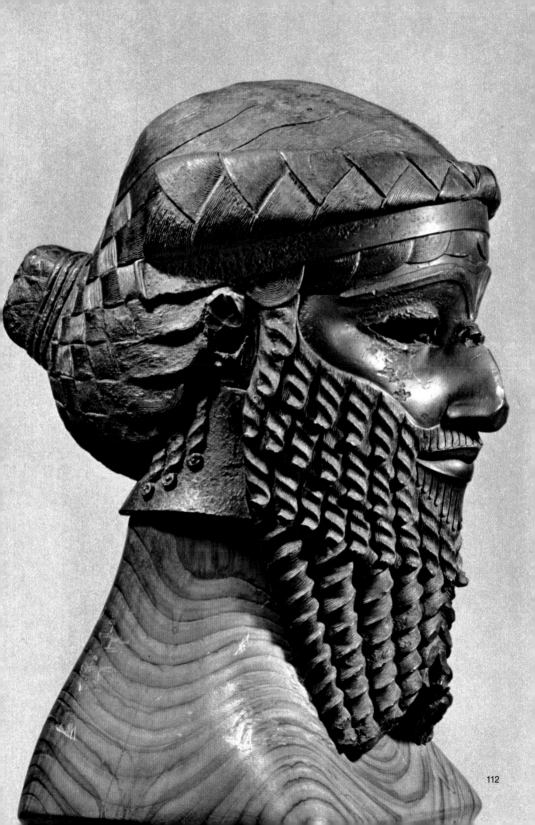

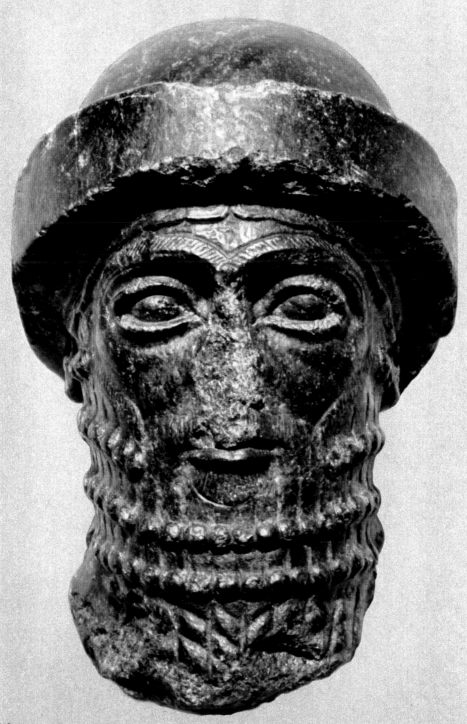

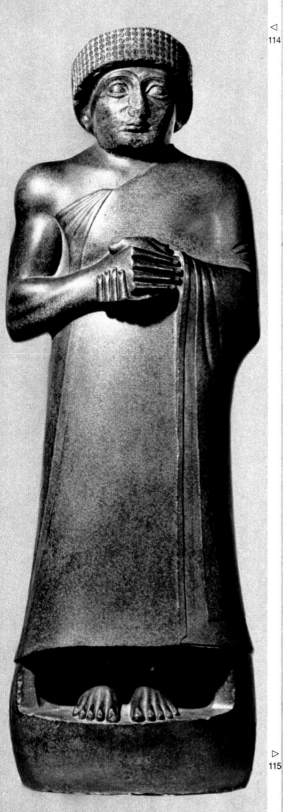

◁
114

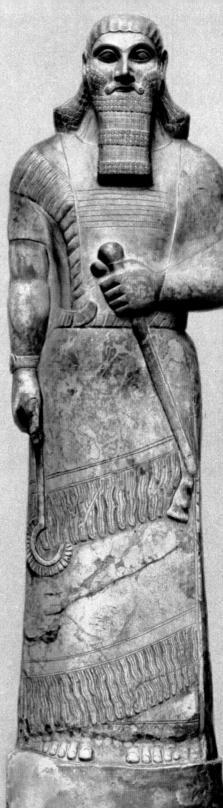

▷
115

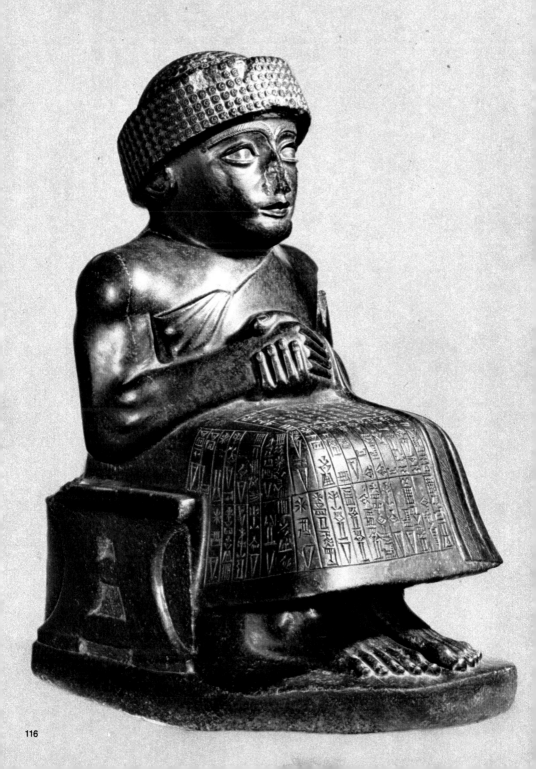

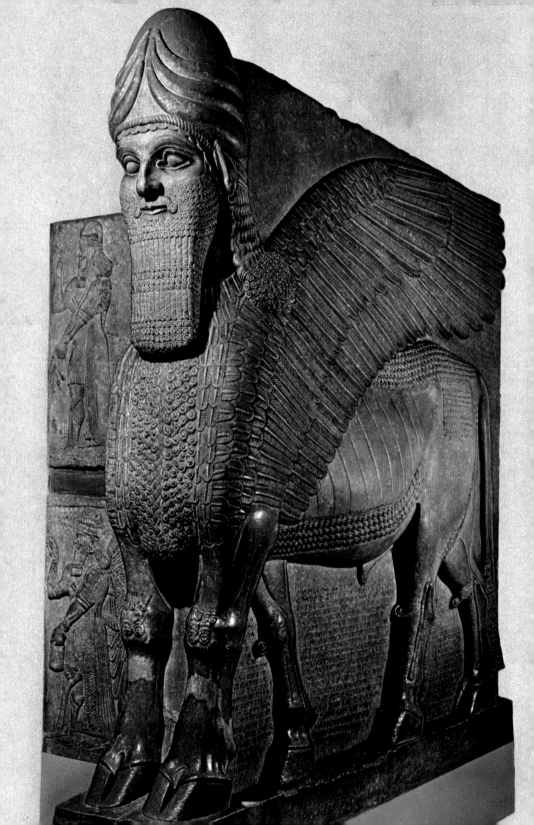

pillow with her legs crossed. Her hands, which have not survived, were originally clasped in front of her breast; she too is a votive figure. Her hair is spread out on her back in curled strands. Her full face is dominated by a powerful nose, and her large eyes are inlaid in the familiar fashion. She seems to be wearing shaggy bloomers, which may suggest that she is a dancer. Whether she performed her dancing, accompanied by her own singing, in the worship of a god or at court as well, remains unknown. At any rate, she donated her statuette, together with another less well preserved one depicting her as a harpist, to King Iblul-il of Mari. The freedom of construction in the limbs is astonishing, and scholars have deliberated whether contemporary metalwork had any influence on it. In fact, extremely free works in bronze are known, especially in the Diyala region. But it should be borne in mind that, in principle, the basic cylindrical form, unlike the cubic form, favors free sculptural composition.

A sitting statue in Baghdad (111), which from all appearances originated in Lagash, comes from the actual Sumerian sphere of influence. The statuette of dark gray stone was donated to the god Ningirsu for the life of the writer Dudu, and it points on stylistic grounds to the beginning of the Ur I Period, that is, a little later than the works from Mari just mentioned. Bald-headed Dudu sits on an angular stool with hands clasped in front of his naked upper body. He wears the usual voluminous shaggy skirt. His head is clean-shaven; the eyes and eyebrows are not inlaid but are carved from the stone. His mouth seems to smile with a bonhomie most apt in such a corpulent man. His thick neck conspires perhaps with the efforts of the sculptor to give greater solidity to this work. The prop between his heels and the seat has the same effect.

This tendency toward solidity and heavier cubism increases in the Ur I Period. As in Dudu, later works avoid separating the arms from the body. Sometimes the shaggy coat becomes a robe that leaves only a shoulder and an arm free and occasionally only the hands. Feet stand close together and are lightly modeled. The statuette of a praying woman (106), similarly an object of trade presumed to come from Lagash, may serve to illustrate how far heavy thickening and the retreat into the block could go. To achieve this aim, the robe is patently used as a convenient instrument of style. The feet stand in a niche and appear in faint relief on the base. The hair, held together by a headband, lies in a broad rectangle on the back.

There is still little archeological material from the great Akkadian kingdom. All the more magnificence is attached to one outstanding work that owes its form to the new concept of the god-king—an almost life-size bronze head (112) found in Nineveh in 1931. It is known to art history by the name of the founder of the dynasty, Sargon, but should probably be ascribed on account of its mature style to his grandson Naram-Sin. It is splendidly preserved except for the eyes, which were once inlaid and have since been gouged out. The plaited hair is gathered behind in a bun and held by a band in ancient Sumerian fashion. The beard, the pride of the Semite, is handled with special care. Three rows of ringlets develop into the twisted strands of the beard's tip. The work is not a portrait but the reflection of a supra-personal conception of the king, full of strength and official dignity. It ranks among the

◁ 117 foremost rulers' portraits in the history of world art.

The best idea of sculpture in the New Sumerian Period derives from the standing and sitting statues that the ensi Gudea donated with a plea for prolonged life to the temple in his city of Lagash. From there, the statues (*114, 116*) have ended up in museums either through French excavations since 1877 or through grave robbers. The thirty known today range between 42 and 140 cm. in height. (Further odd heads do not fit any headless statues.) Gudea wears a simple togalike robe and a broad-rimmed cap sewn with studs. His finely formed hands are folded in prayer, a picture of religious meditation. The featuring of a stocky, not to say corpulent man is hardly attributable to the dolorite or diorite used here but rather the result of a wish to follow the stylistic inclinations of the Ur I Period. All in all, these statues bear witness to an attempt doomed to failure, to revive the Sumerian culture that had long been dead.

The Hammurabi Dynasty provides no stylistic sequence, because there is a lack of firmly dated works. A unique diorite head has been ascribed to Hammurabi (*113*) for good reasons, but without real proof. As the portrait of an aged, weary ruler with sunken cheeks and heavy eyelids, so palpably human, it has no parallel. It is hardly a portrait in the narrow sense of the word, or no more so, at any rate, than the heads from the 12th Egyptian Dynasty of a hundred years earlier, which it calls to mind. The so-called Hammurabi is the last artistically important sculpture in Mesopotamian art.

Of the many Assyrian kings, only statues of Ashurnasirpal II (*115*) and his son Shalmaneser III have survived—stiff, lifeless, pillarlike portraits developed from the cylinder, dressed in the new fashion of winding robe with frayed hems, with a mace and a crook in their hands, all uniform types indistinguishable from each other. The impressive winged composite beings, which since the time of Ashurnasirpal II have guarded the entrances and exits in the palace grounds, embody the techniques both of sculpture in the round and of high relief (*117*) and will be discussed later in connection with the Assyrian friezes, together with which they produced a new genre of sculptural art.

RELIEF SCULPTURE AND PAINTING

Before turning to relief sculpture and painting, we must explain a little about stone-carving, or glyptic art—not only because it had begun in the late Bronze Age, an era from which we possess neither relief work nor painting, but also because its significance for our understanding of the development of Mesopotamian art can hardly be overestimated. Many dated seals survive from all periods. The changes in their pictorial form not only reflect those in full-size art, but the cylinder seals sometimes show these changes more clearly and decisively than the larger works themselves, in view of the poor state of preservation of the latter and the time-gaps between them. The cylinder seal, already established in the Early Period (Uruk VI–IV), was a stone cylinder with a picture carved on it, which, when rolled on the clay of a document or on the mud stopper of a container, left a continuous picture strip. Consequently, this wealth of pictorial material can be seen only in the rolled-off impressions—either the ancient ones, since few of the original seals remain, or the modern ones that have been made from surviving seals. This necessarily brief survey cannot do complete justice to the importance of the genre.

The seal pictures provide important evidence that in Sumerian art a symbol and its representation, abstract form and concrete richness of nature, remained in constant conflict. The urge to break away from schematic, symbolic form and to indulge oneself in the unique original in nature was stronger than in Egypt. Among the themes of the Early Period, besides sacrificial and hunting scenes that continued into later times, there appeared composite monsters in heraldic style, such as a lion-headed eagle and a snake-dragon, or even Dumuzi (Tammuz) as guardian of Inanna's holy herd (*139a*). Composite beings play a significant role throughout Mesopotamian art. They are convincingly terrifying and impressively savage—quite different in this way from Egyptian examples—and betray a tortured fantasy. They went on to influence the orientalizing style of 7th-century Greece and similarly the apocalyptic animals of the four evangelists and the lions and dragons of Romanesque art.

The transition to the Mesilim Period brought an abrupt turn to abstract form (*139b*). Artists of the time loved to portray drinking scenes and the hero who, as a symbol of the power of good, protected domestic animals from beasts of prey. In the Ur I Period the sculpturally rounded animals are again filled with fresh life. A radical change in style caused a peak in the Akkadian era. The outstanding works bring the myths of the gods into the picture and join them with decoratively carved script (*139c*). This poses the question whether there was not a larger relief tradition (one that has not survived) behind these glyptic works. In the New Sumerian Period characteristic introductory scenes appear, in which an interceding deity leads a praying man up to the throne of the principal god (*139d*). The Hammurabi era could not maintain the high standard of the Akkadian, perhaps because the whole genre gradually abandoned itself to mass production. The glyptic art of the Middle Assyrian Kingdom attained a final flowering. After the kingdom had freed itself from Hurrian-Mitannian oppression in the 15th century B.C., the 14th century saw the creation of a separate Assyrian style. Starting with a strong symmetrical composition, it found its way to a free structure making excellent use of the given scope.

The oldest picture that can be regarded as "historical" is a lion hunt stele of the Jamdat Nasr Period at Uruk—a basalt block still 78 cm. high today (*118*). The form of the stele has not yet been developed; side and back faces have been left rough and only the front has been evened out crudely to take the figures, which are dotted indeterminately about the surface. It consists of two scenes reproduced without spatial relation to each other and without a base line. In both cases the warrior is marked by his beard and general appearance as a prince, and he is presumably one of the ensis of Uruk who commissioned the lion hunt subject matter and had the stele erected as an offering in the temple of Eanna. His name was not added, however. In the upper picture he is thrusting a spear into the jaws of a rearing lion; in the lower picture he is aiming a bow and arrow at two beasts already wounded but still on the attack, while a third, with only a few fragments surviving, charges at him from behind. The sculptor has carefully avoided overlapping.

Reliefs on an alabaster vase from Uruk, dating from the same time (*119, 120*), are particularly communicative. The three surrounding friezes, divided by raised bands, achieve a sensitive balance of both space and content. From the water, the basic requirement for all life in Mesopotamia, which is signified by a line of waves, there arise young palm trees and ears of barley. Above stand rams, ewes, and lambs representing the herds. A man appears in the middle bearing offerings in a procession. On top is the main scene: two bundles of reeds, symbols of the goddess Inanna, decorate the entrance to her temple or treasury. Inside are containers full of gifts and a split-level podium with reed bundles, on which two sacrificers are standing, flanked by two sheep. Then comes the main figure, Inanna herself, with some sort of crown, and a sacrificer standing before her. Unfortunately, little has survived of the companion who is walking up to her, but there can hardly be any doubt about the interpretation of the whole. It deals with the cult procession at the time of the new year and the wedding feast, when Inanna receives her bridegroom Dumuzi. It matters little whether we interpret the two main figures as Inanna and Dumuzi themselves, participating in a mythical event, or whether they are regarded as the high priestess and the prince acting

118 LION HUNT STELE, from Uruk. Jamdat Nasr Period. Basalt. Height 78 cm. (originally c. 1 meter). Iraq Museum, Baghdad.

119, 120 CULT VASE. Found at the temple to Eanna at Uruk. Jamdat Nasr Period. Alabaster. Height without largely restored base 92 cm., upper diameter 36 cm. Iraq Museum, Baghdad.

121 STEATITE DISH, from Ur. Jamdat Nasr Period. Height 5.5 cm., upper diameter 13.6 cm. Iraq Museum, Baghdad. Above each bull is an ear of corn symbolizing the fertility of the land.

122 STEATITE BOWL WITH MYTHOLOGICAL RELIEF. Presumed Ur I Period. Height 11.4 cm., diameter 17.7 cm. British Museum, London. A man in a net robe overpowers two hissing snakes.

123 VOTIVE TABLET OF UR-NANSHE OF LAGASH. Ur I Period. Limestone. Height 40 cm., width 47 cm. Louvre, Paris. Offertory tablets of this type appear from the Mesilim Period up to the New Sumerian.

118 ▷

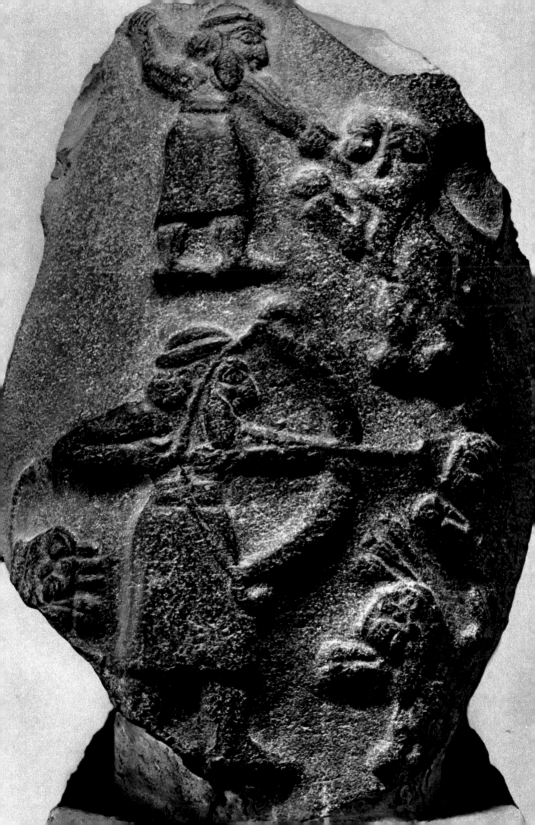

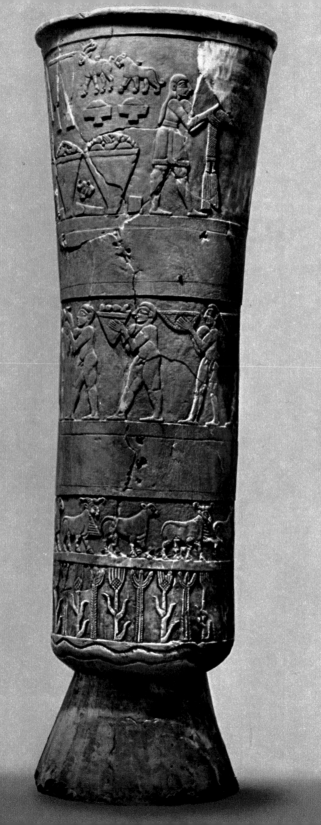

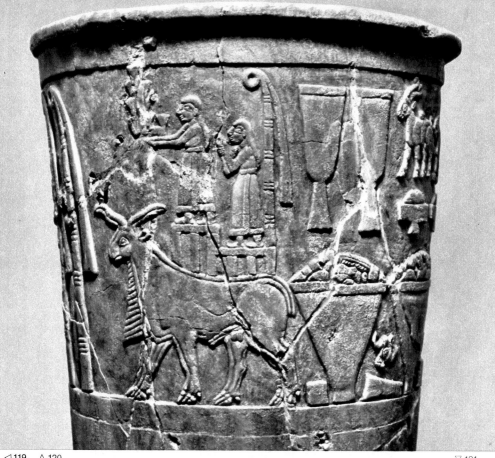

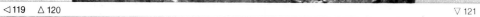

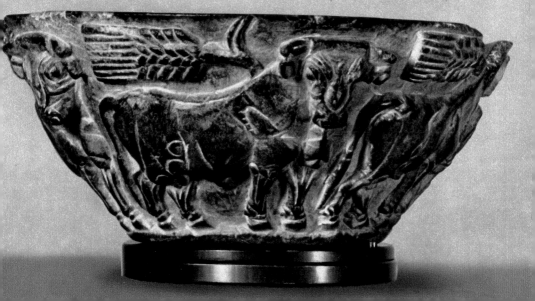

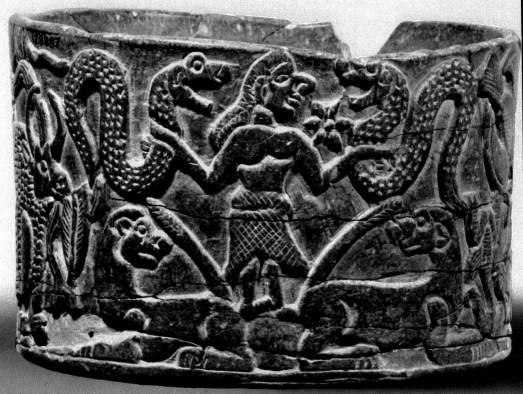

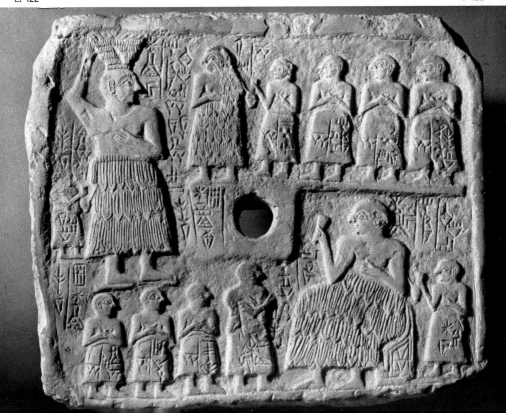

the gods' roles. It certainly made no difference to the Sumerians of the time. And so the Sumerian world is built up in a simple sequence: water, plants, and animals beneath, man in the middle, the divine world of the gods (or rather of high priestess and ensi) above. Thus, the Sumerian artist has matured toward the task of representing his religious ideas artistically and he has shown himself equal to it.

An idea of their symbolism will help one to understand the numerous stone vessels on which sculptural ornament developed into high relief, and in certain cases—as in the steatite dish from Ur (121)—even to complete release, as in free sculpture, from the background of the vessel. The architecture of the vessel is destroyed and these works have a strange effect, but one must remember that the subjects represented—a fight between lion and bull, or lion and eagle, also the heroic guardian of the herds—are related to the cult served by the vessels. The execution is sometimes quite clumsy.

Yet another group is formed by the steatite bowls whose sides are densely crowded with shallow reliefs (122). They portray a charmingly chaotic world of composite monsters —snakes, lions, panthers, camels, and birds of prey—engaged in battle with each other, and owing their creation to an unbridled fantasy oppressive to the modern observer. Naturally there are mythological ideas in the background, as seen before, but their meaning is still a mystery. Firm dating is not possible, but the second half of the 3d millennium B.C. could figure as the earliest time of origin.

A feature common to a number of offering tablets is a central hole whose significance is uncertain. Were they fastened to a beam sticking out of the wall, or did they lie horizontally on the floor with an emblem standing in the middle? They have various themes, sometimes worship before an enthroned god, sometimes a banquet, sometimes the building of a temple. One tablet (123) bears the name of Ur-Nanshe, ensi of Lagash, as its donor; this makes it datable in the Ur I Period (c. 25th century B.C.). On the left, in large scale, the donor appears as the main figure carrying a basket of earth to build the temple. Before him, on a higher level, stand his sons and perhaps a daughter in front of them, who was intended for the office of high priestess in the temple. On the lower strip he is enthroned with a cup in his hand, behind him a servant, as in the picture on the left, and again four sons before him, all with their names inscribed. The scene obviously represents a ceremony attached to the laying of the foundation stone. How gauche and clumsy it all is! It is clearly a scene from real life, but how patently the desire overreaches the performance! One might have imagined this as the earliest attempt at a descriptive scene, were it not that far better ones had been created centuries before. These tablets did not derive from them, but are in fact a fresh beginning.

Ur-Nanshe's successor but one, Eannatum, was responsible for the so-called vulture stele, the first "historical picture" in the true sense of that word (124, 125). The work, which survives only in fragments, immortalizes the victory of the ensi of Lagash over the neighboring city of Umma. On one side, four picture strips describe the actual event: the prince, at the head of a phalanx of his warriors armed with shields and spears, striding over the fallen on which vultures are feasting (125); below, the same Eannatum in his chariot throwing his spear and leading on the infantry. In the third strip, fragments describe the burial of

the dead in the presence of the prince and the priest with the slaughter of sheep and cattle. The empty spaces are filled with the script of a historical text. On the reverse side there is a reminder that victory is a gift of the gods. The massive god Ningirsu dominates the scene. In his left hand he holds a net in which the enemy are imprisoned, while with his right he clubs them to death. In contrast to Egypt, the description of real events comes before decorative effect, the spectacle as a whole before dismembering intellectual analysis. Gloomy seriousness and dull taciturnity pervade the whole. The stele has great significance in the history of culture.

Skilled inlay work was a particular favorite of the Sumerians, as can be seen on their caskets, board games, and the sound boxes of lyres. The most outstanding example is the "Standard of Ur" (126) from one of the royal tombs of the 1st Dynasty. Its significance is unknown. Two boards about 48 cm. long are inclined toward each other in such a way that the intersecting short ends take on a trapezoidal form, and the whole thing looks like a lectern. Both sides show a mosaic of mussel-shell, reddish stone, and lapis lazuli fixed, with the help of bitumen, in three strips contained in an ornamental pattern. On the "war side" are attacking chariots, marching soldiers, and naked enemies fleeing before the king; depicted on the "peace side" are the massing of plunder and the king celebrating a feast with his followers; the principle of composition is virtually arrangement in rows.

Examples showing that a similar technique was used in architecture include the frieze of milkers from Al'Ubaid (127) in which figures of mussel and limestone have been fixed onto slate tablets, which are fastened (in their turn) with bitumen onto wooden boards. Presumably the frieze served as ornamentation on the façade of a temple to a mother deity.

124, 125 VULTURE STELE OF EANNATUM OF LAGASH. Ur I Period. Limestone. Height of the large fragment 1.8 meters. Louvre, Paris.

126 INLAID PANEL, from Ur. Ur I Period. Detail of the "battle side." Wood with inlay work of mussel-shell, reddish limestone, and lapis lazuli. Height 20.3 cm., width 48.3 cm. British Museum, London. Although the actual significance of this piece is not known, one can infer that the pictures are related to a definite historical event.

127 FRIEZE OF MILKERS, from Al 'Ubaid. Ur I Period. Animals of limestone fixed to a wooden background with bitumen, within a framework of sheet copper. Height of the frieze 1.15 meters. Iraq Museum, Baghdad. In the middle, two cows are leaving a pen; on the right, milking is being done; on the left, the milk is being strained.

128 VICTORY STELE OF NARAM-SIN. Akkadian Period. Reddish sandstone. Height 2 meters. Louvre, Paris. The stele was carried off from Sippar to Susa by the Elamites. The hostile Lullubi are distinguished from the Akkadians by their pointed beards and pigtails.

129 STELE OF GUDEA. New Sumerian Period. Limestone. Height 70 cm. Staatliche Museen, Berlin. A counterpart to this stele was erected by Ur-Nammu in Ur and numerous fragments of it were pieced together in Philadelphia. As well as many other details the division of the surface into strips is common to both stelae. The decisive advance shown in the Naram-Sin stele (128), a composition taking up the whole surface of the picture, was not followed by the New Sumerians.

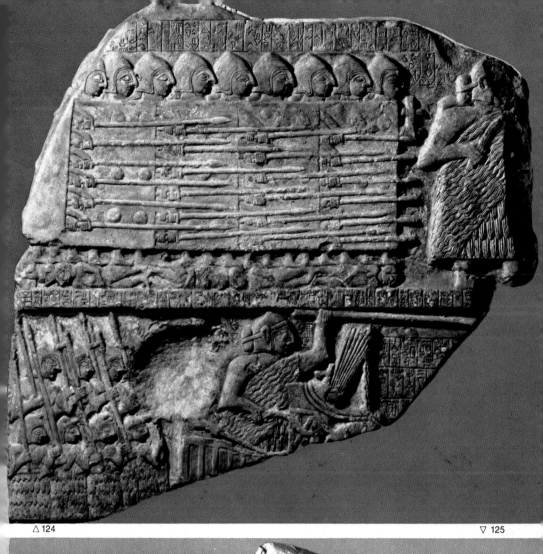

△ 124

▽ 125

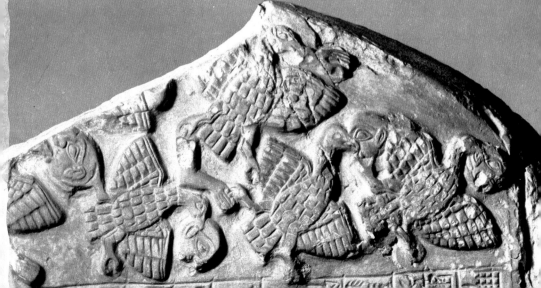

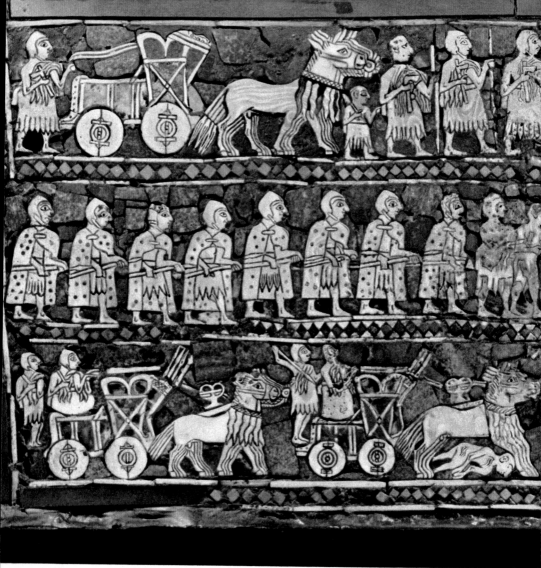

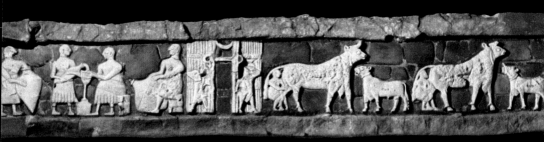

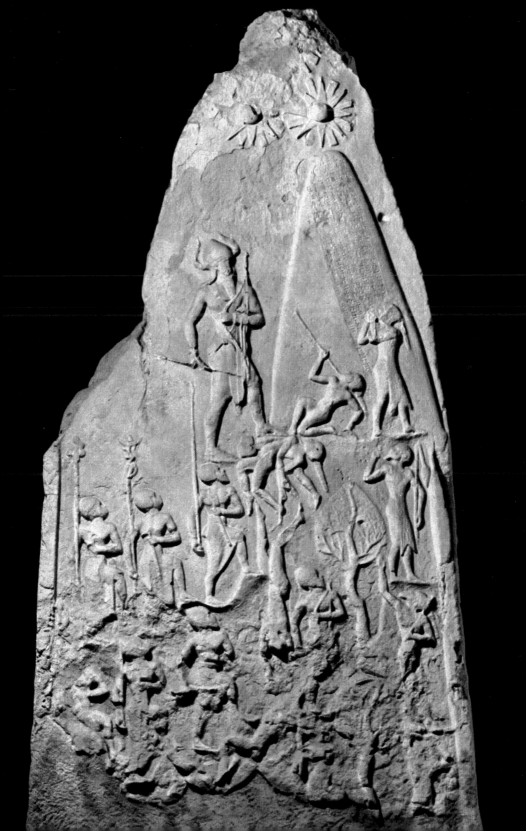

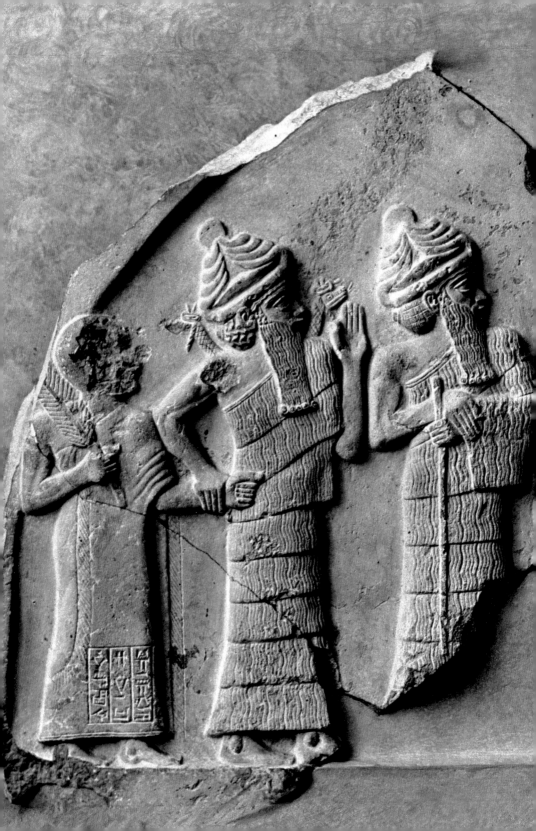

A victory stele of Naram-Sin (*128*) proves more clearly than any other work of Mesopotamian art what feats of artistic genius the Akkadians could perform as inheritors of Sumerian culture. The monument originally stood in Sippar until the 12th century B.C., when it was carried away by Elamites to Susa, where it was discovered in the late 19th century by French archeologists. The inscription, telling that the stele commemorates a victory of Naram-Sin over a mountain people, the Lullubi, was almost completely eradicated by the Elamites and replaced by an Elamite inscription on the cone-shaped pinnacle. The Akkadian army climbs to the top of a pass where a pointed pinnacle towers. Two realistic trees represent a wood. The king stands in a splendid pose up in the free mountain air, with the sun, moon, and Venus shining on him as the symbols of three friendly deities. His great staff, his horned crown, and his weaponry characterize him as a god-king. His foot rests on two wounded men, a third man is falling from the mountain path into a ravine, and a fourth—wounded by the king—has fallen over backward. The rest of the enemy are either fleeing or begging for mercy while the Akkadians march forward resolutely, looking up toward their king. Only by looking at each figure separately can one completely appreciate its convincing sureness of form, springy ease on one side, powerlessness on the other. The expression of the Akkadian spirit can be recognized as much in the beauty, strength, and vitality as in the unique composition of the whole. In contrast to everything encountered in Egypt, in this case a momentary event is contained in a single act of observation. The description is not as analytic as in the vulture stele of Eannatum (*124, 125*) but rather synthetic. The framework of landscape (appearing there for the first time) has the effect of emphasizing the here-and-now character of the scene, but without the transcendental import of the victory being diminished.

Relief sculpture in the New Sumerian Period did not make use of the achievements of the Akkadians. Among the few surviving remains, the fragments of two stelae of Gudea in Berlin stand out for their quality. In the "introductory scene" (*129*) the bald-headed Gudea is led up to the principal god on his throne by a divine herald and the god Ningizzida —known by the dragons' heads growing out of his shoulders—who holds the king, apparently hesitating with fear, by the wrist. Of the principal god only a stream of water remains, pouring from a vessel that he is holding. The gods are wearing tiaras with bulls' horns, which, following ancient practice, are placed in profile, avoiding full-face representation, while the heads face sideways. Another important advance is visible: The eyes of both gods are not added full breadth to the face (as they always were before), but are rather foreshortened to suggest a view from the side.

Since the oldest wall paintings on a larger scale came from the New Sumerian age—mostly from the frequently mentioned palace of Mari—a few more remarks must be added. Painting on a mud or plaster surface is in itself much older; for there are traces of it even in the Early Period, for example in Uruk and Eridu, and there are a few remains of a picture sequence in the temple at Tell 'Uqair that seem to have been influenced by the techniques used in cone mosaics. Yet in Mari considerable pieces of wall painting have been saved, particularly from the audience hall and the courtyard in front of it, which had escaped the
◁ 129 ravages of Hammurabi and defied the assaults of the weather. Anton Moortgat has managed

130 OFFERING SCENES. Wall painting in the audience chamber of the palace at Mari. New Sumerian Period. From a copy. Height c. 3 meters. Its attribution to the Gudea and Ur-Nammu Period is supported by many details. The interpretation of the pictures in all its particulars is still difficult to determine.

131 PROCESSION FOR A BULL SACRIFICE. Wall painting in Courtyard 106 in the palace at Mari. Detail. Reign of Jasmakh-Adad, son of Shamshi-Adad I of Assyria, who was expelled from Mari by Zimrilim, c. 1716 B.C. Height 2 meters. Louvre, Paris. The man in this detail is probably the master of ceremonies who follows directly behind the king.

132 BLUE BIRD. Detail from the "Investiture of Zimrilim" on the south wall of Courtyard 106 in the palace at Mari. Time of Zimrilim of Mari (probably shortly before 1695 B.C.). Louvre, Paris. Like the Scenes of Sacrifice (130), this picture was added directly onto the layer of mudplaster.

133 LION HUNT. Detail from a wall painting in the palace of Til Barsip. New Assyrian Kingdom, time of Ashurbanipal, 7th century B.C. After a copy by Cavro. Height c. 80 cm. The discovery of the wall paintings at Til Barsip (1930–31), with 130 meters of painted wall, broke new ground in the research of Assyrian wall painting.

134 FRONT EXTERIOR OF NEBUCHADNEZZAR II'S ROYAL CHAMBER, Babylon. 6th century B.C. Brick with colored glass. Width of the chamber 60 meters, height 12 meters. Staatliche Museen, Berlin. Facing walls with glazed bricks was not a New Babylonian inventions. Kassites had used decorative tile in 1400 B.C. (100). Assyrians of the Middle Assyrian Kingdom began to glaze in color. From an artistic point of view there is a spiritual link with the Sumerian cone mosaic insofar as both cover the building without any reference to the structural framework.

135 ARCHERS OF THE ROYAL BODYGUARD, from the Palace of Darius I, Susa. c. 500 B.C. Bricks with colored glaze. Height of the surfaces 1.37 meters. Louvre, Paris. This brickmaking technique was taken from the New Babylonians.

136 BULL, from the Ishtar Gate of Nebuchadnezzar II, Babylon. 6th century B.C. Glaze brick. c. 1 meter. Staatliche Museen, Berlin. The bulls, alternating on the gate with snake-dragons, have an apotropaic character (Greek *apotropaion* = sign that wards off evil). The powerful bulls are symbols of life; the snake-dragons, assigned to the gods of the underworld, are symbols of death. Both are age-old features of Sumerian culture.

137 GRIFFIN, from the Palace of Darius I, Susa. c. 500 B.C. Brick with colored glaze. Height of the surface 1.37 meters. Louvre, Paris.

138 STRIDING LION, from the Palace of Darius I, Susa. c. 500 B.C. Brick with colored glaze. Length 2.52 meters. Louvre, Paris.

130

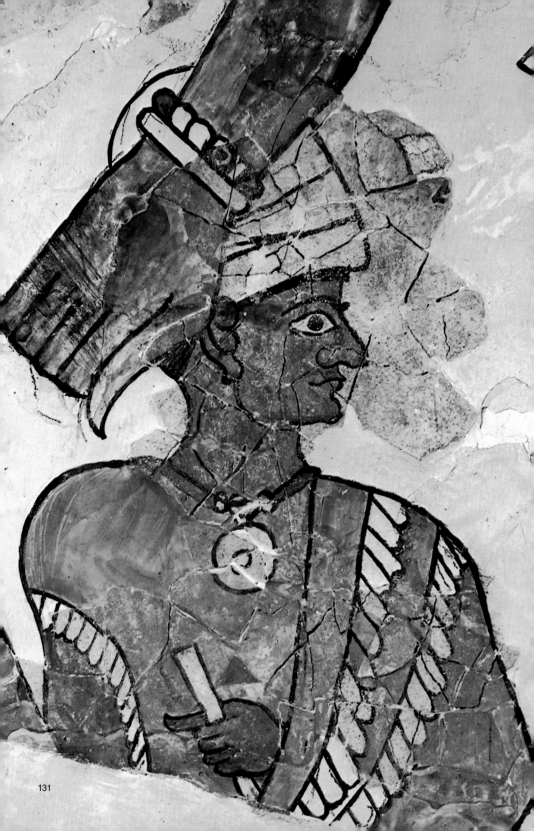

131

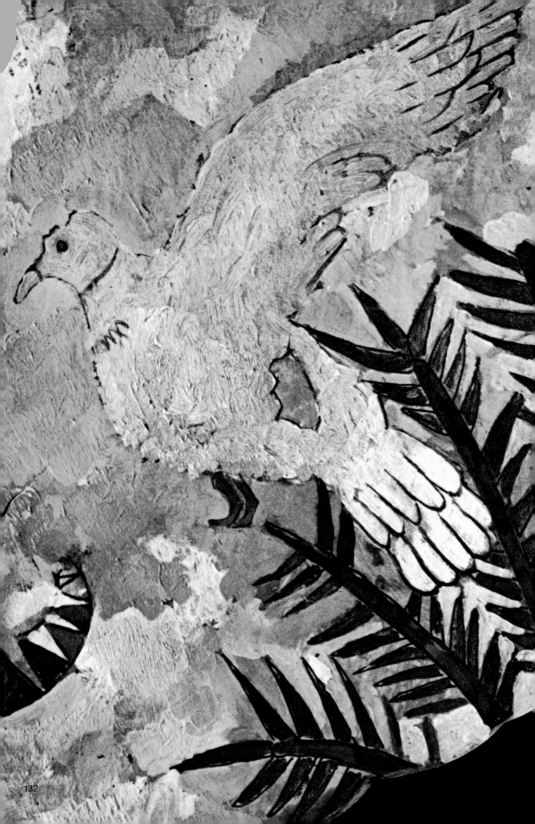

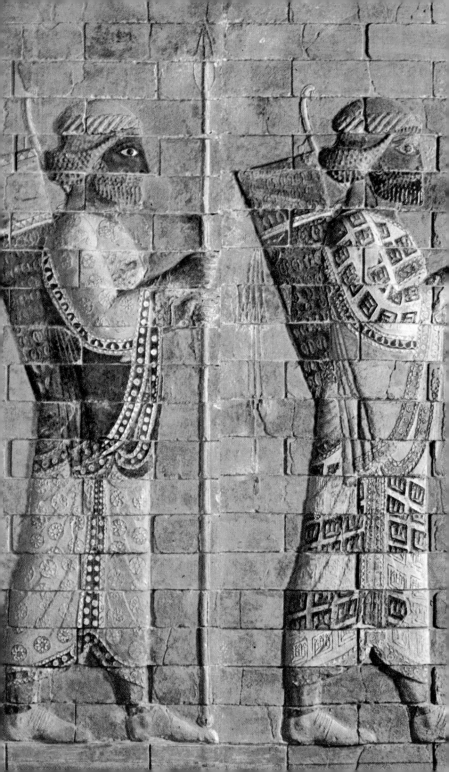

to prove that not all of the paintings are as late as the last stage of building in the palace under King Zimrilim but that some date back to New Sumerian times. Among them is the wall painting in the audience hall, which was painted directly onto the mud facing of the wall; thanks to the care of the excavators its small fragments can now be pieced together with some certainty (*130*). It consists of five picture strips. In one the king with a long beard and wearing a flounced garment offers drink from a cup to an enthroned deity with a holy crown and crescent; in the strip above it the goddess Ishtar sits on a throne while another goddess approaches her with a dish. The scene is framed by winged composite beasts. The range of colors includes black, white, reddish brown, even yellow (blue and green are missing).

From shortly before Hammurabi's sacking of Mari comes a large wall painting that runs 2 meters high around the courtyard (*131*). It is painted in black, white, red, even blue watercolor on a thick plaster facing and depicts the procession to a bull sacrifice. The king leads the way in his office as priest. In this extract only his arm can be seen, and it masks the head of a dignitary.

Dating from the time of King Zimrilim, who was deposed by Hammurabi c. 1695 B.C., is a large wall painting in the same courtyard, which is known as the "Investiture of Zimrilim." A framed middle section has an upper strip showing Ishtar in the presence of several gods entrusting the king with ring and staff. In the lower strip two goddesses pour libations of water from their vessels, a picture that reminded the archeologist André Parrot of the four rivers of paradise, prompting him to connect the composite creatures standing on either side near two stylized trees with the cherubim in the Garden of Eden. If these pictures preserve an austere style, that with the palm trees and two date-pickers climbing up is far less restrained. In its green bower a marvelous blue bird (*132*) is swaying, about to spread its wings and take to the air. The "Investiture of Zimrilim," which includes this extract, ranks as the most important relic of ancient Mesopotamian painting. It is not possible here to go into the manifold problems arising from the Mari wall paintings, but it must be said that there is a hint in the "Investitute of Zimrilim" of an attempt to imitate woven tapestry. This question needs clarification, as does the other involving Aegean influence, which obtrudes above all in the frequent appearance of a spiral band, the so-called running dog.

The "code of law" stele (*140*), like the Naram-Sin stele, was carried off by the Elamites to Susa, where it was dug up in the winter of 1900–1. A rather carelessly handled block of basalt contains the 282 paragraphs of Hammurabi's reformed code of law. It is topped by a relief showing the king greeting the enthroned Shamash, the lord of justice. Does the artistic quality of the stele match the extraordinary significance that was unquestionably attached to it? Scholars have said no—pointing to the traditional formula of the theme, according to all evidence unchanged since Ur-Nammu—but in so doing they have completely ignored the fact that it gives expression to an entirely new style worthy of the great ruler. The relief is highly prominent, relying on the effect of light and shade. This plasticity is apparent, for example in the modeling of the upper arm, but above all in the folds on 138 the figure of the king, whose robe seems to take on a life of its own. The modeling of

139 a) b)

139 IMPRESSIONS FROM MESOPOTAMIAN CYLIN-
DER SEALS. a) Jamdat Nasr Period, 3000 –
2700 B.C. Tammuz the royal herdsman
feeds the holy sheep of Inanna, who is
signified by her reed bundle. The group
is constructed in mirror-image fashion and
thus directed toward symbolism.
b) Transition to the Mesilim Period, 2600 –
2350 B.C. The piece shows a marked break
from the preceding first stage of the civili-
zation. Animals and plants are denatural-
ized and turned into an ornamental surface
pattern.
c) Akkadian Era, 2350–2150 B.C. In the rap-
resentation of Etana's ascension into
heaven the mythological world of the gods
appears. An eagle bears Etana up to
heaven to find a miraculous herb there.
d) New Sumerian Era, 2100–1950 B.C.
A praying man is ushered by a mediator up
to the deified king. Several lines of inscrip-
tion.

the horned crown of Shamash has the same quality, here for the first time not placed in
contradiction to the profile of the head but at the angle at which it would be seen. Finally
the eyes of both are reproduced in profile, as in the Gudea stele, so that god and king really
look each other in the eye. For the first time there is a fluidity, a dynamic relationship be-
tween the pair. One is struck by the memory of those words in Exodus (33:11): "And the
Lord spake unto Moses face to face, as a man speaketh unto his friend." This relief group
is one of the most important works of ancient Babylonian art.

The Assyrians, established since time immemorial beside the upper Tigris under the in-
fluence of Sumero-Akkadian culture, began to exercise their own stylistic inclinations with
the formation of the Middle Assyrian Kingdom. One of the few early pieces of evidence is a
symbolic pedestal that King Tukulti-Ninurta I set up in his capital Ashur (Qal'at Serqat)
toward the end of the 13th century B.C. as an offering with an inscription to the god of light
Nusku (143). He is represented twice in two separate phases of prayer before a fetish set up
on a similar pedestal. The Assyrian style is apparent in the well-balanced composition and
the sure line of the shallow relief. It is also a mark of Assyrian authorship that the god,
unlike a Sumerian or Babylonian one, does not appear in person, but is present only in
symbolic form.

The New Assyrian Kingdom laid down the conditions for creating a common national
art with the task of decorating the royal palaces with powerful relief cycles and giving an
impressive account of the fame and glory of the kingdom in scenes of battles and hunting.
A style grew up that not only exerted strong influence on the people of western Asia, the

c)

d)

Syrians and the Phoenicians, the Urartians and Iranians, but also made an important contribution to art history that can be only briefly summarized here.

First, Ashurnasirpal II in the early 9th century decorated the royal chamber and the main courtyard of his palace in Kalakh with relief friezes (*141, 142*), and the entrances and exits with magic composite creatures (*117*), both obviously inspired by the Aramaeans of northern Syria and northern Mesopotamia, who in their turn had observed the use of gateway sculpture and orthostatic reliefs among the Hittites and Hurrians. The great achievement of the Assyrians lies in the creation of a new style of composition. Only in works concerning the mythical character of the king was the ancient, unchanging, traditional, heraldic style still used. Wherever the deeds of the ruler, or hunting or battle scenes were to be described, an epic style was developed whereby the wall surfaces were divided into two strips and the events progressed according to their sequence in time. In spite of Egyptian anticipations, the invention of this "continuous" method of presentation may be ranked as an Assyrian achievement. It was taken up later in the frieze of Telephos at Pergamon and above all in the Roman column of Trajan. In order to get a clear idea of the Kalakh style one must look at the collection of relief murals in the British Museum. The extracts included here are only a poor substitute for them.

The development continues through the reliefs on the bronze gate at Imgur-Ellil (Balawat), commissioned by Ashurnasirpal's successor Shalmaneser III, and the very plastically conceived pictures of Sargon II in his splendid royal castle Dur Sharrukin (Khorsabad), reaching its apogee in the palaces of Sennacherib and Ashurbanipal in Nineveh. More and more the pictures concerning the mythical nature of the kingdom gave way to those glorifying its historical achievements. This encouraged the tendency toward naturalism, which expressed itself in a more individual conception of single figures but also in the struggle to master spatial depth. A typical example is the representation of the battles of Sennacherib's army in the marshes (*145*), from the Southwest Palace at Nineveh. If in this case the scene is fixed in space by a broad framework of landscape, it is completely absent in the lion hunt of Ashurbanipal (*144*), the last great work of Mesopotamian art.

153

Every one of the lions, charging, hit in mid-air by arrows, tumbling head over heels, dying, is a masterpiece of the most careful observation. But there is another spirit speaking, a stranger to the pictures of cruel, heartless exploits of war: it is a sense of the dignity and pride of the king of beasts, a sympathy for the hunted animal.

In the Assyrian provincial residence of Til Barsip (Tell Ahmar) on the upper Euphrates, considerable fragments of wall paintings were found in 1930–31 that could not themselves be preserved but that were carefully copied. The palace in which they were discovered has a long architectural history. Consequently, the paintings are divided into two groups separated by roughly a century and hence differ strongly in style. The example included here—a detail from a lion hunt (133)—belongs to the later of the two and dates from the time of Ashurbanipal. The colors are black, white, red, and blue, but predominantly the last two (this is also true of the earlier group). The composition is of great beauty, and the drawing has such a sureness and expressive quality, that one is forced to believe it was in painting that the artistic system of the Assyrians found its purest and most direct expression.

The New Babylonian Chaldeans diverged consciously from Assyrian art and began their own traditions in Babylon, decorating their walls with reliefs made from bricks glazed in different colors (134, 136). With the end of their rule and the coming of the Persians, Mesopotamian art lost its spiritual background and was near to its conclusion. Yet its forms lived on to a certain extent in Iran. Accordingly, a quick look at the art of the Achaemenid court is necessary. Features there combine Babylonian and Assyrian elements with Egyptian and Greek elements, to say nothing of Proto-Iranian, Urartian, Scythian, and other influences.

In Susa, where Darius I founded a new capital on ancient Elamite soil, an inscription was discovered in which he reports where his building materials come from, together with the workmen needed to fashion them. Among many others, the Babylonians feature as producers of glazed bricks. In fact, considerable remains of these bricks have been found in the palace rebuilt by Artaxerxes II following closely the design of Darius's palace after it had been destroyed by fire. Among them are the archers of the king's bodyguard, the so-called Immortals (135). They are wearing yellow shoes and white ankle-length robes decorated with quadrangles and stars. Luminous tones of green, blue, and yellow and variations of detail save the motif from monotony. Griffins (137), striding lions (138), winged bulls, and other fabulous beasts rely heavily on New Babylonian models.

After the completion of Susa, Darius I founded Persepolis as a new residence in his native Fars (Persia). It was a gesture made to consolidate the feeling of unity in the kingdom, at the same time providing a setting for the annual new year's feast at which all the peoples of the great empire would gather. Representatives of the Medes and Persians as the ruling peoples of the empire entered through the great gate of Xerxes (guarded by massive bulls) in order to officiate from above at the parade of the people. The relief decoration beside the steps and in the halls is of great richness. Here the "royal hero" thrusts his sword into the body of a rearing lion or a composite creature. On the walls appears the symbol of Ahura Mazda, the highest deity according to the doctrine of Zoroaster, a copy of the symbol the Assyrians devised for their national god Ashur. Persian and Median nobles (146) stride

The Late Minoan Period (1570–1150 B.C.). After the 17th century B.C. Minoan culture lay under the spell of mighty Knossos. Any work of art dating from this time is marked by extreme sophistication and fantasy. Naturally, one would like to know what historical background accompanies this artistic brilliance, but one is hampered by the lack of written sources. Greek mythology regarded Minos as the powerful king of Knossos; and inasmuch as Knossos may have exercised peaceful rule over all the islands, there may be a grain of historical truth in this. The palaces were destroyed by some natural disasters, and they were quickly built up again. Since they contain no form of fortification, they suggest the presence of a powerful fleet equal in strength to any attacker from the sea. But it is more than questionable whether this can be seen as evidence of an omnipotent Cretan sea power or of a "Minoan empire."

After about 1450 B.C. the Achaeans were the new rulers of Crete. No traces have been found to help scholars decide what means were used in this reversal of power. The Achaeans adapted a script now known as Linear A—a script that they found there originally reproducing a non-Indo-European language—to the pre-Homeric Greek they themselves spoke; Michael Ventris successfully decoded this later script, Linear B, in 1953. The Linear B script was limited in Crete to Knossos, but later it appeared on the Greek mainland as well, in Nestor's Pylos in particular, here beginning with the late 13th century B.C. The circumstances surrounding the destruction of the palace at Knossos around 1430 B.C. remain a mystery. This time it does not seem to have been caused by an earthquake. Perhaps the Minoans rebelled against their Achaean lords.

ARCHITECTURE

Nothing emphasizes the deep rift between Minoan thought and custom and that of Egypt and Mesopotamia quite as much as the complete lack of Minoan temple building. The religion of Crete developed from the Neolithic Age was a nature worship. It was completely under the influence of the Great Mother Goddess, with whom the cult of the bull was connected. Neither she nor any of the other male and female gods who accompanied her required their existence to be bound up with a cult statue. They manifested themselves in natural events and could "appear" in any place where they had been invoked by worship and prayer; it made no difference whether one invoked the deity in a natural grotto or reserved special cult rooms for him in the palace. But there was no incentive to monumentalize such crypts.

The palace of Knossos (*148, 149*) is a good basis for general observations about the architecture of the era. The later Greeks called it the labyrinth, a word that refers to the old Aegean *labrys*, a double-axe symbol related to the bull sacrifice. It became the sign for a complicated system of rooms and gangways boxed together. That is how the ruins of Knossos appeared to the Greeks, and Theseus needed Ariadne's thread to find his way through the labyrinth. They could see no definite core to the building and no pattern of rooms arising organically and built up according to firm rules, but rather a confusing abundance of halls and courtyards, pillared rooms and chambers, steps and skylights, store rooms and corridors, all furnished with a refined extravagance, but without any logical architectural method behind it, such as that which by comparison governed the artistic creations of the Greeks from the start. The architecture of the Minoans offers the strongest contrast to the Greek conception of building; but only a view of art that derives its norms solely from classical antiquity could fail to recognize the greatness of the Cretan palaces.

The palace of Knossos covers a surface area of about 150 × 100 meters (*149*). A visitor approaching the west front, which is the main side, from the northwest (or any other direction) would have seen no actual façade conceived as a whole. Instead he would have found himself face to face with an edifice built up unsymmetrically of projecting and retreating parts. It is already clear that this has nothing to do with the static Egyptian form aiming at the expression of timeless being; on the contrary, it is an architecture of movement, intended to work not through ponderous magnitude but by virtue of buoyant exhilaration. Adjoining the great courtyard (50 × 28 meters) on the eastern side are the royal chambers. The stairway, which climbs four stories in an open courtyard, is of particular richness. On the ground floor and on the balustrades of the steps there are wooden columns tapering toward the bottom and resting on stone plinths. On every storey a great hall of double axes serves as a reception and audience chamber. The whole style is characterized by an apparently boundless fantasy and fastidious luxury contrasted with unmistakably primitive qualities.

A reference to the commercial function of this center would not be out of place. As in Egypt and Mesopotamia, business dealings were still transacted in kind rather than in money and required a trading center; and a system of writing reached maturity simultane-

ously with the blossoming of the palace economy. Naturally, a great deal was produced and manufactured in the palace itself, particularly in the early period. But with the increase of barter the need arose for a place where objects worked in gold or ivory, for example, could be exchanged for food. This was best done through the palace, whose power throve on it increasingly day by day.

VASE PAINTING

The bearing that vase painting has on the history and unique character of Minoan culture cannot be overestimated. Vase painting is perhaps its most individual achievement.

During the Early Minoan Period the kiln and the potter's wheel were invented. Both naturally affected form and decoration. At first the various forms reflected those of the Neolithic Age (beak-spouted jugs brought from Asia Minor, beakers, jars, and teapots with long spouts shaped like a bird's head). But the decoration added to them was new, whether they were coated with a uniform colored glaze developed from Urfirnis ware and superimposed with a linear pattern, or whether as in eastern Crete a so-called mottled ware was produced, whose surface glazing was flecked with charcoal. In this way something originally created haphazardly by fire was consciously manufactured and shaped into patterns.

While the older palaces of the Middle Minoan Period were so completely destroyed and rebuilt that any treatment of them here must be foregone, their remains have left a wealth of ceramic material, which ranks among the most astonishing creations known to art history. After a period of transition the high point was reached during the 2d Middle Minoan stage (MM II) with the so-called Kamares style, named after the site of its discovery, the Kamares grotto near the palace of Phaistos. Its inventiveness and ebullient fantasy are without parallel. The technique of pot-making reaches perfection in the thin-walled "egg-shell ware." A beaker from Phaistos (*151*) shows on its dark background an uncommonly distinctive and brightly colored pattern in the form of a curved rectangle with four four-leaved shapes growing out of them. This can by no means be called a naturalistic rendering of a plantlike motif, for nothing more is intended than a decorative playing with beautiful lines. Moreover, a powerful force of movement within the lines impresses the

150 LID OF A PYXIS, from the island of Mochlos. EM II, 2400 B.C. Steatite. Diameter 12 cm. Iraklion Museum.

151 BEAKER, from the older palace at Phaistos. MM II, 1800 B.C. Height 16.2 cm. Iraklion Museum.

152 THREE-HANDLED PITHOS, from the older palace at Phaistos. MM II, 1800 B.C. Height 50 cm. Iraklion Museum.

153 LILY VASE, from the palace of Knossos. MM III, 1600 B.C. Height 27 cm. Iraklion Museum.

154 BEAK-SPOUTED POT WITH GRASS DECORATION, from the palace of Phaistos. LM I, 1550 B.C. Height 29 cm. Iraklion Museum. Beginning of the naturalistic style.

155 VESSEL IN THE FORM OF A BASKET WITH HANDLES, with double-axe decoration, from the island of Pseira. LM I, 1500 B.C. Height 20 cm. Iraklion Museum.

156 BEAK-SPOUTED VASE WITH SCULPTURAL AND PAINTED DECORATION, from a tomb in the harbor area of Knossos. LM II, 1450 B.C. Height 49.5 cm. Iraklion Museum. The vase was found with an alabaster vessel that bears the name of the Egyptian king Thutmose III (1490–1436 B.C.).

157 STIRRUP VASE WITH DOUBLE-AXE AND ZIGZAG PATTERNS, from a tomb in Rutsi near Pylos. LM I, 1500 B.C. Height 21.5 cm. Iraklion Museum. This piece is the oldest example of its type on Greek soil.

158 CLAY ALABASTRON WITH WATER FOWL AND FISHES, from the necropolis at Phaistos. LM III, 1300 B.C. Height 28.5 cm. Iraklion Museum.

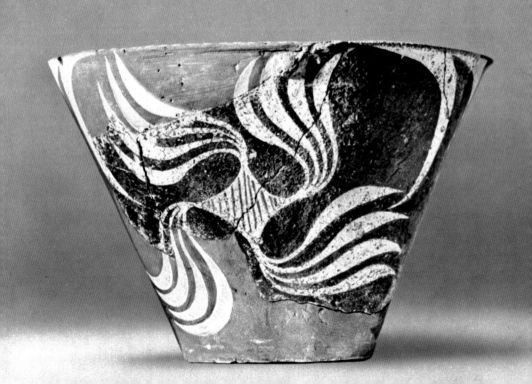

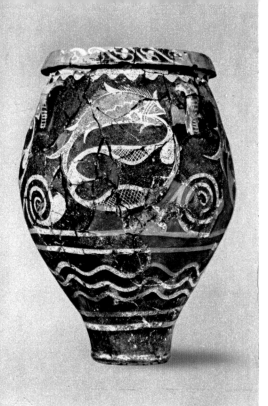

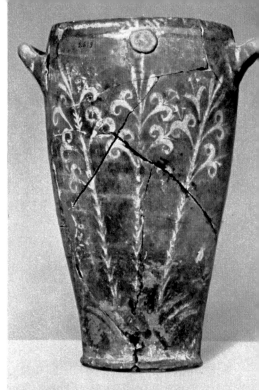

△ 157

▽ 158

through the cordon of guards and twenty-three nations march up to show their loyalty. The whole is executed with the highest technical perfection, every scabbard and every golden jug being reproduced with the greatest accuracy. Yet it is difficult to suppress a feeling of boredom. One is delighted here and there by the sight of Greek drapery, reminding one that Ionians were also at work (*147*). All in all, it is an example of "deliberate" art, which is eager to bring the best together from all parts of the world but cannot produce anything vital that might be capable of generating a life of its own.

140 HAMMURABI'S CODE OF LAW STELE. About 1700 B.C. Found at Susa. Basalt. Height of the entire stele 2.25 meters. Louvre, Paris. Stelae bearing the code of the law were presumably set up in several towns and it is not known from which the Elamite king took this actual piece. Remains of at least one more similar stele were found at Susa.

141 LION HUNT OF ASHURNASIRPAL II. Alabaster frieze from the royal chamber at Nimrud. 9th century B.C. Height 92–95 cm. British Museum, London. The motif of the lion attacking the king's chariot from behind and being shot by him may have come from Egypt, where it is in evidence at the time of Ramses III (12th century B.C.). The rhythmic composition of the hunting pictures becomes clear only when one sees it beside the similarly constructed wild bull hunt and the scene of sacrifice above the killed animals. Each scene takes up the width of one wall panel.

142 BATTLE SCENE OF ASHURNASIRPAL II. Alabaster frieze from the royal chamber at Nimrud. 9th century B.C. Height 98 cm. British Museum, London. The picture of the fortress surrounded by water in which swimmers are trying to escape from archers with the help of inflated bladders is seen from an elevated viewpoint. The water flows and forms waves. Egyptians had always represented water hieroglyphically in the form of schematized zigzag lines. There is even a rendering of the bank covered with trees, although (like the fortress) everything is reproduced in truncated form.

143 SYMBOLIC PEDESTAL OF KING TUKULTI-NINURTA I, from Ashur. Middle Assyrian Kingdom, c. 1200 B.C. Gypsum. Height 57.5 cm. Staatliche Museen, Berlin. Since it obviously deals with the same king appearing in two stages of worship, this is an early example of the "continous" style of representation, which achieved full realization in the New Assyrian picture cycles.

144 LION HUNT OF ASHURBANIPAL. Alabaster relief from the North Palace of Nineveh. New Assyrian Kingdom, 7th century B.C. Height c. 1.6 meters. British Museum, London. The picture is seen from an elevated viewpoint. Since we know from Xenophon's Cyrupaedia that the Persian residences had parks that made it possible to hunt game in enclosed areas, we can infer that there were similar ones in Assyria and that the artist could make close studies of nature.

145 SENNACHERIB'S ARMY FIGHTS IN THE MARSHES. Detail from an alabaster relief from the Southwest Palace in Nineveh. New Assyrian Kingdom, 7th century B.C. Height 1.45 meters. A mounted enemy raises his hand in surrender to his Assyrian pursuer, who is armed with a shield and is jabbing a spear at him. The southern Babylonian marshes are represented by reeds and water with fish in it.

146 MEDIAN NOBLES, on the steps of the Tripylon, Persepolis. 6th–5th century B.C. Stone.

147 SERVANT, on the south doorpost of the western door of room 12 in the palace of Darius, Persepolis. 6th–5th century B.C. Height of the figure 1.65 meters. The servant carries a napkin and an oil flask in his hands.

140 ▷

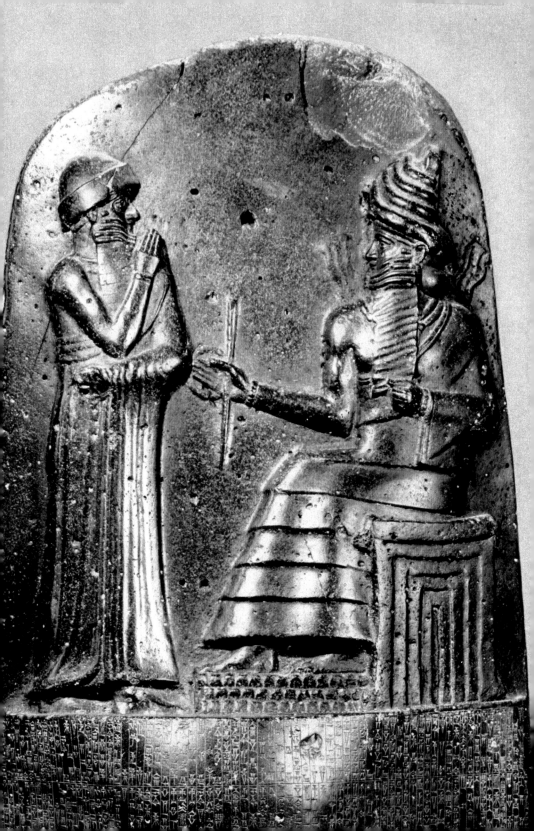

▽ 142

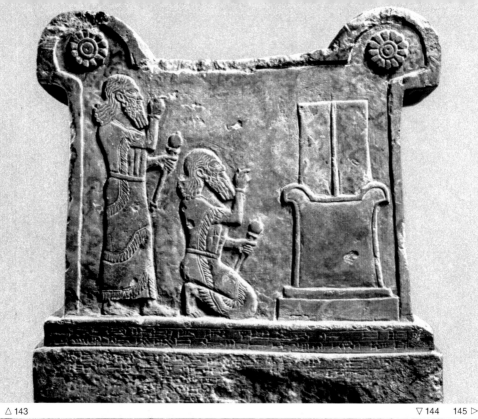

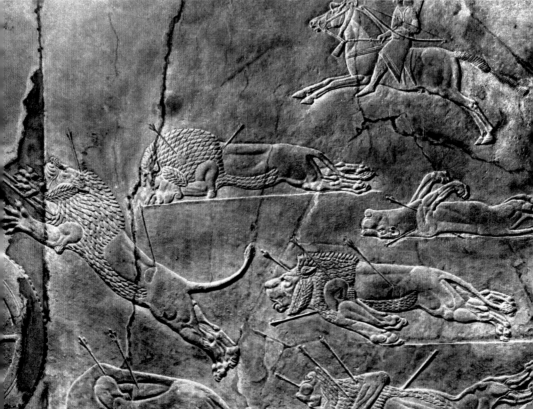

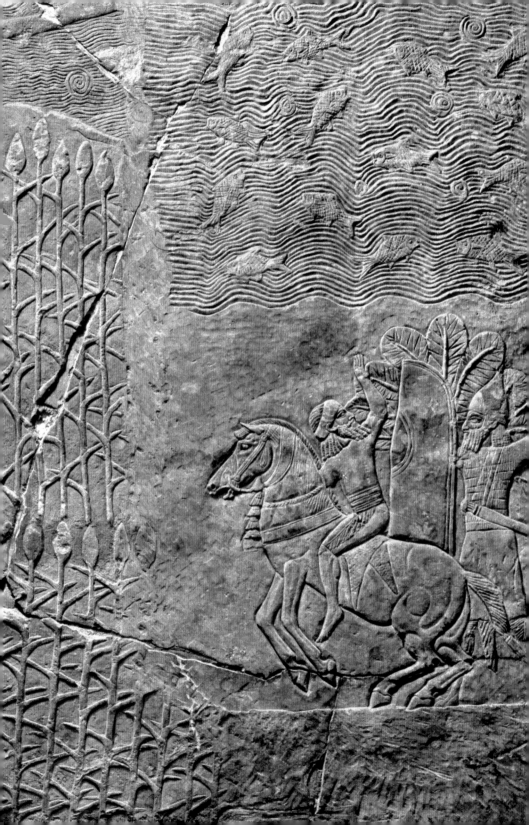

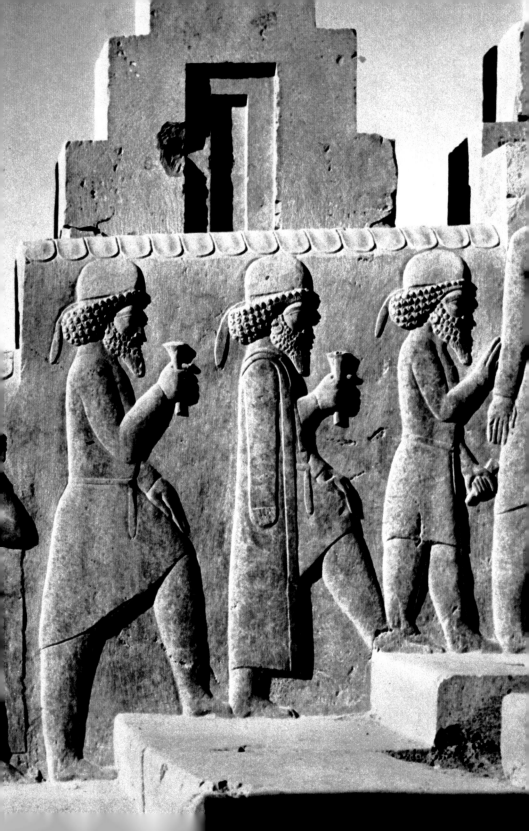

△ 148　▽ 149

THE AEGEAN

INTRODUCTION

The Aegean world—a region with its own unique, amiable, and always slightly mysterious charm—entered history centuries later than Egypt and Mesopotamia. While their forms had long been developed, and their temple architecture, sculpture, political structure, and religious thought were reaching toward their prime, the Aegean world still lived with the simple, slowly changing forms of the Neolithic.

It was in the islands of the Aegean Sea, above all in the Cyclades, that Aegean culture began. From there it spread to the neighboring coastal areas. Argolis and Attica were the birthplaces of the mainland culture now called Helladic. From them it spread over the Peloponnesus and into central Greece. Opposite—on the eastern side of the Aegean—Troy, in the northwestern corner of Asia Minor, took over the shipment of goods from Asia. The island of Crete, in the south, attained its dominant significance as late as 2000 B.C., not least because of its central position between the Peloponnesus and Asia Minor, between Cyprus and Sicily, midway between Greece and Egypt. This particular region experienced a considerable expansion in the course of history, primarily into the eastern Mediterranean basin, where the Phoenician harbors along the Syrian coast as well as those in Egypt were open for trade. In this extremely beautiful area marked by a living relief of hills and valleys, islands and bays, arose the world of forms that will be the object of this study.

The Aegeans of the Neolithic Age of the 5th and 4th millenniums were a Proto-Indo-European population closely linked with Asia Minor. This assumption based on archeology is supported by linguistic evidence (for instance, the names of towns, hills, and rivers ending in the letters *ss*, *tt*, *nth*, and *nd*). The piecing together of a relative chronology was accomplished by Sir Arthur Evans, who excavated the palace of Knossos in Crete at the beginning

148 NORTHERN ENTRANCE OF THE PALACE AT KNOSSOS. The ramp seen in the middle runs north and south to the great middle courtyard and connects it with the outside world; it was also passable to beasts of burden. On the left, a pillared hall with three naves; on the right, the columned hallway on a high pediment, partly rebuilt. These columned hallways enclosed the ramp on both sides; this is the north end of the west side. On the back wall are remains of painted bull reliefs. The reconstruction helps the visitor to imagine how the palace once looked.

149 GROUND PLAN OF THE PALACE AT KNOSSOS, as it was before its destruction in 1400 B.C. c. 150 × 100 meters. The complete plan shows the labyrinthine quality of the building. The following parts are signified by numbers: 1 entrances; 2 living quarters; 3 storerooms; 4 so-called theater; 5 corridor of procession, named after its frescoes; 6 veranda; 7 inner anteroom; 8 steps to the first floor; 9 throne room; 10 cult chapel; 11 pillared hall; 12 private houses. The giant storerooms prove that the palace also had an economic function. Plan after J. D. S. Pendlebury.

165

of the 20th century. From Minos, the legendary king of Knossos, he took the term Minoan to describe pre-Grecian culture in Crete, dividing it into Early, Middle, and Late Minoan (EM, MM, LM) and further into EM I–III, etc. Although they are somewhat too systematized, the divisions have largely survived. The mainland has been given corresponding divisions of Early, Middle, and Late Helladic (EH, MH, LH) and their corresponding subdivisions. Coinciding with the last division was a Mycenaean age during which the Achaeans were in power; formerly it was referred to as Early, Middle, and Late Mycenaean, now it is called Late Helladic (LH) I–III. Absolute chronology—that is, with reference to present-day reckoning—depends mainly on the study of Egyptian finds in Crete and Minoan finds in Egypt.

The Early Minoan Era (2600–2000 B.C.). While one can speak of a population linked with Asia Minor as early as the Neolithic Age, it is in the early metal age that the Aegean-Anatolian cultural union becomes more obvious. In western Asia and Egypt the use of metal had spread more and more during the 4th millennium B.C. and by the early 3d millennium a sophisticated metal culture had developed. The drift of culture from east to west—which archeologists refer to as a "metal revolution"—exerted an unmistakable influence on the form of clay vessels. In the second level of Troy (2400–2150 B.C.) a rich treasure hoard was excavated by Heinrich Schliemann, who maintained it was that of Priam, thus dating it a thousand years too early; scholars now relate it to the hoard of Alaça Hüyük in inner Anatolia.

The Cyclades now enjoyed a period of supremacy during which its people traded from coast to coast and exported their abstract marble idols and copper weapons. There as in Crete the Anatolian innovations were independently worked out according to Neolithic principles. On the mainland the so-called Urfirnis ware represents the hallmark of Early Helladic culture, which spread north from Argolis, Attica, and Boeotia.

The Middle Minoan Period (2000–1570 B.C.). While the culture in Crete made a sharp transition from Early Minoan III to Middle Minoan I, there was a deep rift on the mainland between the Early and Middle Helladic styles. As always it is chiefly from the pottery that knowledge of this break comes. It was the so-called Minyan ware that diverged strongly from the older Aegean-Anatolian type. It is known today that this change points to the infiltration of the first Greeks, who presumably appeared on the peninsula in several waves at the beginning of the 2d millennium B.C. Crete and the Cyclades resisted at first. Apparently a cultural stagnation is linked with those events, yet Crete now experienced a decisive boom. The palaces of Knossos, Phaistos, Hagia Triada, and Mallia were built. Ties were strengthened with the Syrian markets and with Egypt and Mesopotamia, as is shown by a wealth of archeological finds. A hieroglyphic script was developed.

Soon after 1700 B.C. all the palaces were destroyed by an earthquake, but they were rebuilt soon afterward. Consequently, what they were like originally is not clearly known. If scholars are correct in saying that the time of the older palaces was a classical period of balance and refined taste, then it is the ceramics again that support this opinion, with their inventive painting adapted sensitively to the shape of the vessel. There was at this point a change from hieroglyphics to a linear script.

observer and causes him involuntarily to turn the vessel in his hands. Here is a basic tendency of Minoan ornamental technique, torsion, which can be seen at work again and again. Let us recall that we noted such a tendency for motion in architecture. Movement is a trait deeply rooted in Minoan art, affecting all aspects of life; it not only contradicts everything Egyptian and Mesopotamian, but is also totally un-Greek.

On the same site a three-handled earthenware jar, a pithos, was found (152). It has white decoration on a black background. There are wavy lines at the bottom and straight stripes above that with spirals running from them. A yellowish-brown painted fish takes up most of the flat surface. In its mouth it holds the cord of a net that spreads out beneath. Besides circular and spiral devices the painter has taken a living creature as a motif, while avoiding references to water (the Minoan always did, but the Egyptian would never have done so). The fish is not conceived naturalistically but purely decoratively—the net even more so— which reveals that the draftsman was concerned only with the beautifully sweeping line and not at all with an accurate reproduction of his model. It is hardly recognizable any longer. A glance at the structure of the vessel betrays its poor stability, supported as it is by only a weakly formed ring at the base. The handles are remarkably small. The general outline is soft, so that the neck, belly, and foot are not in contrast with one another. This lack of structural quality harmonizes completely with the decoration flowing gently over the surface.

Besides this group of vases (which favored a white pattern, with a sparing use of yellow, on a black background) there was another brightly painted type. One might even say that the Middle Minoan Period became the golden age of polychromy. In this case, too, a delicate black or brown glazing provides the background, with the patterns set on it in varying shades of red, orange, and white. One of the most beautiful examples, a beak-spouted vessel in the Kamares style (170) from the old palace of Phaistos, boasts a powerful brown-red color from which curiously formed patterns (inspired perhaps by plant motifs) stand out in black and light yellow. The abundance of shapes and the attractive patterns are astonishing.

It was obviously the predilection for festive forms that led to the creation of a type of vase on which the surface was worked like a relief after the so-called barbotine technique (French barbotine—potter's clay). A unique vase of this type—a krater measuring 45.5 cm. high (168)—forms a special link between painting and sculpture. On the upper rim were chains that have only partly survived; at one time the ladles presumably hung on them. Seven eight-leaved blossoms have been added under the rim and on the base. The whole points to a metallic model, but the painting of chessboard pattern and grained stone does not seem to agree with it. Kamares ware became widely popular not only in the Aegean world but also in 12th Dynasty Egypt. This fact is significant in the establishment of chronology.

The Middle Minoan technique of using bright patterns on a dark background continued into the time of the later palaces, just as the transition from stage MM III to LM I reveals no gap. The lily vases (153) from the palace of Knossos belong to this period. They were found in a small storeroom next to a chamber kept for cult purposes and were probably

used for religious purification. This prompts the thought that a symbolic value was associated with the groups of three lilies. Possibly the old style of painting—white decor on a lilac-brown background—was retained because of its religious purpose.

In the mid-16th century B.C. such a far-reaching change set in that one can speak in terms of a break in style. Polychromy declined; instead, painting was executed with dark colors on a bright background, including an extraordinary expansion of the motif vocabulary. If at first it was largely plant motifs that provided ornamentation (algae, ivy, tendril, seaweed, grasses, and lotus flowers), now the flora and fauna of the sea were adopted more and more: cuttlefish, starfish, nautili, and snails appeared—all things that were familiar to the inhabitants of the island, but that by reason of their pendulous flexible character corresponded to the Minoans' untectonic style, which was directed toward movement. This miniature world was now strewn with apparent carelessness onto the walls of the vessels in a manner evoking an idea of the momentary, the incidental, the informal, and above all the motile.

A typical example of the naturalistic style in its early stages is a beak-spouted jug (154) from the later palace of Phaistos, which is painted all over with fine grasses, the elegance of its form harmonizing perfectly with the lightness of the decoration. A unique shape is an east Cretan vessel in the form of a basket with handles (155). It is divided into strips containing double axes standing between hills. The motif is possibly explained by the religious use of the vessel. A roughly contemporary double-handled pouring vessel (171) from the palace of Hagia Triada already shows a change toward tectonization and rigidity. With the greatest accentuation of the beautiful profile of the vase, the decoration achieves a pure

159 HARVESTERS' VASE, from the palace of Hagia Triada. LM I, 1550–1500 B.C. Black steatite. Maximum diameter 11.5 cm. Iraklion Museum. The people bear their tools on their left shoulders so that their faces are not blocked. They are carrying staffs that divide into three forklike arms; a sickle-shaped knife seems to be fastened below each staff. These implements perhaps were used for harvesting olives.

160 GOLD BEAKER WITH BULL HUNT, from a tomb near Vaphio in Laconia. 1500 B.C. Upper diameter 10.8 cm. Iraklion Museum. The tomb, a *tholos*, was covered by a mound of earth. Inside the beaker is a tray that is curled around the upper rim for strengthening purposes.

161 CYCLADIC MARBLE IDOL, from the grave enclosure at Koumasa (south-central Crete). EM II, 2300–2000 B.C. Height 23.5 cm.

162 STATUETTE OF A PRAYING WOMAN, from Piskokephalon (eastern Crete). MM, 1800

B.C. Clay. Height 26.4 cm. The right hand placed over the left shoulder and the left hand held in front of the body represent a gesture of humility before the deity.

163 PRIESTESS WITH SNAKES, from the Temple Repositories at Knossos. MM III, c. 1600 B.C. Faience. Height 29.5 cm. Iraklion Museum. A second figure, almost 5 cm. taller, from the same place, is the largest surviving statue. The priestess holds the head and tail of one snake, which she has placed over her shoulders and back; another is around her hips like a knotted girdle; a third hangs from her skirt.

164 RHYTON IN THE SHAPE OF A BULL'S HEAD, from the Little Palace at Knossos. LM I, c. 1500 B.C. Black steatite. Length of the head without the horns 20.6 cm. Iraklion Museum. The filling hole of the vessel is in the neck and the pouring hole is at the snout.

163

165
166
167

165 SEAL IMPRESSION, from Knossos: Mountain goddess and worshiper.

166 AGATE SEAL, from Archanes: Ibex and dog.

167 GOLD RING, from Mycenae: Funeral lamentation (?).

filling of the surface rather than a living picture of nature. This so-called palace style forms stage LM II, which was apparently limited to Knossos and chronologically is coterminous with LM I. On a beak-spouted jug decorated with sculpted buckles (*156*), the papyrus umbels and nautili are largely stylized and have become established types. New vase forms appear, among them the funnel and the famous stirrup vase (*157*). They spread widely, even to Egypt, where they can be dated to the 18th Dynasty, as well as to the Greek mainland, where they were by no means always imported from Crete but were rather locally produced.

Anything made in the 13th century B.C. (LM III), after the destruction of the palaces around 1400 B.C., bears the mark of decline. Technique gradually fell off, ornamentation survived in the fossilized forms of erstwhile naturalism, and increasingly took straight-lined patterns into its repertoire. Preparations were made for the transition to the protogeometric style. A clay alabastron (*158*), with stylized birds and fishes in conjunction with linear patterns, is typical of the beginning of the era, which preceded the dark centuries of invasion by sea-peoples and Doric migration, from which Greek art was later to be born.

RELIEF AND SCULPTURE IN THE ROUND

Even if the Minoans achieved nothing in the realm of relief art comparable to the Egyptian and Mesopotamian stone reliefs, the lack of surviving works should not obscure the fact that at least in the later palace of Knossos stucco relief played a significant role. From the columned terrace at the north entrance comes an over-life-size bull's head that must rank as one of the great works of the time. Of equal merit is the "prince with a crown of feathers" from the hallway of the west wing, which is modeled larger than life-size in stucco on a painted background. Yet it must be said that the urge to monumentalize was

◁ 164 by no means a basic characteristic of the Minoans; they expressed themselves much better

on a small scale. This directs one first of all to the glyptic art that provides the history of style with priceless material and proves itself the most compact and characteristic form of expression in the Old Aegean substratum—so it is all the more regrettable that this field cannot be covered in greater detail here (*165–67*).

Among several surviving black steatite vessels decorated with reliefs, the so-called Harvesters' Vase from the palace of Hagia Triada is of particular interest (*159*). It is a rhyton in the form of an ostrich egg with the bottom half missing. Interpretation becomes difficult in the light of the details. At any rate, its subject is a harvest festival perhaps with suggestions of religion. Under the authority of a man distinguished by his dress, pairs of laborers march along with their harvesting implements over their shoulders. Three singers with mouths wide open are conducted by a fourth man with his left hand, while he shakes a sistrum, an Egyptian cult instrument, with his right. The whole is depicted with the greatest freedom and vitality, and not without a touch of humor. One need only imagine how an Egyptian might have addressed himself to the same exercise, in order to grasp the Minoan character.

Although both of the famous gold beakers from Vaphio (*160*) came from the tomb of a Mycenaean prince around 1500 B.C., they are probably of Cretan importation to the mainland and not a Mycenaean imitation of Cretan originals. The reliefs were beaten out and the handles riveted on. They belong together as a pair, one frieze depicting a wild and dangerous bull hunt, the other the peaceful existence of tamed bulls. A rich framework of landscape helps to create atmosphere. Moreover, the naturalism of the pictures is linked with a framework based on decoration. The composition clearly shows wave tendrils as the basis of the motif.

168 KRATER, with sculpted blossoms added, from the Old Palace at Knossos. Kamares style, MM II, c. 1800 B.C. Height 45.5 cm.

169 FRIEZE WITH THE BULL VAULTING, from the palace of Knossos. Detail. LM I, c. 1500 B.C. Height including the frame 80 cm. The frame, surrounding each area on all sides, is an imitation of colored stone. The vaulters are never armed and the killing of the bull is not shown. The bull sport is a cult imitation of the hunt for the sacrificial bulls.

170 BEAK-SPOUTED VESSEL, in the Kamares style, from the Old Palace at Phaistos. MM II, c. 1800 B.C. Height 12.5 cm.

171 TWO-HANDLED POURING VESSEL, from the palace of Hagia Triada. LM I, c. 1500 B.C. The vessel is of the "floral style," which directly preceded the "palace style."

172 LILY FRESCO, from a villa in Amnisos. MM III, c. 1600 B.C. Height 1.8 meters. The lilies in the flower garden are set into the wine-red background with white paste.

173, 174 SARCOPHAGUS, from Hagia Triada. From a chamber tomb near the Palace. LM III, 14th century B.C. Porous limestone painted in fresco technique. Length 1.37 meters. Iraklion Museum. One of the long sides shows a conjuration of the dead. On the right, the deceased in front of his grave with two bearers of sacrificial gifts approaching him. On the left, two women with vessels followed by a lyre player. This scene continues on the other long side with a bull sacrifice. On one short side, two goddesses in a chariot drawn by griffins hurry to the sacrifice; on the other, a pair of women drive to the funeral conjuration.

175 CHEST SARCOPHAGUS WITH A GABLED LID, from Palaikastro. LM III, 14th century B.C. Clay. Length 1.23 meters.

176 "PETITE PARISIENNE," from the palace of Knossos. LM I, c. 1500 B.C. Fresco. Height of the fragment 25 cm. Iraklion Museum.

168 ▷

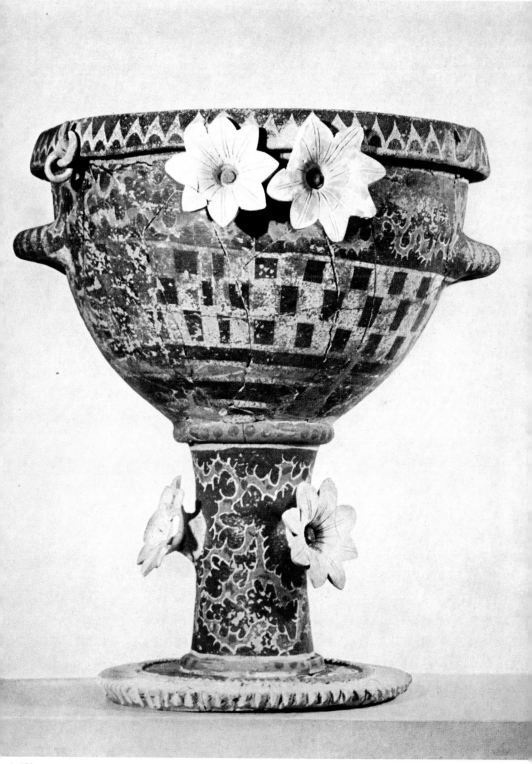

△ 168

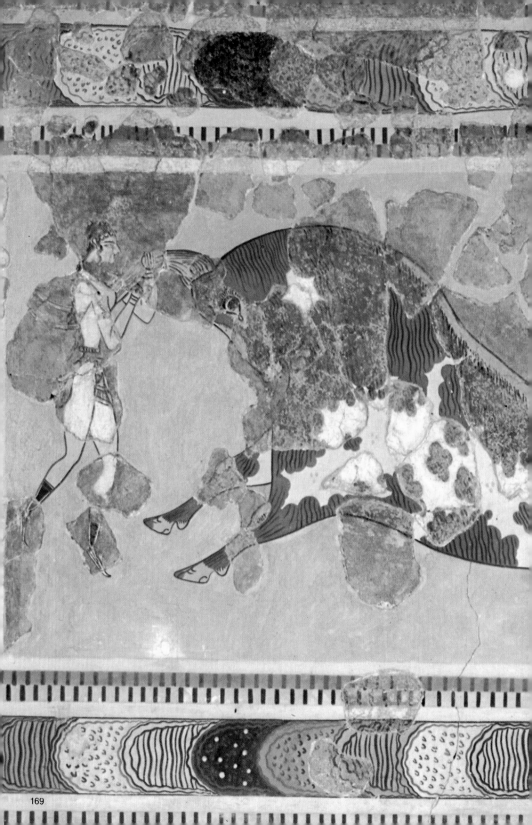

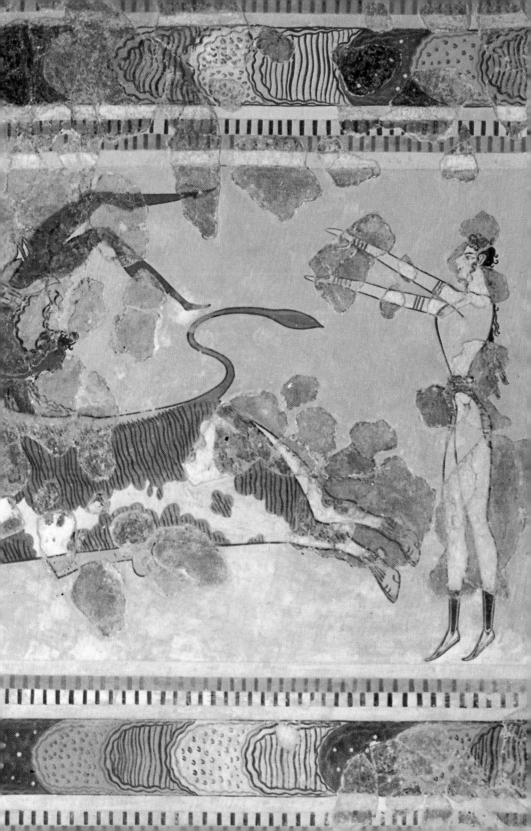

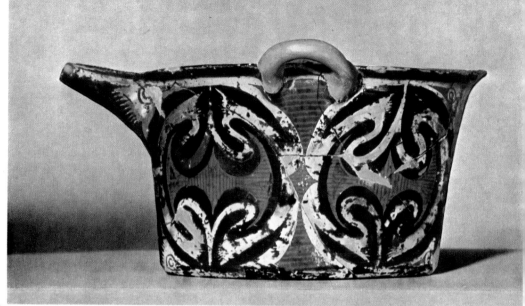

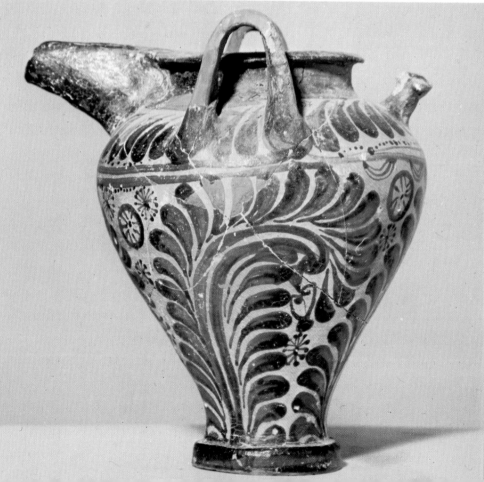

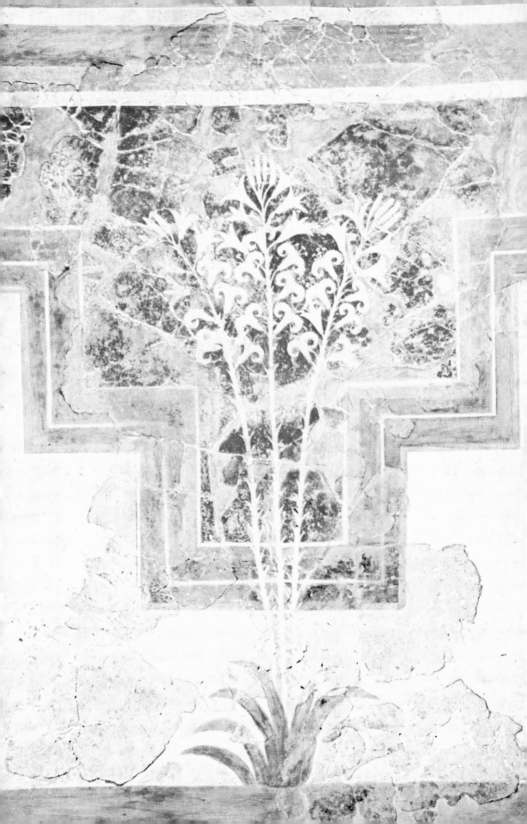

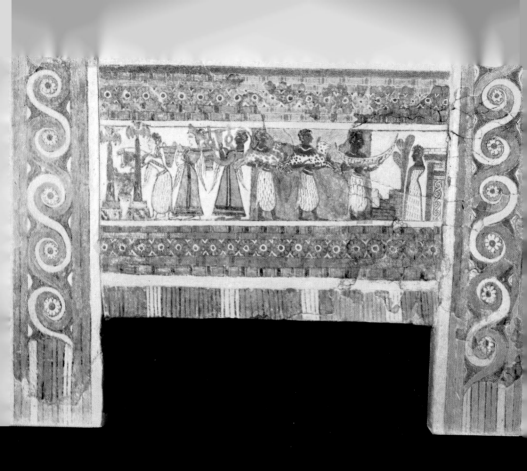

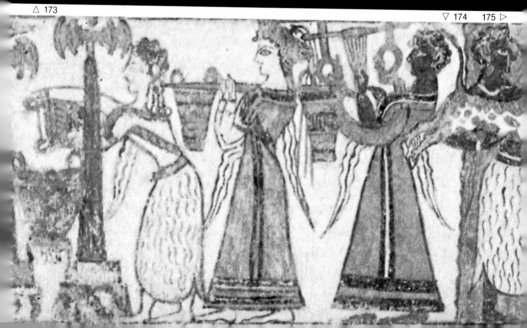

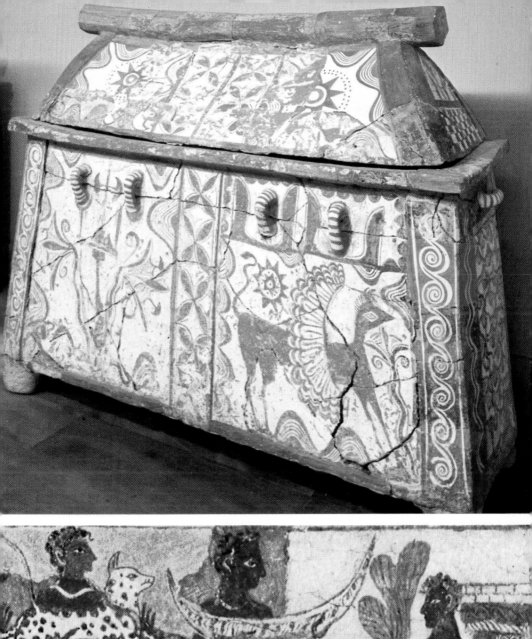

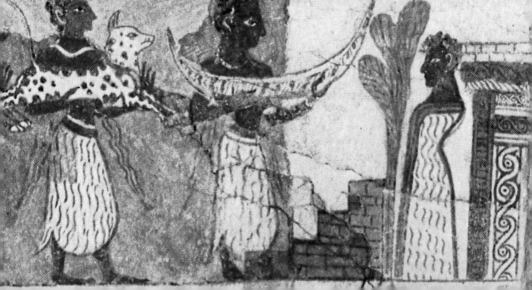

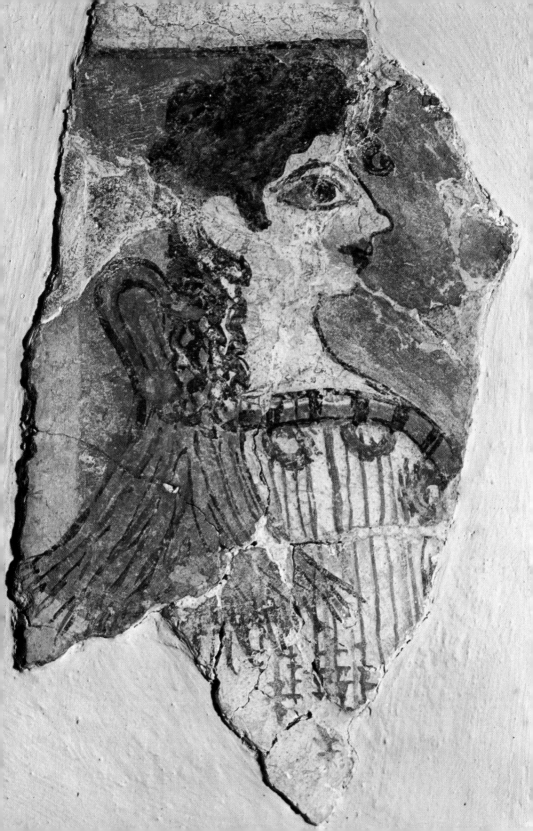

Heading our survey of sculpture in the round is the lid of an early Minoan pyxis in green steatite (*150*) from a tomb on the coastal island of Mochlos. A dog, stretched out indolently, serves as the handle. The Cyclades offer rich material in their marble idols (*161*). Favored by the wealth of marble in the islands, they were produced in great numbers and exported both to Crete and to the mainland, where they were found mostly in tombs. They are often female figures, fertility symbols, which the deceased took with him into his tomb in order to benefit from their influence in the other world as well. Therefore they are not to be seen as religious statues but as magic sources of power like the Egyptian and western Asian predecessors from which they stemmed. Since, instead of the mother-goddess, human figures appear (a sitting harpist, for example), they are certainly intended to be of service to the deceased man. Then also their realistic character is therefore a determining factor. Dating roughly from the last third of the 3d millennium B.C., they brought a fresh idea of form into the world and developed it in a remarkable way. Their abstraction and simplification of forms have something in common with the goals of modern art. One might have said that they were the point of departure for a classical idea of form, but in fact that was not the case.

On the contrary, Minoan art not only developed no large-size relief but not even life-size sculpture, and limited itself to statuettes of modest dimensions. What was the reason? That is best explained by a look at Cretan religion. As already stated, the Minoan worshiped divinities who manifested themselves in nature itself and could "appear" wherever they were invoked by dancing, prayer, and sacrifice. This belief in a divine "epiphany" found expression in illustrations on seals in which gods in human form were invoked at a religious feast; but it did not lead to the creation of a cult of statues which the god was supposed to inhabit. The cult remained without images because the "epiphany" of the divinity had a momentary character. Things were quite different in Egypt, where as early as the prehistoric era there were stone statues of gods larger than life. The question of Minoan statues of rulers is a similar one. The Minoan king is patently not a god like the Egyptian one, but he is first and foremost the priest of the Great Mother Goddess. There was no inclination or need to immortalize him or to see his statue as a symbol of the state. And where there are no royal statues one can not expect to see statues of the local gentry, whose seats lay scattered about the land. Religious and sociological conditions did not therefore encourage the creation of statues.

The achievement of Minoan art lies in its naïve delight in the colorful splendor of life—a factor that has nothing to do with insight into the structure of organism. Everything Minoan tends toward playfulness, spontaneity, and fluidity. Anything tectonic or framed in permanence is foreign to it. And that is no basis for the creation of great works of sculpture. One may compare with this the struggle of the Egyptians toward solid form, which determined the strict tectonic structure of their statues even during the early period.

Clay statuettes of animals and men survive from the Middle Minoan Period. They always come from mountain sanctuaries, in no case from the palaces, and they are without doubt to be seen as votive gifts. Among them are a warrior with a dagger in his belt and a lady with an amusing hat that tells us something about the hairstyle and dress of the women. 176 But artistically it is all rather purposeless and does not continue the tradition of the Cyc-

ladic idols, seeming to be little more than rather gifted amateurism. Those represented are worshipers of the gods living on the heights, to whom they commend themselves and wish to be near, a concept that led to the creation of the votive statue in Mesopotamia as well. Parts of the human body belonged to the same relationship. In the statuette of a praying woman (*162*), the worshiper stands before the deity naked from the waist up in an attitude of prayer. Her dress, which reaches the ground, is held on her hips by a bulging belt.

From the subterranean Temple Repositories at Knossos, as they are called, come two important faience statuettes (*163*) from the beginning of the later palace era. It is a matter of debate whether they depict snake goddesses or priestesses of the Great Goddess, to whose manifestation the snakes belong, or even the queen herself in her capacity as priestess. In any case, they cannot be cult statuettes, but simply votive gifts. The bare breasts and flounced clothes point to court attire. The skirt and headdress have religious significance, yet while they tell about religion and clothes, they say little about the sculpture. Significantly, there is no attempt to indicate feet.

An outstandingly modeled bull's head (*164*) from the Little Palace at Knossos, which was reserved for cult purposes, was also used as a cult vessel, a so-called rhyton. The head is of black steatite, the horns (now enlarged) were of gold foil. The snout is inlaid with mussel-shell. The eyes (only the right one survives) were of rock crystal, with the iris and pupil painted underneath in black and red, respectively. The hair between the horns and the etching to indicate the colors of the hide give the effect of chased metal. Compared with Egyptian treatments of the same theme, this work offers an unstylized, naturalistic interpretation.

WALL PAINTING

Fresco painting can be regarded as the greatest achievement of Minoan art. Admittedly, since only fragments of crumbled, painted stucco remain, it is difficult to get an idea of how the pictures were composed. Although what has survived suffered severe color changes in the palace fires, one can glean some sort of information from it. There can be no doubt that the translation onto the palace walls of motifs developed in vase painting—the living world of plants and sea fauna and the creation of large scenes full of movement in which man also was given a role—started only with the rebuilding of the palaces, or more accurately during the third stage of the Middle Minoan Period, which ended about 1570 B.C. Two factors

177, 178 TWO WOMEN AND A CHILD, from Mycenae. 15th century B.C. Ivory. Height 7.5 cm. Found in 1939 in a Mycenaean temple.
179 CLAY IMITATION OF A LITTLE TEMPLE.

c. 1100–1000 B.C. Found in a Minoan settlement south of Knossos. Height 22 cm. Giamalakis Collection. The significance is not known. The circular building has a removable door.

177

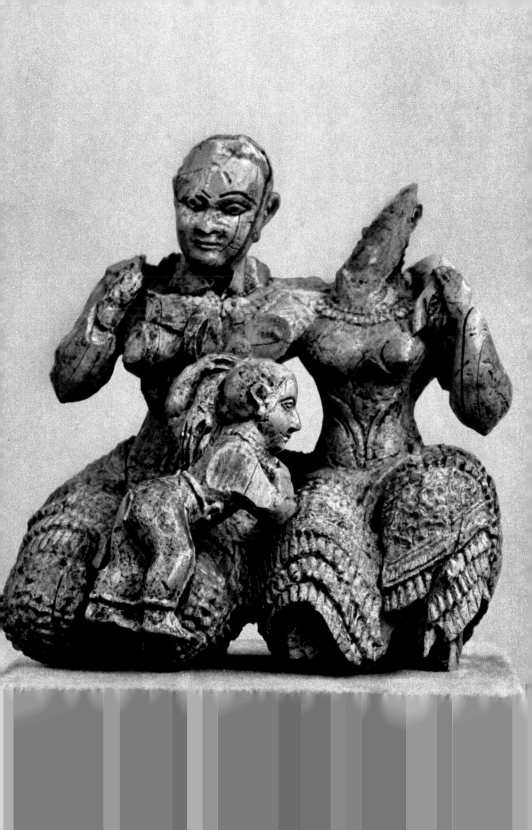

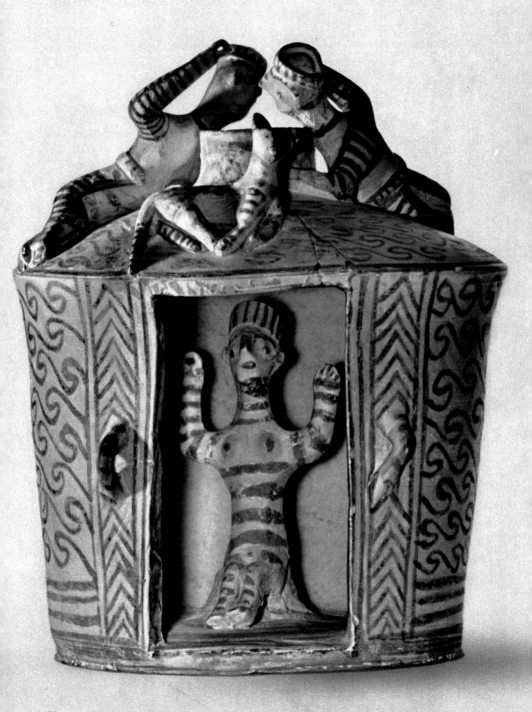

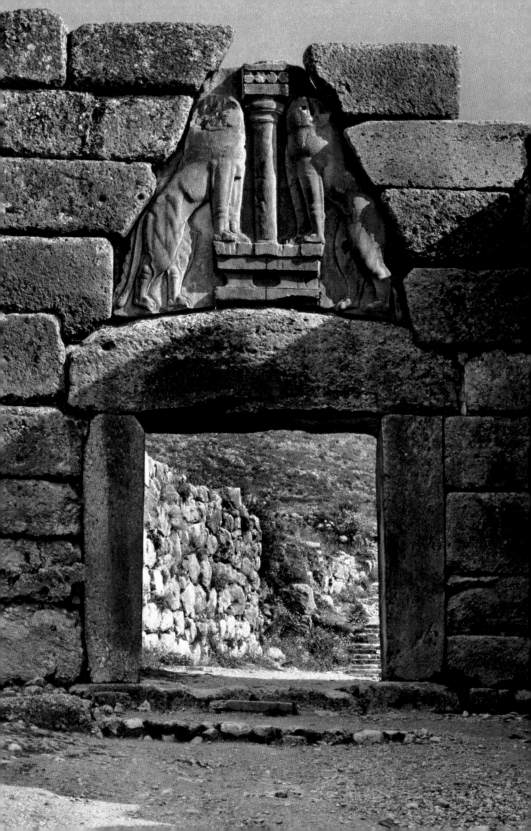

180 LION GATE, at the citadel of Mycenae. First
third of 13th century B.C. Height of the
relief tablet, over 3 meters. The lion is
assigned to the Great Goddess; the col-
umns are an abbreviation for the palace
façade in its cult function. The lion relief in
this exposed position is a powerful symbol
which conjures up the protecting deity.

seem to have made this artistic step possible: the presence of skilled masters who at the re-building of the palaces set about producing completely novel works of the greatest perfection, and the influence of Egyptian wall painting, which had become familiar in the meantime. Yet it must be stressed that, from the beginning, Minoan fresco painters not only managed to express their own uninfluenced individuality but that they were also independent in their technique. In contrast to Egyptian wall paintings those of Crete were genuine frescoes, that is, paintings on wet stucco.

Among the earliest pieces is the splendid Lily Fresco (172) from a villa in Amnisos, a harbor of Knossos. A feature of the building was a hall of double-columns on the top storey, which housed the fresco. The Madonna lilies stand in a well-kept park, their noble white color projecting impressively from a red background. The same motif, probably symbolic, appeared on vases belonging to MM III.

Most of the frescoes belong to the Late Minoan Period (LM I), roughly the century 1570–1470 B.C. Among them are landscape scenes, which are closely related to Egyptian ones and provide useful comparisons, as, for example, in a picture in the palace of Hagia Triada of a cat stalking a bird in a bush. In Egypt the animals seem to have been taken from a book on natural history. Because of his objective attitude to the surrounding world, the Egyptian artist created pictures onto which he spread all those sides of the object that to his way of thinking seemed essential. They are hieroglyphs, in fact, that must reproduce the objective nature of things in order to be intelligible. Not so the Minoan artist; with him the eye is always the first judge, and up to a certain point he adapts things to its visual requirements. In this way the fleeting moment retains its urgency and he gives the movement not only in potentia, as the Egyptian artist does, but in actu. There is only a short period in the history of Egyptian art, the Amarna era, when the Egyptian method of presentation approaches the Minoan. At that time Cretan influence must have been at work because Egyptian art struck out in an identical direction.

Besides landscapes there were also religious scenes. Among them is the frieze with bull-vaulting (169) in which the different stages of the mortally dangerous game were represented in scenes divided into square areas. The background was alternately yellow and blue. Youths and maidens faced the charging bull, grabbed the horns, and let themselves be tossed backward, landing on the ground again in a death-defying leap. In this sport, requiring the utmost skill and coolness, religious duty and the curiosity of the crowd become synonymous. In one scene in which a number of people are gathered is the famous "Petite Parisienne" (176). She embodies a trait that in fact characterizes everything Minoan, the combination of primitiveness and refinement. Her enormous eye has been added to the face in the old fashion like a hieroglyph, but the lock of hair hanging coquettishly over her forehead, the

individual snub nose, her hair bound together in a knot at the nape of the neck (black against the bright flesh color), her mouth (red on a blue background)—all this is of the greatest delicacy.

The sarcophagus at Hagia Triada (*173, 174*) is of limestone painted in the fresco technique and belongs to the end of the Late Minoan Period (LM III), when the traditions of the Palace Era were still alive. A convincing interpretation of the pictures as a group is yet to be made.

MYCENAE

At the beginning of the 2d millennium B.C. Indo-European tribes appear on the peninsula; they become archeologically traceable in the Middle Helladic cultural era. About 1600 B.C., while Crete applied itself to restoring to their old magnificence the palaces, which had been destroyed by an earthquake, a transition was made on the mainland to a stage that is now called Late Helladic I (early Mycenaean). The Achaeans were the instigators of this culture. Mycenae came to the fore in the 16th century B.C. as the ruling power in the Peloponnesus—the same Mycenae that Heinrich Schliemann excavated in 1874–78. The main testament to this epoch is Schliemann's shaft grave circle A (*181*), to which a second (B) roughly a generation older was added by further excavations in 1951. The 15th century that

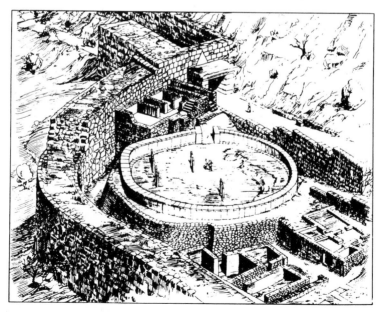

181 MYCENAE. Grave circle A inside the citadel wall, containing six shaft graves. Ten grave-stones stand at the heads of the bodies, facing west. Reconstruction after Wace.

followed reveals an expansion of Mycenaean influence over the whole Aegean sphere. The shaft graves are replaced by *tholoi*, chamber tombs whose form was derived from the Minoan, like so much else.

After the second half of the century (Late Helladic II) the Achaeans were lords of Crete as well. This is the more remarkable because artistic evidence from the last decades before the destruction of the palaces reveals no change in favor of the ruling race. The frescoes in the royal chamber at Knossos (to some extent) and the vases in the "palace style" can be interpreted without difficulty in terms of an uninterrupted development of style. The dictum "no archeological break—no intrusion of people" seems to have no truth in it, at least as far as Crete is concerned.

The 14th century B.C. found Mycenaean culture at its highest peak (Late Helladic III). Soon after 1400 B.C. heavy Mycenaean colonization began, extending to Miletus in Asia Minor. In the middle of the century the magnificent additions to the castle of Mycenae were completed and soon afterward those at Tiryns as well. In the first half of the 13th century B.C. the so-called Treasury of Atreus (*182*) and the famous Lion Gate (*180*) were built at Mycenae. Immediately afterward the shadow of the catastrophe fell. The lower town of Mycenae and the castle of Tiryns relapsed into ruin; work began on building great fortresses and a boundary wall for the Isthmus. Around 1200 B.C. the catastrophe arrived with full force, spelling the end of Mycenae, Tiryns, Pylos, Thebes, Orchomenos, and other cities. The probable cause was an invasion by sea-peoples.

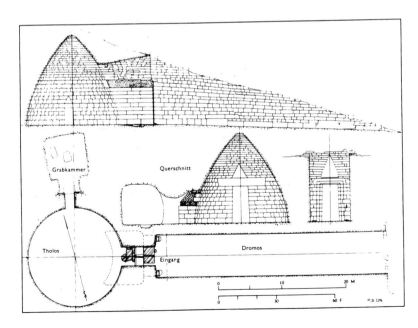

182 MYCENAE. Treasury of Atreus, 1300–1250
B.C.

Grave circle A, discovered by Schliemann in 1876, had been incorporated into the fortifications later, during extensions to the citadel; grave circle B, discovered in 1951, lies outside the walls. A contained six graves and B fourteen; they were marked by gravestones. The largest grave in A contained three men, two women, and two children. The death masks found on the faces of the men were clearly modeled on the faces themselves. However striking they may be, it seems somewhat exaggerated to see in them the first evidence of Indo-European large-scale sculpture. If these masks represent a Mycenaean funeral rite, and therefore Mycenaean handiwork, then the work of Cretan masters can be seen in the majority of the finds whether they were imported from Crete or produced on the mainland under Mycenaean commission. Among the latter are several dagger blades inlaid with gold, silver, and niello. The most beautiful one shows four heavily armored men on one side and one bowman fighting with a lion; on the other side is a lion attacking gazelles. If this motif reminds one of Egyptian influence it is even more true of another blade with the picture of a papyrus thicket in which a wild cat is hunting duck. But typically Cretan motifs like nautili and dolphins also appear. The inlay technique has been completely mastered, and the style is pure Cretan.

Among the drinking vessels made from precious metal, which were provided in great numbers for the dead in the aforementioned graves, there are some whose clear, well-articulated forms stem from the Middle Helladic tradition. The gravestones carry pictures, engraved or worked in shallow relief, of fighting warriors, bull-catching, and lion-hunting—motifs borrowed from the Minoans but handled in a new and still rather unwieldy way. In all these cases, just as with the masks, the work is of mainland craftsmen. In it is a clear example of how the influence of people of a different type encourages the development of a new world of forms.

Of the surviving works of small-scale sculpture in clay, ivory, and bronze, an ivory group found in Mycenae as recently as 1939 (*177, 178*) deserves distinction above all the rest. Two female figures are crouching next to each other. A shawl worn over both their backs reinforces the unity implied in this gesture. Their dress is Cretan, with bare breasts and flounced skirts. A child plays around their knees. The work is of great interest in the context of both religion and art history. Certainly there is a myth behind it of the divine child who is saved by two divine nurses and brought up by them. The style is free from any directional tension.

The greatest artistic achievement of the Achaeans is found in the architecture of the century from 1350 to 1250 B.C. The citadel of Mycenae lies high above the landscape of Argolis, dominated by the peak of Mount Hagios Elias. It is surrounded by a massive wall built in the Cyclopean manner, following the crevass-scarred terrain. In the neatly constructed Lion Gate (*180*) the projecting flank and the wall with the gateway were built with the projection of the rectangular blocks. Over the lintel a triangle has been set apart by projecting the slabs forward. And inside it is the lion relief, the first large-scale sculpture on Greek soil. Two lions facing each other rest their forepaws on a double pedestal from which a column rises. The heads, which are now missing, were made of different material and faced the front.

Not much has survived of the living quarters and the farm buildings inside. The palace was built at the highest point in the terrain. More is known about the one at nearby Tiryns and also about the one at Pylos in Messenia. Tiryns in its final form—with its long ramp leading up to the gate, its casemates, and the fortress belonging to it—is a masterpiece of fortification. At the center of the palace is a megaron consisting of two antechambers and a large hall with a hearth in the middle. Four columns standing around it support a "lantern." There is no longer anything Cretan about this architecture, for its Grecian character is unmistakable. Yet the decoration is entirely Minoan. In their motifs and in their technique the frescoes of the megaron have close parallels in Crete.

The tholoi, which replaced the shaft graves after c. 1500 B.C., derive from Crete, as can be seen from the definite originals found there. In the most impressive one, the Treasury of Atreus (*182*) from the 13th century B.C., a passageway (*dromos*) 6 meters wide and 36 meters long (it sides are faced with square blocks) runs into the rock. The 10.5-meter-high façade of the tomb had a rich relief decoration above the door consisting of two half-columns with spiral bands stretching between them and incrusted with red and green stone, their surfaces covered with a relief of zigzag lines and spirals. The cupola room itself, reached through a corridor 5 meters long, is overpowering. It is the most beautiful of its kind before the Pantheon in Rome, Hadrian's rotunda, built 1,400 years later. In the manner of the "false vault," thirty-three projecting stone rings are built up on top of each other from a lower diameter of 14.5 meters to a height of 13.2 meters, creating a chamber of marvelous harmony. Bronze pegs in the walls suggest that the surface was decorated with rosettes. A chamber leading from the cupola room has been hewn out of the rock. In this work it is striking to see how a completely un-Minoan heaviness and daring construction in stone are combined with the playful levity of Minoan decorative motifs. The Treasury of Minyas in Orchomenos comes close to it in impressiveness. A whole series of similar tholoi has been preserved in Mycenae and Pylos.

A few closing words about Mycenae: After the Doric migration—which can be dated in the Greek tradition along with Thucydides at 1104 B.C. or, after present-day opinion, a few decades earlier—Mycenae and Tiryns fell into decline and with them the arts and linear script. Only ceramics were able to assert themselves a little longer. The 12th century B.C. saw the so-called sub-Mycenaean style. Things were the same in Crete, where especially among the Eteocretans (who must be regarded as the descendents of the Minoans) sub-Minoan pieces have been brought to light, such as the clay model of a little temple (*179*) with the statue of a goddess visible in the doorway, guarded from the roof by two male figures and an animal. All these examples seem paltry and clumsy, and yet in a gentle way they announce fresh ambitions and a different kind of beauty.

BIBLIOGRAPHY

GENERAL

Akurgal, E. *The Birth of Greek Art*. London: Methuen, 1968. Also issued as *The Art of Greece: Its Origins in the Mediterranean and Near East*. New York: Crown, 1968.

Badawy, A. *Architecture in Ancient Egypt and the Near East*. Cambridge, Mass.: MIT Press, 1966.

Groenewegen-Frankfort, H. A. *Arrest and Movement: An Essay on Space and Time in the Representational Art of the Ancient Near East*. London: Faber and Faber, 1950; Chicago: University of Chicago Press, 1951.

Smith, W. S. *Interconnections in the Ancient Near East: A Study of the Relationships Between the Arts of Egypt, the Aegean, and Western Asia*. New Haven: Yale University Press, 1965.

Woolley, L. *The Middle East*. London: Methuen, 1961. Also issued as *The Art of the Middle East*. New York: Crown, 1961.

EGYPT

Aldred, C. *The Development of Ancient Egyptian Art from 3200 to 1315 B.C.* London: Tiranti, 1952.

Badawy, A. *A History of Egyptian Architecture*. 3 vols. Berkeley: University of California Press, 1966–70.

Bothmer, B. v. *Egyptian Sculpture of the Late Period, 700 B.C. to A.D. 100*. Brooklyn, N.Y.: Brooklyn Museum, 1960.

Evers, H. G. *Staat aus dem Stein*. 2 vols. Munich: Bruckmann, 1929.

Lange, K., and M. Hirmer. *Egypt: Architecture, Sculpture, Painting in Three Thousand Years*. London: Phaidon, 1968.

Lhote, A. *Les Chefs-d'œuvre de la peinture égyptienne*. Paris: Hachette, 1954.

Mekhitarian, A. *Egyptian Painting*. Geneva: Skira, 1954

Müller, H. W. *Altägyptische Malerei*. Berlin: Safari, 1959.

Smith, W. S. *Art and Architecture of Ancient Egypt*. Harmondsworth and Baltimore, Md.: Penguin, 1958.

– *History of Egyptian Sculpture and Painting in the Old Kingdom*. Boston: Museum of Fine Arts; London: Oxford University Press, 1946.

Vandier, J. *Manuel d'archéologie égyptienne*. 4 vols. Paris: Picard, 1952–64.

Westendorf, W. *Painting, Sculpture, and Architecture of Ancient Egypt*. London: Thames & Hudson; New York: Abrams, 1968.

Wiesner, J. *Ägyptische Kunst*. Berlin: Ullstein, 1963.

Woldering, I. *The Arts of Egypt*. London: Thames & Hudson, 1967. Also issued as *God, Men and Pharaohs*. New York: Abrams, 1967.

Wolf, W. *Die Kunst Ägyptens: Gestalt und Geschichte*. Stuttgart: Kohlhammer, 1957.

– Die *Welt der Ägypter*. Stuttgart: Kilpper, 1955.

MESOPOTAMIA

Beek, M. A. *Atlas of Mesopotamia*. London and New York: Nelson, 1962.

Frankfort, H. *Art and Architecture of the Ancient Orient*. Harmondsworth and Baltimore, Md.: Penguin, 1963.

– *Cylinder Seals*. London: Macmillan, 1939.

Ghirshman, R. *Persia: From the Origins to Alexander the Great*. London: Thames & Hudson, 1964. Also issued as *The Arts of Ancient Iran*. New York: Golden Press, 1964.

Godard, A. *The Art of Iran*. London: Allen & Unwin; New York: Praeger, 1965.

Huot, J. L. *Persia: From Its Origins to the Achaemenids*. London: Muller, 1966.

Margueron, J.-C. *Mesopotamia*. London: Muller; Cleveland: World, 1965.

Moortgat, A. *Altvorderasiatische Malerei*. Berlin: Safari, 1959.

– *The Art of Ancient Mesopotamia*. London: Phaidon, 1969.

– *Vorderasiatische Rollsiegel*. Berlin: Gebr. Mann, 1966.

Osten, H. H. von der. *Die Welt der Perser*. Stuttgart: Kilpper, 1956.

Parrot, A. *The Dawn of Art*. London: Thames & Hudson, 1960; New York: Golden Press, 1961.

– Nineveh and Babylon. London: Thames & Hudson, 1961. Also issued as *The Arts of Assyria.* New York: Golden Press, 1961.

Porada, E., and R. H. Dyson. *Ancient Iran: The Art of Prehistoric Times.* London: Methuen, 1965. Also issued as *The Art of Ancient Iran.* New York: Crown, 1965.

Potratz, J. A. H. *Die Kunst des Alten Orient.* Stuttgart: Kröner, 1961.

Schmökel, H. *Ur, Assur und Babylon.* Stuttgart: Kilpper, 1955.

Strommenger, E. *The Art of Mesopotamia.* London: Thames & Hudson, 1964. Also issued as *5000 Years of the Art of Mesopotamia.* New York: Abrams, 1964.

Wiesner, J. *Die Kunst des alten Orients.* Berlin: Ullstein, 1963.

Woolley, L. *Mesopotamia and the Middle East.* London: Methuen, 1965. Also issued as *The Art of the Middle East.* New York: Crown, 1965.

– Excavations at Ur. London: Benn; New York: Crowell, 1954.

– Ur of the Chaldees. London: Benn, 1929; New York: Scribner, 1930.

THE AEGEAN

Bossert, H. T. *The Art of Ancient Crete.* London: Zwemmer, 1937.

Chadwick, J. *The Decipherment of Linear B.* Cambridge: Cambridge University Press, 1958.

Demargne, P. *Aegean Art.* London: Thames & Hudson, 1964. Also issued as *The Birth of Greek Art.* New York: Golden Press, 1964.

Desborough, V. R. d'A. *The Last Mycenaeans and Their Successors: An Archaeological Survey.* Oxford: Clarendon Press, 1964.

Heubeck, A. *Aus der Welt der frühgriechischen Lineartafeln.* Göttingen: Vandenhoeck & Ruprecht, 1966.

Hood, Sinclair. *The Minoans: Crete in the Bronze Age.* London: Thames & Hudson; New York: Praeger, 1971.

Marinatos, S., and Hirmer, M. *Kreta und das mykenische Hellas.* Munich: Hirmer, 1959.

Matz, F. *Crete and Early Greece.* London:

Methuen, 1965. Also issued as *Art of Crete and Early Greece.* New York: Crown, 1965.

– Kreta, Mykene, Troia. Stuttgart: Kilpper, 1956.

Mylonas, G. E. *Mycenae and the Mycenaean Age.* Princeton, N.J.: Princeton University Press, 1966.

Palmer, L. R. *Mycenaeans and Minoans.* London: Faber and Faber; New York: Knopf, 1965.

– A New Guide to the Palace of Knossos. London: Faber and Faber; New York: Praeger, 1969.

Pendlebury, J. D. S. *The Archaeology of Crete: An Introduction.* London: Methuen; New York: Norton, 1965.

Platon, N. *Crete.* London: Muller; Cleveland: World, 1966.

Schachermeyr, F. *Die ältesten Kulturen Griechenlands.* Stuttgart: Kohlhammer, 1955.

– Die minoische Kultur des alten Kreta. Stuttgart: Kohlhammer, 1964.

– Agäis und Orient: Die überseeischen Kulturbeziehungen von Kreta und Mykenai mit Ägypten, der Levante und Kleinasien. Vienna: Öster. Akad. d. Wiss., 1967. (Denkschrift 93.)

Taylour, W. D. *The Mycenaeans.* London: Thames & Hudson; New York: Praeger, 1964.

PALESTINE, SYRIA, ASIA MINOR

Akurgal, E. *The Art of the Hittites.* London: Thames & Hudson; New York: Abrams, 1962.

Bittel, K. *Grundzüge der Vor- und Frühgeschichte Kleinasiens.* Tübingen: Wasmuth, 1950.

Bossert, H. T. *Alt-Anatolien.* Berlin: Wasmuth, 1942.

– Alt-Syrien. Tübingen: Wasmuth, 1951.

Jirku, A. *Die Welt der Bibel.* Stuttgart: Kilpper, 1957.

Klengel, H. *Geschichte Syriens im 2. Jahrtausend v.u. Z.* 2 vols. Berlin: Akademie-Verlag, 1965–69.

Riemschneider, M. *Die Welt der Hethiter.* Stuttgart: Kilpper, 1954.

INDEX

Descriptions of the illustrations are listed in boldface type